Being Again of One Mind

Women and Indigenous Studies Series

The series publishes works establishing a new understanding of Indigenous women's perspectives and experiences, by researchers in a range of fields. By bringing women's issues to the forefront, this series invites and encourages innovative scholarship that offers new insights on Indigenous questions, past, present, and future. Books in this series will appeal to readers seeking stimulating explorations and in-depth analysis of the roles, relationships, and representations of Indigenous women in history, politics, culture, ways of knowing, health, and community well-being.

Books in the series:

Being Again of One Mind: Oneida Women and the Struggle for Decolonization, by Lina Sunseri

Indigenous Women and Feminism: Politics, Activism, Culture, edited by Cheryl Suzack, Shari M. Huhndorf, Jeanne Perreault, and Jean Barman

Taking Medicine: Women's Healing Work and Colonial Contact in Southern Alberta, 1880-1930, by Kristin Burnett

Being Again of One Mind
Oneida Women and the Struggle
for Decolonization

Lina Sunseri

UBCPress · Vancouver · Toronto

21 20 19 18 17 16 15 14 13 12 11 5 4 3 2 1

Printed in Canada on FSC-certified ancient-forest-free paper
(100% post-consumer recycled) that is processed chlorine- and acid-free.

Library and Archives Canada Cataloguing in Publication

Sunseri, Lina
 Being again of one mind : Oneida women and the struggle for decolonization /
Lina Sunseri.

(Women and indigenous studies series)
Includes bibliographical references and index.
ISBN 978-0-7748-1935-0 (cloth); ISBN 978-0-7748-1936-7 (pbk.)

 1. Oneida Indians – History. 2. Oneida women – Ontario – Social conditions.
3. Oneida Indians – Ontario – Politics and government. 4. Oneida Indians – Canada
– Government relations. I. Title. II. Series: Women and indigenous studies series.

E99.O45S85 2011 971.3004'975543 C2010-904839-3

e-book ISBNs: 978-0-7748-1937-4 (pdf); 978-0-7748-1938-1 (epub)

Canadä

UBC Press gratefully acknowledges the financial support for our publishing program of the Government of Canada (through the Canada Book Fund), the Canada Council for the Arts, and the British Columbia Arts Council.

This book has been published with the help of a grant from the Canadian Federation for the Humanities and Social Sciences, through the Aid to Scholarly Publications Program, using funds provided by the Social Sciences and Humanities Research Council of Canada.

UBC Press
The University of British Columbia
2029 West Mall
Vancouver, BC V6T 1Z2
www.ubcpress.ca

CONTENTS

FOREWORD
Patricia A. Monture

Several years ago I came across a quotation that significantly influenced my thinking, and it is appropriate to share it again here. LeAnne Howe (Choctaw) (2002, 29) wrote: "Native stories are power. They create people. They author tribes. America is a tribal creations story, a tribalography." We each have our own stories, and when we share these stories among the people, we help to restory the land. This is one significant way that we are able to use the academic world to take a stand against colonialism (or the destorying of the land). In her work with twenty women, Lina Sunseri makes a significant contribution to the restorying of the territory of the Oneida nation.

It was more than thirty years ago that I started my university career as an undergraduate student. At that time, few courses were offered outside of anthropology departments on anything Indigenous. And the foundations of that discipline reinforced the idea that we were "primitive" people and belonged to cultures that were certain to vanish over time. The Iroquois were a popular topic for many anthropologists, and I remain quite convinced that if and when our people shared their stories with them, the anthropologists most often did not have the proper skills to listen to them or interpret them. Entrenched in the academic literature of those "experts" is a reflection of my people that does not fit the way I understand who I am or who we are as peoples. A number of academics have taken the findings of these Iroquoianists to task and have thus provided a foundation on which we can place our own understandings of who we are as Haudenosaunee peoples and as women of the Haudenosaunee League (Johansen 1998).

Women such as Lina and myself are often described as "living in two worlds." I dislike this construction of who we are. Every time I go to the

university, or step into a classroom, I have my Mohawk self with me. Perhaps, if you are not familiar with the ways of my people, you will not be able to see how I am grounded by who I am as a citizen of the Haudenosaunee League. Knowing who I am (my name, my clan, my nation, as well as where I come from) not only always grounds who I am but has also made possible the things that I have accomplished (including things like tenure and promotion in the university). It is with celebration that I embrace this work, as it is an acknowledgment that we can now carefully bring our Indigenous selves – selves that are gendered – to the practice of generating academic knowledge.

As you consider this work, please pay particular attention to the methodology in use. The book starts with the author locating herself both in her Oneida community and within academic traditions. In this way, she honours Indigenous ways that teach us how knowledge is shared. Sharing knowledge always commences with a sharing of who we are. When the methodological framework of academia is harmful or counterproductive (such as asking a clan mother to sign a consent form), it is set aside respectfully. In the end, Dr. Sunseri is able to provide a beautifully woven methodological framework that answers first to Oneida traditions and then to sociological or feminist ones. This is an important example for other scholars who wish to move beyond a critique of Western knowledge methodologies and into action.

There is a further reason why I celebrate the publication of this important work on Oneida women, nationalism, and colonialism. Thirty years ago, the university had a very different face than it does today. Not one of my professors was an Indigenous person until I took an Ojibway-language course. And after that course, I never met another Indigenous professor in the universities where I studied. This meant that to get a complete education, I could not rely solely on the university. I had to return home and connect with the teachers in our own communities. As a student, I was not really conscious that I was doing twice as much work and twice as much learning as the other students around me. When I look back from what I understand today, I see this clearly (as should our current Indigenous postsecondary students). Today, the face of the university has begun to change. There is now hope that my children will find among their teachers Indigenous people who hold doctorates and are among the university faculty. In my day as a student, much of what we did each day was about our merely surviving. Today, we have a reasonable belief that at some times, in some places, and with some

professors, the university now offers us the opportunity to understand who we are from within our own knowledge systems. This book is one of those moments.

The women of our many nations have a special role in recovering from the many colonial oppressions we have survived, and this book not only documents those successes but also informs us and is a call to action. Among the Haudenosaunee peoples, women are the first teachers. These Oneida women, who in these pages share their stories with us through the commitment and diligence of Dr. Lina Sunseri, will teach many people of many nations.

Ayewahhandeh, Mohawk Nation, Grand River Territory
Patricia A. Monture, LLD
Department of Sociology
University of Saskatchewan

ACKNOWLEDGMENTS

It is an Oneida tradition that before any other words are said, we must greet All Our Relations and give thanks to everything that surrounds us so that we can live in balance and harmony with each other and all living things. I give thanks to Mother Earth, for she feeds and nurtures us all. I give thanks to all the gifts that she has given us, acknowledging that each of these gifts has a purpose in life: the waters and all the lives that are in them; all the trees, plants, and medicines; all the animal life on Mother Earth, those that are four-legged and those that are two-legged; all the birds that fly above us in the sky, especially Eagle, the most sacred bird, for he is the closest to the Creator. I give thanks to the winds, the thunder beings, the stars, the sun, and Grandmother Moon, who is mother to all women. Thanks, Creator, for giving us all of these gifts, and if I have forgotten to name any, this was not my intent. Now our minds are one. Tahʌne'to.

There are so many people I would like to thank; without their support, guidance, love, energy, passion, and hard work, this book would not have been possible. First, I would like to thank the faculty members at York University, in Toronto, who guided me through the first hard steps of this project and provided me with much-needed feedback as well as encouragement to develop this project into a book. This development into a book would not have been possible without the support, effort, and attention to detail of the editorial team at UBC Press, especially Darcy Cullen, Melissa Pitts, and Anna Eberhard Friedlander. This book has been published with the help of a grant from the Canadian Federation for the Humanities and Social Sciences, through the Aid to Scholarly Publications Program. Also, the comments, criticisms, and suggestions made by two anonymous reviewers helped to strengthen the quality and content of the book.

It has taken years to research and write this book, and many people close to my heart have been right by my side, often having to be patient with me when I felt overwhelmed, stressed, or sad because of the topics and histories in which I was immersed. There is my immediate family, especially my sister Elayne, who shared my passion for the topic and also taught me much about our Oneida culture. I love you all, my dear family! There is my partner, Chris, and his boys, who have entered my life and are just as dedicated to the betterment of our Indigenous communities (they are Chippewas) as I am. It is so nice to be able to share our cultures and values with each other. There are the many, many extended family members whom I care about and love. They each inspire me to persist in (re)discovering knowledge and to be proud of our heritages. And of course, there are the many friends and colleagues who have supported me throughout my work on this book.

There are also many people who have shared their knowledge with me, either in person or with their written words of wisdom and courage: elders, clan mothers, faith keepers, community workers, and activists like Darlene Ritchie of AtʌLohsa Native Family Healing Services in London, Ontario, teachers, scholars like Patricia Monture, Taiaiake Alfred, Linda Smith, and Janice Acoose, to name only a few whose ideas inspired, motivated, and moved me to pursue an academic life while reminding me never to distance my work from the communities to which we belong.

And then there are the broader Indigenous peoples with whom I am connected and who have truly made this worthwhile. Our ancestors, I am grateful for all you have done for us, for enduring so much in your lifetimes and resisting the colonial beast. It is because of you that our stories, our teachings, our languages, and our ways of governing are still alive today. All those courageous men and women who are presently working for the wellbeing of our nations, there are no words that can truly do justice to the gifts you are giving to us all. It is true that there is much pain and struggle in our communities, but your relentless work ensures that there is also hope for a better tomorrow; healing and recovery are occurring every day because of you. My thanks to you. And our youth, you are our cherished future, the gifts that the Creator has given to our nations. Through your smiles, your tears, your dances, your words, your songs, and your artworks, each day you remind us of the work that must be done to move forward. Sometimes, we fail you; I fail you. May you forgive us and find the strength to keep reminding us. We

must find our way back to good relations so that the next generations of Indigenous peoples will stay strong and proud.

But mostly, this book was ultimately possible only because of those women who gave their time, their energy, their passion, and their knowledge. They shared their personal experiences, views, emotions, and feelings with me and were willing to tell the whole world about past and current conditions of Oneida women's lives. I could not have written such a needed book without your contribution and knowledge. Yawʌko.

This book is dedicated to all Indigenous women of Turtle Island: those who have passed to the Spirit World and are watching over us; those who are on Mother Earth and staying strong despite many challenges; those very young ones whose eyes and ears are wide open and thirsty to learn about living in a good way; and those who have yet to come – may we not forget that each act we do on Mother Earth will be our legacy to them. May we act according to the principles of the Great Law of Peace.

Being Again of One Mind

Introduction

We are connected to this land in a special way. Our stories teach us how Turtle Island was started, and we are supposed to say thanks to this land, to Mother Earth, for giving us life ... We are supposed to take care of the land, like our ancestors did hundreds of years ago. (Mary)

There is so much to feel proud to be Oneida. We belong to a very good nation, where women were central to everything, and a very equal society. Also we belong to a tradition of peace, of co-operation. That is because we belong to the Haudenosaunee [League]. We were united by the Peacemaker and we are supposed to love each other, but also respect each other's freedom. (Frances)

With colonialism, you have that others came and started to control us, to tell us how to run our own communities, you know? Wanted to change us into becoming like them. They called us savages, wanted to save us, they said. But we didn't get salvation. If you ask me, we got what? Hell, that's what we got. We got stripped of our rights, our freedom, tried to destroy our culture. (Anne-Marie)

Colonialism has tried to make us forget the teachings of the Long-house, which were ways to make sure we lived in a good way, and that needs to come back. We need the elders to tell us how to do that again, and we need us, the women, to be involved in all of that. We have much to lose if we don't get involved. Our role as mothers of the nation demands that we do, and it is better for us that we do, that way we make sure we help our nation to be good again. We leave a good legacy for the next generation. (Lisa)

These quotations come from conversations I had with four of the twenty women who participated in my research for this book. I have chosen to begin my introduction with their words for two reasons: first, I want to give central space to the voices of the Oneida women who shared important and at times personal and painful stories with me and whose voices need to be central in this academic work. The perspectives of many marginalized groups, like Indigenous women, are often not included in academic theories. Even when these groups are studied, the voices of their members are often given only a small place within the published texts. Mohawk scholar Dawn Martin-Hill agrees that this marginalization/silence is quite prevalent in academic disciplines, her discipline of anthropology included. This does not mean that Indigenous women haven't had much to say; quite the contrary:

> They often have a lot to say, yet they are rarely asked. Male researchers often write that they consider it inappropriate to interact with women; that is the rationale they offer for excluding their experiences ... Aboriginal women have a multitude of experiences that men do not ... we Aboriginal women have borne the brunt of colonialism's legacy. (Martin-Hill 2008, 121)

This book indeed discusses this multitude and this brunt. The opinions expressed above by Mary, Frances, Anne-Marie, and Lisa best capture the overall topic – the multitude of Oneida women's experiences in their nation and within Canadian society. This book examines the current processes of decolonization in Canada, particularly of the Oneida nation, and links these to issues of gender, colonialism, and nationalism. It explores the existence of Indigenous nations and nationalisms prior to and outside of European-based characteristics of nation. More specifically, the book deals with the transformations of gender relations within Oneida due to colonialism. Through the narratives of twenty Oneida women, an overview of traditional governance and teachings, and a critical reading of the leading literature, the book shows that a decolonizing nationalist movement has the potential to restore the gender balance that existed in their nation prior to colonialism. The book reveals that women's participation in the decolonizing movement is complex and full of contradictions and challenges; hence, I ultimately argue that for true liberation from colonial oppression to occur for all members of the nation, decolonizing governance practices must be inclusive and

should follow the traditional principles of governance found in the Great Law of Peace: peace, power, and righteousness. When these practices are put into place, women can (re)gain political, social, and economic agency through their active involvement in shaping a nationalist discourse that is based on Indigenous concepts of nationhood.

This book examines some of the traditional roles of Oneida women in their nation and shows that the powerful positions held by Oneida women were transformed by centuries of colonialism, which, together with many other devastating consequences, created both an imbalance in gender relations and many divisions within the Oneida nation. I further discuss how women, together with their male counterparts, have always resisted colonialism and are currently involved in the decolonizing movement taking place in Canada.

As Lisa comments in the fourth of the quotations that open this introduction, many Oneida women point to colonialism as a central cause of the present oppressive conditions faced by Indigenous peoples. Hence they feel that women must take part in the decolonizing movement to ensure that their specific needs are addressed and that a decolonized nation can offer them better experiences.

I define decolonizing nationalist movements as those aimed at forming new relationships that break away from colonialist structures of governance and that are rooted in notions of nationhood and sovereignty. Such movements are committed to re-establishing autonomous and self-determined nations and to looking at Indigenous peoples' unique historical experiences of nation and nationalism (Ladner 2000; Alfred 1995, 1999; Monture-Angus 1999; Simpson 2000, 2007; Turner 2006). As such movements are embedded within an Indigenous notion and history of nation and nationalism, I argue that the Oneida nation, like other Indigenous societies, has a history of nation and nationalism that dates to centuries prior to Europeans' arrival in North America. I therefore offer a theory of nation and nationalism that is an alternative to that offered by modernist theorists who argue that nation and nationalism originate with modernity and are linked to the formation of a state. One can find examples of nations outside of Europe and outside of modernity, although they might be founded upon phenomena different from those that underlie Western nation-states. The Oneida nation was inclusive and based on the values of equality and freedom, on a consensus-based decision-making model, and quite important, on gender balance. It is essential that in the process of decolonizing, we keep in

mind and re-establish those principles that formed the Oneida nation and its nationalism: peace, power, and righteousness.

Many feminist theorists have provided good analyses of the gender dynamics that exist during and after nationalist movements, and their individual reactions to most nationalist movements have been mixed. Some theorists admit that women should not be seen merely as duped subjects who are used by males and other elitist nationalists to further their own, rather than women's, interests; they note that during national liberation struggles, for example, some women can gain a form of empowerment through their active involvement in the movement. Others question the possibility that women's interests are best served through any form of nationalism. Overall, most feminist critiques have argued that most or all nationalisms, particularly those that focus on genealogy and origin as the major organizing principles of the nation, are gendered and oppressive for women (McClintock 1995; Yuval-Davis 1997).

Although all of these theories provide a critical look at nationalisms by unveiling the gendered and unequal power relations that take place within nationalist discourses and practices, I question in this book how or whether these critiques apply within an Indigenous context, specifically an Oneida one. Through my own experience with nationalism within my community, and in talking throughout the years with many women in my community, I have seen and learned that a large number of women, together with their male counterparts, believe that a decolonizing nationalist movement is empowering for them both as women and as Oneida people. They believe that liberation from colonialism is the most important step that can be taken to better their conditions. I also contend that they have an inherent Indigenous right to reclaim their own nation, free from colonial interference. Such a nationalism can be inclusive and liberatory, and is rooted in a rich, woman-centred idea of nation. These women's position vis-à-vis nationalism is not rooted in a mainstream feminist framework. For them, the roots of their vision of liberation are within Indigenous cultural traditions and ways of governing, which are based upon a notion of gender balance. Moreover, gender equality is not the only or the primary concern in their struggle, so it is debatable how relevant mainstream feminist theories are to these women's lives. For them, Indigenous rights, like decolonization, are strongly connected to their rights as women; the two are never separate but are always simultaneously lived in their everyday lives. As well, one of the aims of these women is a reaffirmation

of traditional womanhood and women's roles, with an emphasis on the notion of "mothering the nation."

Some feminists have critiqued the notion of "mothering the nation," revealing how it has often been used to control women's sexuality by constraining them to submissive positions in the private sphere. These theories, however, do not apply well to Oneida women. "Mothering the nation" has a specific cultural meaning and a long history within Oneida and other Haudenosaunee nations, where it was not used to constrain women. However, some feminist critiques of nation and nationalism do offer important insights into the complexity of women's positions and participation in nationalist movements. They show the implications of some discourses within nationalism, like "purity of blood," that have particular gendered applications and have been found to affect negatively the women of nations that abide by such notions. Indeed, the present situation of Oneida women is full of complexities, paradoxes, and challenges because of how – as the example of "mothering the nation" demonstrates – "tradition" can and has been used not to empower them but to perpetuate their marginalization and oppression within their communities.

In sum, then, I argue that there is no single version of either feminism or nationalism. Both can be either progressive or reactionary in the case of Oneida women. Within a decolonizing nationalist movement rooted in a history of nation that has been inclusive and based on gender balance, there is a possibility that nation and nationalism have not been oppressive for women. Oneida women within the movement are (re)gaining political, social, and economic agency by contributing to the formation of a decolonized nation. Their participation can influence and challenge any existing patriarchal and essentialist concepts of nation and may make it possible to establish an Oneida nation in which women's roles and rights are ensured and realized. This would mean putting into place the founding principles of the Great Law of Peace, accommodating differences, and eliminating present divisions that exist in our community.

I begin this book by engaging with theories of nation, beginning with those that link nation to modernity. I do so to show the Eurocentric bias in those theories, which tend to dismiss any other forms of nation, such as that of the Oneida people – and those of other Indigenous peoples – although the Oneida nation and other nations of the Haudenosaunee League have a long history of nation that precedes that of most European

nation-states. It is important to acknowledge this Indigenous history so that fully decolonized future relations between Indigenous and non-Indigenous peoples can be conducted on a nation-to-nation basis. I then turn to postcolonial and Indigenous literature on nation to illustrate how historically in white-settler colonies such as Canada, issues of nation, culture, gender, and colonialism have been interconnected and have shaped the experiences of Oneida people and other Indigenous peoples. Chapter 2 gives a history of Oneida from the time of precolonialism to the present, making clear that Oneida and the other nations of the Haudenosaunee League have a rich tradition of governance within each nation, within the league, and with outsiders. I then show how colonialism altered the internal and external relations of the Oneida nation, similar to its effect on the relations of other Indigenous nations. The focus is on the change in gender relations since colonialism, specifically the shift from matrilineal, egalitarian nations to more patriarchal ones. The rest of the book is dedicated to discussing how the participants in my research consider colonialism to have shaped their lives and that of their ancestors and their communities, with an emphasis on how they envision a decolonizing nationalist movement to be able to restore balance, equity, and wellbeing to their own lives and that of their nation.

Standing, Looking, and Writing on Turtle Island: Locating Myself and My Work

How did this book evolve into what it is today? It is actually difficult to specify when and how I selected the particular topic or focus of my research. In some ways, the choice was influenced by my experiential knowledge of issues of Oneida identity, nationalism, gender relations, and colonialism as a member of the Oneida community. My own identity has meant an informal daily inquiry into the current challenges faced by Oneida people and other Indigenous peoples. The need to make sense of those experiences increased during my graduate studies. Two particular events triggered in me a need to rigorously investigate my experiential knowledge of the complex relationship between Oneida nationalism and gender. The first event was a graduate workshop on the topic of diaspora and hybridity, during which I articulated to the group that although I did agree with some of the postcolonial theories we were discussing, I did not think they fully explained the experiences of some colonized groups, such as the nations of the Haudenosaunee League.

However, I did not have enough knowledge of either postcolonial theories or the history of colonialism and the current decolonizing movements to be able to convincingly present an argument. I knew that I needed to better inform myself about the history of the Oneida people's traditions and colonial experiences in order to better connect them with contemporary national liberation struggles.

The second event that motivated me to develop my experiential knowledge into a social-research topic was my experience in a graduate class that dealt specifically with the topic of gender, nationalism, and ethnicity. This course introduced me to many theories of nation and gender and also looked at many feminist theories that critiqued the relationship between nationalist movements and women. Although I agreed with most of the arguments, Oneida women's experiences within nationalist movements were not well reflected in the theories. In particular, I felt that the concept of women as "mothers of the nation," which was critiqued by many feminist theorists, had a different history for Oneida women. Indeed, I had learned through many oral teachings and by participating in many traditional ceremonies that "mothers of the nation" was an enriching and empowering notion for Haudenosaunee women. I wanted to make better sense of my own experiences with nation, nationalism, culture, and tradition in relation to what I was reading and learning within the university walls. Several questions began to preoccupy me: Is nationalism really dangerous for women? Why are Oneida women involved in a nationalist movement? Are our Oneida traditions empowering for women or not? Why don't Oneida women seem to have the same powerful positions they once had? Why are there so many divisions in our community? What is needed to heal our community?

Many years before I started my graduate studies and my current academic profession, I had already acquired a lot of knowledge about these questions by having everyday conversations with Indigenous friends and relatives on issues of colonization, decolonization, culture, tradition, gender, and nation, by listening to stories and teachings from elders, by taking part in ceremonies at the Longhouse, and by participating in workshops that dealt with healing the community. I knew that I needed to incorporate this acquired knowledge into the knowledge that I was gaining in my new academic life. Until recently, Western male theorists have dominated the literature on Indigenous peoples' history and have not always included Indigenous voices, especially those of women,

Indigenous ways of knowing, or oral histories, which has resulted in many biases and gaps in the *his*torical accounts. Given this omission, and encouraged by the additional reality that Indigenous scholarship has been growing rapidly, I am committed to including voices and written words of Indigenous people in this work rather than those of non-Indigenous people. Of course, other theories and works that are relevant and can help us to analyze the effects of colonialism on Oneida people and to examine the current struggles of decolonization are also included. But this book, given that it deals with the topic of decolonization and in fact aims to contribute to the overall decolonization project of Indigenous peoples, privileges Indigenous scholars, voices, and knowledges in order to break away from the academy's Westerncentric approach.

I wanted to investigate the topic of gender and nationalism as it pertained to Oneida. I had done research in 1996-97 on the effects of neoconservative social policies on Indigenous single mothers, and I had sensed that many of the women who participated in that research were interested in talking about women's roles in the Oneida nation, especially about how these had been altered through colonialism. I contacted a couple of the people I thought might want to participate in my research. Also, I spoke with some family members, friends, and acquaintances about my newly developed research topic. My mother and sister suggested that I discuss my topic with my clan mother, or Laothuwisʌ'tsla?, and ask her for guidance about cultural protocols and traditional teachings. She and I met a few times, and she became a participant in my research as well as my teacher of Oneida history and traditions. I wanted the research to be collaborative and for the participants to be as involved as they wanted to be throughout the process. I hoped that about twenty-five women would agree to participate.

Interviewing Oneida Women

Oneida of the Thames, whose original name is Onyota:aka, or People of the Standing Stone, is one of the three communities that form the Oneida nation.[1] It is located in south-western Ontario, where its first members arrived in 1840 after migrating from the original territory in what is now called New York State. One of the other two Oneida communities is still located in the original territory, which has been reduced in size due to a series of policies of dispossession, and the other is in Wisconsin. Both I and the women who participated in my research belong to the Oneida of the Thames community. The Oneida nation is one of the original five

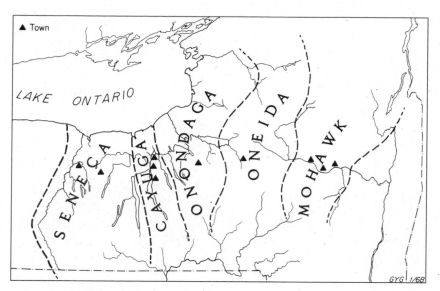

The five founding nations of the Haudenosaunee League, united as early as the mid-fifteenth century under the Great Law of Peace. Map by Gwynneth Y. Gillette. Courtesy of New York State Museum.

nations of the Haudenosaunee League, whose name means People of the Longhouse. This league is also known as the Iroquois Confederacy because the early French settlers named the Haudenosaunee peoples Iroquois. The other four original nations of the league are Onondaga, Mohawk, Cayuga, and Seneca. In 1722 Tuscarora joined the league through adoption by Oneida. Each nation of the league is structured by a clan system. The Oneida nation is made up of three clans: Turtle, Bear, and Wolf. I am of the Turtle Clan, and in our language, when identifying my clan affiliation, I say aʔnowál niwakiʔtaló•ta.

I met two women from Oneida of the Thames and discussed with them the general topic of interest and the type of research process that seemed most relevant to our own cultural traditions. They felt that my research would be interesting and could be useful to Oneida women and to the overall community. After agreeing to participate, they each signed a consent form. The one person who did not sign a consent form was my clan mother, as this would not have been culturally appropriate. Clan mothers have many roles in our communities, one of which is to impart to younger community members the teachings and ways of being

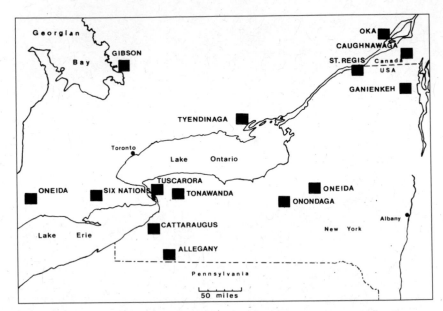

The eastern Haudenosaunee settlements, showing the location of Oneida of the Thames in south-western Ontario, whose first members arrived from New York State in 1840. Also shown is the location of the Oneida community remaining in New York State. The third Oneida community (not shown) is in Wisconsin. Courtesy of Syracuse University Press.

of the nation. It would have been insensitive to impose such a foreign formality on the relationship that she and I had been building. The first two women said that they would ask other women to participate whom they thought would be interested in the research, and they also provided me with the names of some women who had been involved in many cultural and political activities. After my many initial communications with potential participants, a total of twenty women agreed to work with me on this collaborative research.

I met with each of the participants at least twice. Eighteen of the women agreed to be audio-taped. I did not have preset questions, only general themes, such as what it means to be Indigenous, Oneida, and Haudenosaunee in a contemporary context; what some of the most important challenges are that Indigenous peoples, particularly Oneida, face today; what meaning they give to the terms "nation," "decolonization," "self-determination," and "self-government"; and issues surrounding membership in the Oneida nation (e.g., the Indian Act's rules on

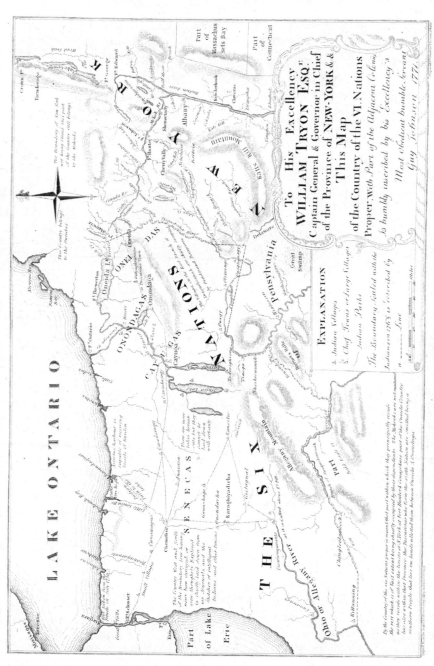

This map showing the lands of the six nations of the Haudenosaunee League was drawn in 1771 for Governor William Tryon by Guy Johnson. Courtesy of New York State Library.

status, blood-quantum criterion, reserve residency, Bill C-31, and traditional criteria for Longhouse membership). I also had in mind gender-specific themes, such as the traditional roles and responsibilities of Oneida women and how these changed after colonialism; the meaning of concepts such as women as "mothers of the nation"; and the role of women in current decolonizing movements. Together, we decided which themes to focus on.

Some of the women live in the Oneida of the Thames community, and others live in an urban setting in Ontario. Most are in a long-term relationship, either a marriage or a common-law union, and have children, but a few are single and childless. In terms of education, there is also variation: some never finished high school, whereas others commenced and/or completed a postsecondary education, and a few attended a residential school. The majority have held a position of paid employment during their adult lives, and only two have been a "full-time mom." Most consider themselves "traditionalists of the Longhouse"; although some do not, almost all are quite familiar with the Longhouse teachings. Almost all of the women have Indian status, and about half have some European ancestry in addition to Oneida. Ultimately, the opinions expressed are those of these specific women, shaped by their own experiences and knowledge of issues of identity, land, nation, colonialism, and decolonialism. These opinions cannot be expected to represent the views of all or most Indigenous peoples, or even of all Oneida women, on the various subjects. But these women's insights and views tell us much about the challenges that Indigenous women have faced in their nations since colonialism and about the potential for regaining gender balance, as well as for removing other oppressive colonial legacies, through a decolonizing nationalist movement.

The format of the interviews was very informal and open-ended, and we agreed that both I and the interviewee would collaboratively participate throughout. This approach ensured that they could ask about my own views on some topics so that we would be able to practise the sharing principle of our cultural traditions.[2] As well, after I transcribed and made an initial analysis of the interviews, the women were invited to view and go over them with me. I also told them that I would keep a research diary where I would reflect on the whole research process, including the interviews. They did not desire to see the diary, but they did want to see the transcripts of our conversations and the analysis. My second exchange with each woman was a follow-up on our first

conversation. The time between the two meetings gave each of us an opportunity to think more about the topics we had discussed, to clarify some points, or to discuss how we felt about our first meeting. Having an opportunity to discuss our feelings after some time had passed was very important. A lot of the topics discussed in the first meeting caused some degree of discomfort and pain because of memories of racist or sexist experiences. As well, because some of the participants and I had opposing views on some points, meeting again reassured us that our relationship was still good and respectful. Since these women belong to my community, and since some of them are of my clan, we felt that maintaining good relations was an important aspect of our work together. We wanted to be true to ourselves, to be honest with each other, and to present our own stories during the conversations while remembering that we are related to each other. I agreed to share the completed work with them and to provide it to those in the community who might want to see it.

In addition to recording collaborative narratives, my research involved participation in traditional ceremonies, teachings, workshops, and conferences. The ceremonies and teachings helped me to understand better the traditions of the Oneida nation, the responsibilities that members have toward each other, and the roles that women have historically played in Oneida. I have learned the teachings of the Great Law of Peace, KayanlΛhsla?kóin the Oneida language, the importance of the clan system, and the differences between Haudenosaunee ways of governance and those shaped by the Indian Act and other colonial practices. In the summer of 2002, on the advice of my clan mother, I attended a weekend workshop in the Oneida people's original territory, in New York State, that dealt with the current land-claim dispute between the Oneida nation and New York State. This gathering was informative for me because it provided both an overview of the land claim and an opportunity to visit the original Oneida territory. During the weekend, I had conversations with some women about Oneida history, and I witnessed how Oneida women still play an important political role in their community.

My immersion in the literature on nationalism, gender and nationalism, colonialism, postcolonialism, decolonization, Oneida history, and Haudenosaunee history, the knowledge that I acquired through my collaborative interviews with Oneida women, my previous experiential knowledge, and my participation in various cultural and political activities – all have been influential in shaping this book. In the end, this

book offers an Indigenist, women-centred perspective on decolonizing nationalism. Although the process has been challenging and emotional, I am happy that I have been able to combine all the various sources of knowledge into this final result.

Some Comments on Terminology

Many terms appear throughout the book that might not be familiar to the reader or that are used differently from the way others use them because of their reference here to specific Indigenous contexts. As a descendant of the Ukwehuwé, or Original Peoples, of this land, I must note my preference for the term "Indigenous," as it acknowledges that the people identified in the book are connected to the Indigenous nations that existed on Turtle Island (Turtle Island is how many Indigenous peoples refer to Canada) prior to the arrival of Europeans on this continent. Therefore, there is a political element in the choice of the term. This term, I must admit, is not commonly used by most of the people in my community during their everyday conversations. The two most frequently used terms are "Native" and "Aboriginal," whereas "First Nations" is the term more commonly found in academic circles in Canada. I am grateful to Taiaiake Alfred's latest work, *Wasáse* (2005b), for making me think more critically about the various labels given to Indigenous people. As he explains, "Many Onkwehonwe today embrace the label of 'aboriginal,' but this identity is a legal and social construction of the state, and it is disciplined by racialized violence and economic oppression to serve an agenda of silent surrender" (Alfred 2005b, 23). I attempt, therefore, to refer to people by the name of their Indigenous nation (e.g., Oneida) as often as possible, while also retaining the terms used/chosen by the individuals interviewed for my research. I rarely use the term "Indian" unless it is written as such in a particular text or unless I am discussing the Indian Act of Canada, which still uses the term. The term is viewed as offensive by most members of my community and by other Indigenous nations. However, at times, the term is used by some Indigenous people of Canada, especially when talking among ourselves. In such cases, the term is used in a sarcastic way or as an attempt to politically reclaim it by removing its past derogatory meaning. An example of this is its use in the phrase "Indian country." The implied message in the usage of this phrase is that the land in North America originally belonged to those whom others have labelled as "Indians." Whenever I use the term "Indian," I place it in quotation marks in order to problematize it. "Status Indians," however, is a legal term used to refer to those who are

registered as "Indians" under the Indian Act, to whom the Canadian state has a specific relationship.

I discuss the importance of "tradition" for Oneida women in their attempt to reclaim Indigenous ways of relating with men, children, and all other beings on Mother Earth. "Tradition" is a complicated term for Oneida women, as its current usage is full of contradictions and complexities. I do not use the term in a simplistic, essentialist, or romanticized fashion. I find Anderson's (2000, 35) definition of the term the closest to my understanding of it: "When we say 'tradition' in our communities, we are referring to values, philosophies and lifestyles that pre-date the arrival of the Europeans, as well as ways that are being created *within* a larger framework of Euro-Canadian culture, or *in resistance* to it" (original emphasis). This definition recognizes that "tradition" is a living entity subject to change. Tradition is constructed by communities to suit specific changing needs, while simultaneously focusing on and revitalizing those elements of the teachings, the stories, and the ceremonies that have survived throughout colonization and can still apply to contemporary realities.

Learning of Healthy Relations from the Oneida Creation Story

I shall start by telling you a short version of the Oneida people's Creation Story, as it has been told to me over the years by my elders and teachers. (Indigenous peoples have some marvellous storytellers, and often the stories are very long, lasting hours depending on the orator, but a shorter version seems more appropriate here.) There is a saying within my Oneida community, and it is probably heard in other communities as well: "You can't know where you are going unless you know where you came from." This saying teaches us that we must go to our roots, to the beginning, before we can move forward. This book covers Oneida's ongoing decolonizing nationalist movement and women's roles within it. As we dream of a healthy, free Oneida nation in which the balancing of men's and women's roles is regained and future generations will be free of destructive colonial legacies, I believe that we first need to go back to a time when Oneida women had a central and sacred role as mothers of the nation. The Oneida people's Creation Story is a testimony to the rich and powerful roles women held in the nation. Sky Woman, or Otsitsa, created Turtle Island, and Lynx Woman gave birth to the first human species who inhabited it. Because of this, Oneida women were viewed as givers of life and mothers of the nation. They were considered to be the drumbeat of the nation. However, due to many factors covered

throughout this book, many stopped listening to the beat. But women have kept drumming. It is time that we listen carefully to the beat and go back to where we came from, to the teachings given to us by the story of "Sky Woman Falling from the Sky."

At one time there were no humans in this land, as there was no earth; there were only water animals in the water. In the Sky World lived other species and there was a big tree. In the Sky World there was Sky Woman, the daughter of the chief of the Sky World. Sky Woman had been married to a man. One day the Sky Woman had quarreled with the man, who had been mean to her and was jealous of her, of her beauty, and he doubted that he was the father of the child she was expecting. One day Sky Woman was beside a hole by the big tree, when she fell from the Sky through that hole. Some say that he pushed her. As she came down, she carried with her the three sisters corn, squash, and beans in one hand and tobacco and strawberry seeds in the other. As she was coming down, some of the animals that were living under the Sky World saw this creature coming down. One of the animals cried out "Look, a strange creature is falling down. What is it?"; then they realized it was a human person. They wondered what to do. One of them said: "She won't survive here, we have to catch her." They caught her. They thought over about who would carry her. Finally it was decided that the Turtle would, as it was larger and stronger and more flat, so she could sit on top of him. When she arrived, they put her on top of the Turtle. The seeds and the three sisters that she had brought with her grew and spread on top of the Turtle shell, making mud and becoming a large mound of earth. So this is how the earth was made, from the Sky Woman who fell from the Sky World and who brought with her the beginning of life. Later on she gave birth to a woman, Lynx. The two became very close until the Lynx ignored the warnings of the mother and became pregnant from a Sky creature, the Wind, and gave birth to twin boys. She died giving birth. Her mother had warned her that it would be dangerous if a union between someone from the Sky World and Earth was to happen. And that was true: the Lynx woman died, but

she gave life to the first humans made on Turtle Island. The boys grew up and each one became responsible for giving life and taking care of different things on earth. They would tease each other with different tricks to do on earth. So, this is how Turtle Island was made, by the first woman from the Sky World coming down to earth, giving birth to the Lynx Woman, and then the Lynx Woman became the Mother of Nations, having mated here and given life to the Twins.

Theorizing Nations and Nationalisms: From Modernist to Indigenous Perspectives

What drives some individuals of Indigenous groups in Canada to mobilize and strive to re-establish healthy, self-determining nations? How is it possible that even after centuries of colonialism and attempts by the colonial state to "get rid of the Indian problem," cultures of Indigenous peoples have survived? Likewise, how is it possible that we can still hear the heartbeat of our Indigenous nations despite efforts from the colonizers to force that heartbeat into silence? What do some people mean when they say, "We are the First Nations of this country"?

In the introduction, I argued that not all nationalisms are necessarily oppressive for women or based on fixed and exclusionary criteria of membership in the collective community. Through the voices of the women who contributed to my research, and drawing on my own participation in cultural and political activities of the Oneida nation, this book articulates the possibility of an "alterNative"[1] discourse of nation and nationalism. Before embarking on this discussion, I need to review some of the prominent literature on nation and nationalism and how it applies in the case of Oneida. This review uncovers the Eurocentric biases of earlier male/mainstream theories and then shows how, in contrast, postcolonial and Indigenous theories, by linking colonialism and decolonialism to nationalism, best fit into the analysis of the Oneida nation's decolonizing nationalism.

Modernity and Nation

Mainstream theorists of nation treat nations as social constructions that are tied to modernity. The theories may at times give different dates and places of origins of nation and nationalism. However, they all argue that it was Western modernity that ultimately generated the need to imagine national identity and the formation of nations. In agreement with other

Indigenous scholars (Ladner 2000; Simpson 2000; Alfred 1995, 1999), I argue that this conceptualization of nationalism is Eurocentric and dismisses those experiences of nationalism that existed prior to and/or outside of modernity and that in many cases preceded the time of contact with Europeans and colonialism, such as the experiences of Oneida people and of other Indigenous peoples.

Gellner (1983), to begin with, strongly connects nation with the state, seeing the latter as a centralized, hierarchical political organization. We can clearly see this linkage when Gellner (1983, 4) writes that "not all societies are state-endowed. It immediately follows that the problem of nationalism does not arise for stateless societies. If there is no state, one obviously cannot ask whether or not its boundaries are congruent with the limits of nations." So what is one to do with and to call those state-less societies? With regard to "hunting and gathering bands," which is how he incorrectly describes all Indigenous societies, such as the Oneida and the other Haudenosaunee peoples, Gellner states that these are too small to have a "political division of labour which constitutes a state" (5). Despite this erroneous description, I do concur with some of his argument. Most Indigenous societies did not have what we would now call states. Where I do differ from Gellner is in his linking state with nation to arrive at the conclusion that "the problem of nationalism does not arise when there is no state" (5). The "problem" of nation and na-tionalism has existed and continues to exist for many Indigenous soci-eties, including Oneida and the other nations of the Haudenosaunee League, who formed a confederacy of nations centuries before the for-mation of modern states in Europe and who continue to demand that their nationhood be respected by those who have come to share the land on which their confederacy sits.

Gellner (1983, 24) exhibits Euro/Westerncentrism and a positivistic opinion of modernity and industrialization by correlating mobility with egalitarianism, as well as a strong functionalist view of nationalism. Not surprisingly, his linear theory of stages of development of societies leads him to view only the West as modern, progressive, egalitarian, and the birthplace of nations. This is shown in his frequent references to mod-ernity, to economic growth, to the development of states, to centralized authority, and to homogenous culture as the essential and necessary components of a nation. Critics of modernity have pointed out that: (1) the modernity of the West was never egalitarian for/toward all groups, especially given that the construction of the modern "West" went along with the colonization of "the Rest" (Hall 1992, 280); (2) it is debatable

whether homogenization of culture was ever present or possible; and (3) the tendency to equate state with nation is Eurocentric and likely not valid. If one considers other interpretations and definitions of nation, one can hardly credit the origins of nationhood exclusively to Europe, for it can be dated back to perhaps many years prior to European industrialization, the period that Gellner (1983, 55) names the "age of nationalism." However, since Gellner defines nationalism exclusively within a European framework, he considers those material conditions that brought forward modernity and industrialization to be foundational for the formation of a unified nation. But, as Indigenous scholars like Simpson (2000, 119) argue, Gellner's definition has at least two short-comings: first, by treating nationalism as a pure and absolute manipulation of the population by the elites, he dismisses "the collection of meanings (through event, history and present interaction) that distil into the consciousness of nationhood in a people"; second, as a "theory, nationalism should be extended to the aspirations and actions of those collectivities that do not fit the template ... Among other non-western people are the experiences of native peoples in Canada." Ultimately, although Gellner's theory stresses that identities such as national identity are social constructs and not to be treated as frozen or static, his theory ignores that Oneida people – and other peoples of the Haudenosaunee – had constructed a national identity outside of modern, Western, and industrial environments.

Like Gellner, Hobsbawm (1992, 10) ties the origin of the nation to a modernist state, one that has clear territorial boundaries and arises from an advanced stage of technological and economic development. Hobsbawm admits that prior to the particular modern states, there were collective formations that resembled nation-states. However, he argues that these were not nations, as they had only a liberal bourgeois origin (24). He outlines what the essential criteria of a nation are: first, its historic association with a state; second, a long-established cultural elite among whom there is linguistic unity; and third, "a proven capacity for conquest" (38). When studying socio-historical events that followed the European Industrial Revolution and led to the more recent and modern type of colonialism, ultimately tied to imperialist projects of the modern nation-states, one sees that Indigenous nations did not prove capable of conquering but were the recipients of colonial conquests; therefore, they do not fit easily within Hobsbawm's typology. Moreover, as statehood is a crucial and necessary element for a nation, again only "some" societies can be ranked in Hobsbawm's theory of nation premised on

evolutionary stages. In fact, he himself states, "It is thus essential to bear in mind that 'nation-building', however central to nineteenth-century history, applied only to some nations" (42). Due to such claims, we must critique theories such as his for being based exclusively on European experiences, ideas, and concepts as well as for equating nationalism with statehood and territoriality (Alfred 1995; Ladner 2000; Simpson 2000).

Hobsbawm's Eurocentric bias surfaces in his calling the nation a novelty to be found originally in industrial Europe, a claim that ignores nation-building projects that have occurred outside of Europe and that may have taken place along with or outside of the development of industrialization, such as the Oneida nation and the other nations forming the Haudenosaunee League. As well, Hobsbawm's (1992, 170) Eurocentric view is also evident in his differentiation between "good" nations, which for him obviously means the nineteenth-century European models, and the "separatist and divisive 'ethnic' group, [whose] assertion has no such positive programme or prospect." His denial of any progressive element in models of nations that do not follow the European ones would lead him to disapprove of some new (or renewed) nation-building movements, such as Indigenous decolonizing movements, when these demand national sovereignty, which could cause, according to him, "separatism and divisiveness" in existing nation-states (170). Lastly, Hobsbawm argues that "in spite of its evident prominence, nationalism is historically less important. It is no longer, as it were, a global political programme, as it may be said to have been in the nineteenth and earlier twentieth centuries" (181). This particular aspect of Hobsbawm's theory is both inaccurate and problematic, for he does not take adequate account of the persistent and emergent decolonizing movements that have been happening throughout the world, which are often grounded in a strong sense of nationhood, such as those of many Haudenosaunee nations.

For the sociologist Benedict Anderson (1991), nation and national identity are cultural artefacts, or "imagined communities." But for Anderson, which particular cultural factors can best explain the construction of such imaginations? He traces the birth of modern nationalism to the decline of religiosity in the eighteenth century, which required replacing religiosity with some other secular form that could provide the same sense of continuity, contingency, and meaning. What distinguishes Anderson from other theorists of nation is not that he traces the origins of nations to modern culture but that he locates these origins in the "New World," the Americas (46-47). It is of striking importance to remark

that he, similar to other modernists, ignores for the most part the existence of Indigenous nations holding a long history of oral traditions, nations whose peoples lived on the American continent and possessed strong political systems long before the arrival of Europeans. Hence, it is not surprising to read his claim that the "Creoles" of both North and South America, defined by him as those of European descent born in the Americas, built new nations in the "New World" (191). These individuals named "New Cities" in these nations (i.e., New York, New Jersey, New Orleans, and the list goes on), and in doing so, they imagined new communities that paralleled those in the "Old World" (192). In the process of imagining these new nations, new narratives of "identity" and belonging were imagined and allowed to proliferate, all of which, Anderson reminds us, "was made possible by the ruptures of the late eighteenth century" (205).

For the most part, then, Anderson (1991) overlooks the existence of nations in the "New World" prior to his assumed date of the birth of nationalism in the land called "America." Additionally, the few times when he does mention the "natives," he refers to them as the "half-exterminated natives" and strips them of any agency in the construction and imagination of the Americas, both prior to and following the colonization of it by his own imagined European-Creole heroes (58, 193). But Indigenous peoples and cultures have always resisted colonization, have survived it, and are now in the process of rebuilding their nations, contrary to his view that "the indigenous were conquerable by arms and diseases, and controllable by the mysteries of Christianity and complete alien culture (as well as, for those days, an advanced political organization)" (58). From this statement, one can see that Anderson, in fact, dismisses the many ways that Indigenous peoples have resisted this "alien culture"; evidence of this resistance rests in the survival of Indigenous traditions and their revitalization. Oneida people and the other Haudenosaunee peoples *did* have, *for those days,* an advanced political organization, a confederacy of nations that later influenced the formation of the United States of America and was admired by European theorists like Karl Marx and Fredrick Engels. And they had a detailed and sophisticated body of laws, the KayanlΛhsla²kó, or Great Law of Peace.

Ethno-symbolist approaches to nation, like that of Smith (1993, viii), relate identity and nationalism to "questions of ethnic identity and community." What would then distinguish a national identity from an ethnic one? Smith reserves the former for European modern societies,

thereby dismissing that formations like Oneida also constitute nations. A characteristic that Smith aligns with the concept of nation is that of patria, which he describes as a "community of laws, and institutions with a single political will. Sometimes, indeed the patria is expressed through highly centralized and unitary institutions and laws" (10). Some elements of this concept, specifically a community of laws and a political will, can in fact be seen in the Haudenosaunee League, a confederacy of six nations, each its own entity, that have been united through the Great Law of Peace, a guideline on governance, since the mid-fifteenth century. This unity has survived, although it has been transformed due to many internal and external factors. And the Great Law of Peace is being revitalized as a central notion in the decolonizing of Canada by many Haudenosaunee people. Within my nation, the Great Law of Peace is what underlies the structure of our Longhouse, and its teachings are told to us by our elders during ceremonies and taught to our youth in our Tsi Niyukwalihu:tʌ (traditional schooling of the Oneida of the Thames community). In June 2007, other nations of the Haudenosaunee came to our Longhouse for a Condolence Ceremony, where new chiefs were appointed in accordance with the teachings given to us by the Peacemaker. A ceremony like this had not happened for a couple of decades, and about one hundred people gathered at the Longhouse for the whole day to witness the appointment of new chiefs. This revitalization is also evident in the fact that a number of teenagers now give public speeches at the Longhouse and sing our traditional songs, all in the Oneida language.

Smith (1993, 11) argues that "nations must have a measure of common culture and a civic ideology, a set of common understandings and aspirations, sentiments and ideas that bind the population together in their homeland." With regard to the Haudenosaunee peoples, particularly Oneidas, these characteristics are present, except for permanent territorial boundaries and a highly centralized and hierarchical political organization. Yet Smith credits these characteristics only to the Western world. According to him, the non-Western model of nation is ethnically conceived, and its "distinguishing feature is its emphasis on a community of birth and native culture; you belong to these by being born to and cannot ever separate from them" (11). I agree with some of his argument, except that in the case of the Oneida nation and the Haudenosaunee League, one's membership in the community is through a clan, and although this is most often by birth and through a mother's line of

descent, it can also be through adoption. This, then, allows for a more flexible definition of national/cultural identity. Some of the Oneida people I have talked with view national and cultural identity as involving much more than just "being born Oneida." Another criterion repeatedly found is political involvement in the community. As one woman remarked,

> It's one thing to be born Oneida, to be born in this community. But you need to have a sense of responsibility for the whole community, to do what you can for the benefit of all, to struggle with the rest so we have a better future, for our children to be proud to live one day in a free Oneida. You have to live in a good way with all relations, no? (Mary)

An ethnic community relies on descent, or presumed descent, rather than on territory (Smith 1993). But in the case of the Oneida nation, land does matter a great deal because it is viewed as the spiritual, social, and political connection that binds the people together. However, Indigenous relationships to and uses of land differ a great deal from those of Western paradigms (Little Bear 2004). Whereas an Indigenous paradigm sees humans as a part of creation, land included, not as the owners of it, and in fact considers land to be the giver of life, Western paradigms treat it as a "subject of use, disposal, or transfer to another for value" (Little Bear 2004, 34). This relationship to the land, like all relations, including how to treat other nations, is codified in the Great Law of Peace, a very sophisticated, large body of laws for the Haudenosaunee League to follow. Although this Law is not written in a form that mainstream theorists of nations are familiar with, wampum belts[2] *are* traditional recordings of knowledge that include rules each nation must abide by in order to "live in a good way and be of one mind."

Admittedly, Smith (1993) does offer a definition of nation and national identity that, although not perfectly in alignment with Indigenous characteristics, in some ways can be used to examine the case of the Oneida nation. He states that "a nation can therefore be defined as a named human population sharing an historic territory, common myths and historical memories, a mass, public culture, a common economy and common legal rights and duties for all members" (14). As this definition stands, it indeed appears that one could include Oneida and the other Haudenosaunee nations in his category since they share the listed characteristics. However, as Smith insists on fixed boundaries of territory

and on laws based on Western models, Oneida and the other Haudeno-saunee nations do not fit his definition. Moreover, he ultimately makes a distinction between ethnic communities and nations, the former refer-ring to cultural phenomena that could give rise to nations and the latter being limited to a Westernized model. Given that Smith remains within a Western framework of nation, he fixes political communities such as the Oneida nation into the category of ethnic community, or "ethnie" (21). As Ladner (2000, 35-36) argues, such "literature dismisses the pos-sibility that nationalism existed outside of Europe ... and it censured, colonised and renamed [Indigenous] experiences. These experiences are nationalisms, contemporary expressions of social, cultural and political identities that have a long history independent of the western Eurocen-tric experience."

Ethnic identity is historical, symbolic, and cultural (Smith 1993). This identity is historically bound and can therefore change over time as experiences change. Colonialism, for example, is a specific historical experience that affects colonized nations' identities: either the members of these nations want to assimilate to the mainstream colonizer's culture or they strategically reinforce their own cultures as a way to resist col-onialism, or both. Since ethnicity contains *both* consistency and fluidity, "we need to reconstitute the notion of collective cultural identity itself in historical, subjective and symbolic terms" (Smith 1993, 25). The cultural and national identities of Oneida and the other Haudenosaunee nations contain both consistency and fluidity. For example, these identi-ties are consistently tied to kinship, with the centrality of clan being its major element. However, due to experiences with colonialism, these identities have had to adapt to new realities: in the case of the Oneida people, the dispossession of land caused some groups to relocate in new territories, which altered their sense of belonging to the "old," "original" territory and also affected their sense of belonging to the new one.[3] Hence a series of historical experiences have changed the construction of such identities, challenging any static notions of identity and belong-ing to a nation. The symbolic and subjective nature of cultural identity is present within my community: the co-existence of fluidity and dur-ability is what often underlies ethno-national identity, and the discourses of nationalism are to be seen within this parameter. This means that, although transformed by historical experiences and by new elements introduced over time, some core elements persist, such that we see a combination of traditions passed from one generation to the next, with

each new generation selectively changing as its members adapt to new realities.

Overall, then, Smith's (1993, 43) concept of nation leaves some room for recognizing Indigenous forms of nations within and outside North America since he argues that "nation is a multidimensional concept, an ideal type that provides a standard or touchstone which concrete examples imitate in varying degrees." A concrete example is the Oneida nation, whose existence illustrates that fixed territorial boundaries, written laws, hierarchical centralized power, and a homogenous culture are not necessary criteria of nation that must be shared by all types of nations. Postcolonial theories can offer us a way to unmask the biases and gaps of earlier mainstream theories and indeed treat entities like Oneida as nations.

Postcolonialism and Nationalism

There has been much debate about the term "postcolonial" itself and about the potential of postcolonial literature to be an effective tool for resisting and dismantling the various colonial structures. To begin with, much of the debate is centred on the prefix "post." Some question whether the prefix implies a temporal movement beyond the colonial condition; if it does, then this is quite problematic because such an approach discounts that many Indigenous peoples of some "postcolonial nations," such as Canada, have not moved to a stage after colonialism but, indeed, still live under colonial conditions (Loomba 1998; Monture-Angus 1999; Shohat 1993; Dirlik 1994; Smith 1999; McClintock 1995). Also, this approach implies that overall inequities based on colonial rule have been removed in the so-called postcolonial world, again denying the harsh, unequal power relations that do linger in many countries, both in the so-called First World and in the non–First World (Loomba 1998). Indigenous economies continue to be attacked by (neo)colonialism, as our lands continue to be under threat by governments and multinational corporations in their never-ending pursuit of accumulation of wealth. Moreover, postcolonial theorists must be cautious not to universalize and generalize the process of decolonization itself. This process has varied from place to place, such that decolonization by white settlers from Great Britain in places like Canada has not been identical to that experienced by Indigenous peoples still living under colonial conditions (Loomba 1998; Smith 1999; C. Hall 1996). In addition, "hybridity," a concept much referred to in postcolonial literature, is less

evident between descendants of white settlers and descendants of Indigenous peoples in countries like Canada, Australia, and New Zealand. As Loomba (1998, 9-10) argues, "No matter what their differences with the mother country, white populations here were not subjected to the genocide, economic exploitation, cultural decimation, and political exclusion felt by indigenous peoples."

To these criticisms, some postcolonial theorists have responded that postcolonialism is a process of analysis, which emphasizes the discursive and material effects of colonialism (Ashcroft 2001; Quayson 2000; Ashcroft, Griffiths, and Tiffin 1989; Loomba 1998). Within this type of analysis, "postcolonialism" refers to the contestation of colonial domination, and it incorporates the history of anticolonial resistance. Such an analysis aims to discredit and to dismantle master narratives. This book fits within this type of analysis, entering into a critique of master narratives of the nation and nationalism and arguing that some Indigenous peoples had and may continue to have a different concept of nation. Also, a postcolonial framework can demonstrate how many Indigenous peoples' identities have been transformed by colonial domination, without losing sight of the many forms of resistance expressed by Indigenous peoples. In terms of resistance, some researchers have critiqued postcolonial theorists, especially Edward Said or Homi Bhabha, for decentring the concepts of power and subject to a point where power becomes too pervasive and the subject too fragmented, making it almost impossible to think of a colonized subject as able to act and resist colonialism. The fact that Indigenous peoples in Canada have resisted and continue to resist their colonization – as seen, for example, in events like the Stony Point Nation occupying Ipperwash Park to protest the Government of Ontario's refusal to return their lands as promised as well as the standoff at Caledonia by the Six Nations at Grand River in their dispute with the same government over outstanding land claims – indicates that the colonized are quite able to resist an oppressive agent of power. A second flaw I see in postcolonial literature is its heavy concentration on the literary, on the notion of "text," which often results in a treatment of colonialism merely as a text and perhaps also results in a movement away from the material, everyday experiences of domination.

Overall, postcolonial writing connects colonialism to other patterns, such as nationalism, gender, race, identity, resistance, hybridity, and diaspora. With regard to nation and nationalism, many postcolonial

theorists emphasize that nation is a ground of dispute and debate, a site of competing interests, and they therefore critique most of the modernist theories that tend to view nation as a unifying and homogenous entity and nationalism as a master narrative. Theorists like Bhabha (1989, 1990, 1994), Gilroy (1987, 1993), Young (1990, 1995), C. Hall (1994, 1996, 1999), and S. Hall (1992, 1994, 1996a, 1996b) relate nationalism to colonialism and point out that nationalist colonial discourses are not complete, all-pervasive, or successful in dominating the colonized. Bhabha (1990, 1994) more specifically articulates that such discourses always maintain internal ambiguities and contradictions and that there are thus no neat binaries such as colonizer/colonized, insider/outsider; rather, there always exist slippages in the narratives of nation and of colonialism. Hence colonized subjects can negotiate and find in-between spaces where they can resist and challenge official discourses of nation and colonialism. Identities, such as national ones, are not fixed and static but are fluid and socially constructed. As S. Hall (1994, 392) argues, identity must be thought of as a "production, which is never complete, always in process, and always constituted within, not outside of representation." Bhabha and Hall offer an innovative and creative way to imagine the identities of Indigenous peoples in the process of colonization: one must consider the possibility that these identities are not the same as they were before colonial contact, that in fact they have been shaped by the exclusion, marginalization, dispossession, and loss of control produced by colonial discourses and institutions. Indeed, colonial practices such as the Indian Act have had a tremendous influence on the current discourses of nation and identity that are taking place in different communities.

Hybridity has become a central concept within postcolonial theories because many postcolonial theorists argue that colonialism has never been fully stable or certain and has not always successfully imposed itself on the colonized. The concept of hybridity moves us away from other initial contributors to postcolonial studies, such as Edward Said. Said, in *Orientalism* (1978), presents a critical analysis of the construction of the "Orient" by the "West." The latter, Said argues, has produced a discourse of the colonized that is always in opposition to that of the colonizer. This discourse has led to a dichotomous binary construction. The colonized is constructed as backward, lazy, wild, nonintellectual, and sexually unrestrained. The Western subject is constructed as having achieved the positive attributes of humanity, a civilized subject capable

of rational thought. Said points out that it is important to remember that this discourse served as a justification for the colonizer (the West) to view itself as morally, economically, and politically superior to the Orient, the colonized. Said can be criticized for homogenizing both the West and the Orient. Colonial identities, both of the colonizer and colonized, are always in flux, displaced. Bhabha argues, for example, that the colonized desire both to attain the attributes of the colonizer and to maintain their own differences. Colonial authority itself, he further argues, is also ambivalent, as it cannot replicate itself completely in the colony; it cannot fully contain the colonizers, and it comes to both desire and reject the Other, the colonized (Bhabha 1985). Ultimately, then, both the colonizer and the colonized, as split subjects, are living in a liminal space. Bhabha (1985, 1990) believes that ambivalence and hybridity open up a space for resistance, but in his view resistance is not always in complete opposition to, a simple negation of, the colonizer; rather, it is a product of the inherent ambivalence existing within the colonial condition.

Overall, then, postcolonial studies have given us the opportunity to rethink the notions of nation, culture, and colonialism, especially by considering nation as a narrative that is quite complex, often contradictory, unstable, and fluid. This narrative contains official and unofficial discourses; yet these discourses do not equally engage in the construction of narratives, due to the many unequal power relations and contesting interests that exist within the nation and due to the external pressures placed upon it. Bhabha's (1994, 2) questions about who speaks and writes about/for the nation, and how the nation is represented in those discourses, are very important ones to reflect upon during any analysis of nation and nationalism. It is true that during colonialism, the colonizer and colonized were engaged and positioned quite differently in the narratives of nation. This differential positioning must not be forgotten; in fact, an overemphasis on hybridity can tend to overlook the tension and unequal relations that do exist between the colonizer and the colonized (Parry 1994). Also, many colonized peoples may not have such an ambivalent sense of identity but might clearly view themselves as different from and in opposition to the colonizer. Perhaps Stuart Hall's (1994) argument that the cultural identities of colonized subjects are composed of a sense of both being and becoming is a well-founded one, meaning that although there cannot be an easy return to a precolonial identity based on pure origins, it is also true that this past

for colonized subjects is not merely an imagination; in fact, "the past continues to talk to us. But it no longer addresses us as a simple, factual 'past', since our relation to it, like the child's relation to the mother, is always-already 'after the break'" (S. Hall 1994, 395). I understand this to mean that although colonized subjects, having been affected by colonialism, cannot return to life as it was, they do not completely wish to, nor do they, mimic the colonizer. But, yes, they are acquiring new identities that contain some elements of a past culture and some elements of the newer ones. And I do see that this process is happening in the case of contemporary Indigenous peoples. We are tied to a past culture but have necessarily integrated some elements of other culture(s), as we are living cultures shaped by our overall environments, not frozen "Indians" from Hollywood westerns.

Frantz Fanon has undoubtedly been one of the most influential critical theorists of colonialism through his two well-known works, *Black Skin, White Masks* (1967) and *The Wretched of the Earth* (1963). *The Wretched of the Earth* was written after his involvement in the Algerian Revolution and offers an elaborate discussion of the possibility of anticolonial revolutionary movements. Fanon presents the complexities of identity formation for the colonized subject. These complexities comprise an ambivalence of the position of the colonized subject, whose identity is constructed under the chains of colonialism, producing in him (Fanon uses the male pronoun throughout) a distorted psyche, one that is mostly defined by, and as the mirror image of, the white master. In this construction of the self, the black man, Fanon argues, is no man at all, as he searches to obtain what the white man is/has; his identity becomes too entrenched in the power structures of colonialism, and blackness is therefore linked with the desire for whiteness, emptying it of its own subjectivity. This blackness is constructed in relation not only to what it is but also to what it is not. Within the unequal, oppressive conditions of colonialism, the black man (like other colonized subjects) is constructed as inferior, in opposition to the superior white man. This, according to Fanon (1967, 36), leads the black man to strive to negate his blackness, to want to acquire those traits that make up whiteness, and through this negation, he obtains an alienated, split, assimilated psyche. Of course, Fanon does recognize that despite all attempts to assimilate, the black man will never be able to erase his blackness from his body and will be seen as such in the eyes of the white man. He will come to appreciate – and despise – the fact that "he is rejected by a civilization

that he has none the less assimilated" (93). Fanon remarks that this complex of inferiority and dependency that makes up the identity of the colonized is related to the superiority of the colonizer, and he argues that we must "have the courage to say it outright: *it is the racist who creates his inferior*" (93, original emphasis).

But is a colonized subject someone who is always struggling with such a split psyche, so ambivalent with desire for and rejection by the colonizer? One must not universalize the colonized subject in this way. One must admit that Fanon's portrayal of the psychologically split subject more accurately describes "native elites or those colonised individuals who were educated within, and to some extent invited to be mobile within the colonial system than [it describes] those who existed on its margins" (Loomba 1998, 147). In fact, Fanon's theorization of the psyche of the colonized subject is heavily derived from his own experience as a professional, educated Martinican in France and also from his exchanges with patients who suffered from such split personalities and who shared his characteristics. Could marginalized, nonintellectual Natives who are not of the middle class fit into his category? Although one could argue that they might desire the material resources from which they are excluded, it is quite something else to conclude that they reject their whole culture or their own "blackness" in the process. They might very well be able to pursue material and other "Western" goods without desiring to become the colonizer. I cannot easily agree that they must always be constructed as ambivalent or hybrid subjects. I know many Oneida people who still speak our language, know the traditions very well, teach them to others, lead ceremonies, and yet also want a bright new SUV to drive to the city and a nice home with all the amenities that make life more comfortable. Are they truly to be viewed as having a split personality?

Fanon's *The Wretched of the Earth* (1963) is what has defined him as a theorist of anticolonial nationalism. Not surprisingly, this work has influenced a number of other Indigenous theorists, like myself. In this work, Fanon places emphasis on the colonized subject's cause and act of national liberation. Influenced by his involvement in the Algerian independence movement, Fanon argues that the one possible and necessary path toward liberation from colonial oppression for the colonized is to actively resist the foreign colonial nation and reassert an Indigenous nation through a reawakening of a national culture. For Fanon, decolonization is a historical process that involves a complete change of the order and must come from the bottom up, meaning that it must

be accompanied by a truly popular struggle (29). He further acknowledges that there could be a need for violence in putting this program of liberation into practice, when he writes that "the native who decides to put the programme into practice, and to become its moving force, is ready for violence at all times" (31).

In the process of developing a national culture, however, Fanon (1963) does not ask for *any* type of nation or nationalism, as he is set against an elitist, bourgeois nationalism. This type of national culture, Fanon argues, would only replace one type of oppression with another, the only difference consisting of the "race" of the ruler (160-63). But any program of liberation that comes from the bottom up must contain a concept of nation, according to Fanon. A colonized people must realize themselves as a nation in order to successfully liberate themselves from the colonial oppressor through the struggle (200). He links the contemporary situation of oppression faced by the colonized with the colonizers' erasure of the colonized's national culture. This is accomplished by constructing the latter as inferior, uncivilized, and in need of replacement with a foreign national narrative.

He argues, however, that some modified elements of the precolonial national culture still exist within those people who have continued to resist its erasure. For Fanon (1963), then, decolonization is interconnected with a nationalist movement. Through a struggle for a nation that is free from colonial power, the "native" – a term that Fanon treats as being constructed by colonialism itself and that erases the specific national and cultural characteristic of each Indigenous nation, transforming all Indigenous people into a universal Other/Native – can assert his or her own definition of self again. However, Fanon believes that the national culture of the colonized is distinctively different from what it was prior to colonization. He states that after centuries of colonial domination,

> there comes about a veritable emaciation of the stock of national culture. It becomes a set of automatic habits, some traditions of dress and a few broken-down institutions ... We find a culture which is rigid in the extreme, or rather what we find are the dregs of culture, its mineral strata ... the withering away of the reality of the nation. (191)

However, in the end, Fanon puts trust in the oral storytellers and in those intellectuals who can retell oral "traditions" that have been modified and contextualized to fit the current situation. This process

of revitalization of culture is important for Fanon and is part of the formation of a liberated nation.

Fanon's view that colonization has ultimately caused the destruction of precolonial cultures has been critiqued by some, who have argued that in fact "precolonial social, cultural, and ideological forms survived the colonial era meaningfully. Indeed, they continue to survive meaningfully today, in the 'postcolonial' present" (Lazarus 1999, 89). I agree with such criticism, as I can speak of the social, political, and cultural traditions of members of the Oneida nation. Despite attempts to eliminate our traditions, many ancestors of my nation have kept them alive, and although it is true that some aspects of tradition are threatened, such as the Oneida language, I also know that the language is still used by many people in my community and that classes are presently taught to both children and adults in the reserve community, as well as in urban areas. For example, at the initiative of some of our women elders, in the Oneida of the Thames community a Language Recovery Project has been implemented that both recognizes the urgency of teaching the language to the young and to adults and participates in funding projects to make it happen. In 2008, at a Buffy St. Marie concert in London, Ontario, some of us organized a silent auction of artworks with the approval of Buffy St. Marie and raised a few thousand dollars for the Oneida Language Recovery Project.

In Oneida of the Thames, we have Tsi Niyukwalihu:tʌ (traditional schooling in the Onyota:ka language), which offers traditional teachings to people mostly in our original language and provides lessons with the land. I have also personally attended Oneida language classes at Nokee Kwe, a Native Literacy and Development Skills Centre in London, Ontario, and these were regularly attended by a number of people whose ages ranged from early teens to late adulthood. Although it was difficult to learn a new language, the determination and pride in each of us was evident in the class. We recognized the important link between language and the maintenance of our cultures, and in a discussion I had with one of the learners, we both viewed the revival of the Oneida language as evidence that colonialism did not succeed in fully assimilating us or in "killing the Indian" in us. Moreover, I have taken part in many traditional ceremonies, spoken in the Oneida language, and I have witnessed that the knowledge of the traditional political structure is still alive and is being revitalized within the community. By comparing those traditional events in which I have participated with how they are described in older

texts, I can claim that colonialism did not succeed in producing the death of the Oneida national culture.

Colonialism was not able to fully eradicate Indigenous cultures, and I reject the idea that nationalism is a modern phenomenon and that all nationalisms outside of Western nation-states are derivative of a Western model. Although it may be true that some aspects of the lives of the colonized are derivative of Western modernity, other aspects have been resistant to assimilation into the Western, colonizer's worldview (Chatterjee 1986). Anticolonial nationalism in some ways is derivative because it depends on its opposition to the "West," the colonial nation-state, but it also tries to achieve its own sovereignty by claiming a cultural domain that is distinct, is divorced from the colonial nation-state, and has been maintained in this way throughout the period of colonial domination (Chatterjee 1993). Therefore, anticolonial nationalisms are not always only imports, mimicries of Western modernity. Nationalists of these movements can incorporate some components of Western modernity and simultaneously keep some distinct cultural identity. I do not view this to be contradictory, more like a pragmatic or a conscious decision made in order to form a national identity that can speak of the current realities of colonized peoples and attract them with a discourse that reflects their reality so that they might engage in an anticolonial struggle.

Other contemporary Indigenous scholars of Canada similarly argue that some Indigenous peoples of North America could be defined as nationalists even prior to colonization (Ladner 2000) and/or as currently being in the process of decolonization and (re)imagining nations and a national identity that are not an absolute replica of Western modernity yet are not always completely opposed to all that is "Western" (Ladner 2000; Simpson 2000, 2007; Alfred 1995, 1999). They have explored the idea of nationalism as it pertains to the history of Indigenous peoples in Canada. In doing so, they have looked at how historical Indigenous nationalisms existed prior to colonization and have also examined some contemporary nationalist movements of some Indigenous communities (Ladner 2000; Simpson 2000, 2007; Alfred 1995, 1999).

Alfred (1995) and Simpson (2000) are two Mohawk scholars from Kahnawake, a community located near Montreal, Quebec. Through an examination of some of their own lived experiences in that community, they offer valuable contributions to political thought by theorizing about nation, nationalism, colonialism, and identity within an Indigenous

perspective that moves beyond matching nationalism with statehood, with modernity, and with other Western concepts.

Alfred's first published work, *Heeding the Voices of Our Ancestors: Kahnawake Mohawk Politics and the Rise of Native Nationalism* (1995), examines the contemporary Mohawk politics of Kahnawake as a dynamic political revitalization movement that is deeply rooted in notions of sovereignty and nationhood. He argues that this movement represents an attempt to break away from colonialist structures and values imposed on Indigenous peoples. In resisting persistent colonialism, Kahnawake Mohawks are currently re-examining the roots of their own traditional Mohawk political institutions and political thought. This re-examination combines a rediscovery of both cultural and political components of their traditions (7). For Alfred, then, movements of "self-government," "self-determination," and "aboriginal rights" in North America are manifestations of the assertion of nationhood (10). This is the case because they are rooted in a dynamic nationalism. With regard to the Oneida example, most of the women who participated in my research do share Alfred's view, arguing that achieving national "self-determination" means regaining the freedom that their nation claimed before colonization and establishing ways of governance that are culturally specific and derived from a rich traditional past.

These movements are also nationalist in the sense that when recognizing the diversity of Indigenous identities in Canada, one can see that each Indigenous community has its own distinct culture and historical experience, such that each of them is a distinct group that organizes itself more around a reassertion of nationhood than around pan-Indianism (Alfred 1995, 12). This type of Indigenous political activity can be explained, according to Alfred (1995), as a *variant* of ethno-nationalism, the goals of which include cultural survival as well as the achievement of autonomous control of one's own community, free from a colonial Canadian nation-state (15). Alfred then explains how a political identity such as Kahnawake Mohawk is a "nested Mohawk identity," where there are no strict boundaries between localized Kahnawake, national Mohawk, broader Iroquois, and pan-Native identities (18). They are nested because the Iroquois constitutes a broad world, a confederacy to which the Mohawks belong, therefore linking all Mohawks with the other members of each nation of the confederacy. Today, Kahnawake is a localized community in Quebec, so those living there have a multi-layered identity "which incorporates each one of the communities he

or she has inherited, and which also includes broader Native identity from the racial affiliation and identification as the Indigenous peoples of America" (20).

This notion of "nested" identity does indeed describe how some of the women who participated in the research for this book understand themselves: Lori said, for example, "I am Haudenosaunee, and then also Oneida. All these matter to me. Being Native in general makes me similar to other Natives in this country." Debbie viewed her identity in a similar fashion: "I am Oneida, from here [Oneida of the Thames], but I am also connected to Oneida from New York ... Then we are of the Longhouse, so all Iroquois people are my family too." This interconnectedness meant for Nancy that "we might not have a lot of wealth in terms of money, but man! We are so rich when it comes to relations, we have a large family that we are connected with, all the way from the rez here to New York and even all other Haudenosaunee living all over the Americas."

The emerging Kahnawake Mohawk nationalism derives symbols from the past as well as the present. Its connection to the past includes a re-interpretation of the KayanlΛhslaʔkó, or Great Law of Peace, the guide-lines provided to the confederacy by the Peacemaker. Its incorporation of the present includes recognition of the current band council, the elected form of governance existing in the community, whose authority is not derived from traditional forms of governance. All of these influ-ence each other, and together they influence the visions of nationalism existing in contemporary Kahnawake. This interplay has produced a hybrid form of nationalism, some of whose components are not based upon the KayanlΛhslaʔkó. This discourse is contested between those who would like to return to a stricter traditional way and those who try to reinterpret tradition, accepting some features of the KayanlΛhslaʔkó but not others. As Alfred (1995) recognizes, this is partly the result of prag-matic decisions made by some community leaders who are trying to assert their own sovereignty against the Canadian state while also at-tempting to ensure the survival of Kahnawake as a community with a strong Mohawk culture. This approach has met with opposition in the community due to disagreements over issues of "authenticity," criteria for membership in the nation, and other matters. Although Kahnawake Mohawks have attempted to revitalize some of the traditional political configurations of their own nation, they have at the same time dismissed some aspects, such as the clan as the foundation of national membership as well as matrilineality. Instead, they have attempted to establish a rigid

form of blood-quantum criterion, to which some "traditionalists" who are quite knowledgeable of the Great Law of Peace are opposed. As some of the women in my own community have argued, "it is not our way, it is the Indian Act way, or some other colonial way" (Louise).[4]

Alfred's first book for the most part focuses on a syncretic, hybrid form of contemporary Kahnawake nationalism, as he discusses mainly the revitalization of some form of Mohawk nationalism, one that contains some older traditional elements but is simultaneously influenced by current reactions to a colonized reality. His second book, *Peace, Power, Righteousness: An Indigenous Manifesto* (1999), examines in more depth the traditional roots of Indigenous notions of the nationhood of Haudenosaunee peoples, Mohawks included. In that work, Alfred outlines the main principles that formed political thought for the People of the Longhouse: peace, power, and righteousness. These principles are strictly rooted within an Indigenous worldview of nation held by the Iroquois Confederacy, which began centuries before colonization, and he argues that contemporary leaders of his Kahnawake Mohawk community need to relearn and follow these principles during their struggle to assert their freedom and national sovereignty. Just as he argues in his first work, Alfred (1999, 2) maintains that this movement toward the restoration of cultural and political autonomy is "founded on an ideology of Native nationalism and a rejection of models of government rooted in European cultural values."

Admittedly, as Kahnawake Mohawks move toward a postcolonial future, it is still not clear what the new form of political structure will be. Although Alfred (1999, 3) argues that it might be difficult and almost impossible and unrealistic to completely reintroduce structures identical to those that existed before colonization, a Kahnawake Mohawk postcolonial nation must ensure that it does not simply replicate non-Indigenous systems, which might not address and eradicate the current oppression and social ills existing in Indigenous communities. Attempts must be made to try to recover those elements of past political structures and principles based on Indigenous worldviews that can still apply in modern realities. In his book, Alfred does not address issues of gender implicated within the Kahnawake Mohawk nationalist discourses, nor does he engage in a deeper critique of some steps taken by the Kahnawake band council that are not founded on traditional ways of governing, as outlined by the founding principles of the Great Law of Peace, but are actually quite derivative of a colonial mentality (e.g., blood quantum as a criterion for membership in the nation). Such notions perpetuate

some forms of exclusion and division in many communities and affect some Indigenous women in a particularly negative way.

The issue of membership is taken up by Simpson (2000, 2007) in her examination of Indigenous nationhood in Kahnawake. Simpson describes how from 1984 to the present, the community was engaged in a discourse of nationhood that included a redefinition of self free from rules set by the Canadian state and an attempt to reobtain autonomy in internal decisions under a discourse of national sovereignty. In her examination, Simpson (2000) argues that Kahnawake Mohawks, just like members of the other nations of the Iroquois Confederacy, "have a long and well-documented historical self-consciousness and recognition as peoples that constituted themselves and were thus constituted by others as nations" (115). This political historical past is currently shaping and informing the political consciousness of contemporary Kahnawake Mohawks, who are engaging with the state through a nationalist discourse. However, this discourse has, "unlike the nationhood of western states ... been bifurcated and disassembled with global processes of colonialism" (116). A major part of this bifurcated discourse is concerned with the debated notion of membership in the nation, based on the question of who is a Mohawk.

Simpson (2000, 125) argues that one way of addressing such questions might be to move away from essentialist notions of being and to engage instead with the "flux of lived life," an approach that has "as its premise the untidiness and fluxist nature of culture." In placing more attention on the *experiences* of nationhood, one needs to look at how historical experiences are shaping contemporary discourses of nationalism in the Kahnawake Mohawk territory. The history on the land, including the relationships that have been built around it both within the community and with those outside of it, tells of lived experiences of nationhood. These experiences make up a discourse of maintaining and reclaiming autonomy on the land in order to have autonomy in decisions that affect those who live in and/or are members of that Mohawk territory. Similar to Alfred (1999), Simpson (2000) argues that the members of that community, due to oral traditions that have been passed on to them from their ancestors, have a strong sense of Kahnawake's nationhood, which also combines an affiliation with the rest of the Haudenosaunee League and a sense of connectedness with other Indigenous nations.

Simpson's (2000, 135) essay reveals the tensions and divisions that are currently present in the process of reclaiming autonomy: due to historical experiences such as colonialism, contemporary nationhood is a "terrain

of agreement, discord and hopeful contemplation that unites Kahna-wakero:non in their search for a way through the mass of contradictions that one interlocutor at a community meeting referred to." Those tensions are related to lived experiences of dispossession of land, external impositions of self, and a struggle to keep traditional culture alive. Only recently has Kahnawake had the opportunity to define its own membership criteria. The debates about membership criteria are influenced by interactions with a Canadian state reluctant to give complete decision-making power to Indigenous nations and by interactions with non-Indigenous individuals, including through intermarriage. All of these past experiences, some of which have been quite negative, influence the current discourses of nationhood in the community. In 1985, when Kahnawake was given the right to devise its own membership codes, "[it] had already assimilated some tenets of the Indian Act into the social fabric of the community. The means for defining kinship and determining community belonging, the traditional means for determining descent – through the mother's clan – was supplanted by the Indian Act and its European model of patrilineal descent" (Simpson 2007, 73). Clearly, as Simpson (2007, 73) points out, "this was an unambiguously raced and gendered injustice that Indian women, disenfranchised from their Indian status across Canada, fought against. But the complex of factors ... led, in part, to the development of a blood quantum code." The tensions created by colonial factors are lived in contemporary Kahnawake; these must be addressed, and in moving beyond colonialism and asserting their own nationhood, the community's members must find ways to heal and unite. This implies a process of memory and forgetting (Simpson 2000, 136).

In her contribution to political theories of nationalism, Ladner (2000) demonstrates that nation and nationalism can be conceived outside of the dominant Euro-Western paradigm. Different from other theorists, including some Indigenous ones such as Alfred (1999), Ladner (2000, 36) conceptualizes Aboriginal nationalisms as "traditional nationalisms unto themselves" that existed prior to the European invasion and colonization of North America. In mainstream theories, however, these nationalisms have been dismissed as forms of nationalism because they do not fit neatly and perfectly into concepts of nation developed by European scholars of nationalism. As Ladner (2000) argues, we need to move beyond such racist and dominant European frameworks and recognize that nations and nationalisms can take different forms depending on cultural and historical contexts.

Through personal knowledge of oral traditions, and having received teachings from elders in various Indigenous communities, Ladner (2000) traces Blackfoot nationalism to a date prior and external to European influence, but she also shows how processes of colonization have reshaped this nationalism. Ladner presents convincing arguments of Blackfoot nationalism as inclusive and as combining politics, culture, and spirituality. For example, members of the Blackfoot Confederacy are connected to each other by a common origin and descent derived not only from blood kinship but also from an inclusive and fluid notion of community membership through other criteria such as adoption. In this conceptualization, what matters in defining someone as a "member" is a shared cultural, spiritual, and political identity and a commitment to nationhood (Ladner 2000, 38). This conceptualization is shared by the Haudenosaunee League. Each unit of the Blackfoot Confederacy maintains its own autonomy in internal affairs but is considered one part of a unitary, collective political organization, a nation in itself (39). Thus the Blackfoot Confederacy contains characteristics that can qualify it as a nation, as these units share a language, culture, territory, a form of governance, and a sense of common history and destiny. What differentiates the Blackfoot Confederacy from a European-based nation is the lack of a state. Although the units definitely have a strong economic, cultural, and spiritual connection to the Blackfoot territory, they do not have a narrow or fixed notion of it. Moreover, they have never had a highly hierarchal political structure, as they govern themselves through an egalitarian, consensus model, similar to that of the Haudenosaunee League. Hence the Blackfoot Confederacy and Blackfoot nationalism differ from, and also share some similarities with, a European experience of nation and nationalism, yet, as Ladner (2000) argues, this fact does not justify the persistent claim that its units were merely tribes and not parts of a collective nation. Their own oral traditions speak clearly of their rich historical experience of nationalism. For example, their creation stories say that they were placed in a particular territory by the Creator, and this knowledge has influenced them to acquire a strong sense of a collective national identity, a sense of being parts of a distinct nation in a territory, to which they are responsible as guardians and to which they are linked spiritually.

Like other Indigenous nations, the Blackfoot Confederacy has undergone many negative changes through colonization, but now a "new nationalism" is occurring, one that has roots in a traditional past but that also reacts to current realities (Ladner 2000, 49). This new nationalism

is anticolonial, in that it is a reaction to a foreign colonial state to which it is trying to redefine its relationship. Through this reactive form of nationalism, the Blackfoot Confederacy is engaged in reclaiming its territory and national identity, often using discourses that can be understood by "outsiders" but that are still "intrinsically bound to a current sociocultural understanding of community and identity" (51). A central component of this nationalism is its persistent commitment to forming an autonomous nation, without necessarily resorting to complete secession from Canada.

Hence contemporary discourses and movements of Indigenous rights vis-à-vis the state must be treated as challenges to the official Canadian state's claim of complete political and territorial sovereignty (Turpel 1992, 579), which is based on a myth of the "two founding nations" (i.e., English and French) and Indigenous surrender of autonomy. But as far as Indigenous peoples are concerned, this surrender never occurred in reality. As Turner (2006, 22) points out,

> many Aboriginal peoples do not perceive the political relationship as one of subservience; that is, they do not view their rights as somehow legitimated by the Canadian State. Rather, many Aboriginal peoples understand the political relationship as one of "nation to nation" ... [They] argue that they owned their lands before contact with Europeans, that they made treaties with the European newcomers to share the land, and that after contact they never gave up their claims of ownership.

From this perspective, then, discourses of Indigenous rights ultimately include the concept of self-determination of Indigenous nations. Broadly speaking,

> self-determination can be conceptualized as requiring that every culturally and historically distinct people have [sic] the right to choose its political status by democratic means ... and with international support ... self-determination is considered synonymous with self-preservation of indigenous peoples. It would provide the freedom from state hegemony needed for their survival and for their transmission of their cultures to future generations. (Turpel 1992, 592-93)

This form of Indigenous nationalism is exactly the one that characterizes the Oneida nation, and it is supported by the many women who

participated in my study. Due to this complex character of nationalism, both postcolonial theories and, even more so, Indigenous theories of nation and nationalism can be used to analyze the ongoing acts of resistance examined in the book. These acts of resistance are decolonizing since they redefine a new form of relationship both within the Oneida nation and with the colonial Canadian state. They are nationalist since they are rooted in a historical concept and experience of nationhood and since they aim to reclaim a free Oneida nation. But this movement is not free of complexities, contradictions, competing interests, and divisions, and the women with whom I talked offered insights into some of these characteristics. Most of these insights are gender-based, so feminist theory does offer some perspective on the situation, although the gender issues of which the women spoke are culturally specific and tied strongly to colonialism. A decolonizing nationalist movement does offer possibilities of empowerment for these women, as it could free them from existing oppressive colonial conditions, yet aspects of gender analysis must be incorporated at all stages for it to be a truly revolutionary movement.

A History of the Oneida Nation: From Creation Story to the Present

This chapter reviews the history of the Oneida people to provide a context for my analyses. During the process of retrieving reputable sources of historical knowledge, I placed most importance on oral stories and traditions. Until recently, in Western academia there has been a tendency to regard only written texts as valid sources of history. These texts have been written mostly by Western middle/upper-class white males who often went only to other males to inquire about historical "facts." This history is thus incomplete because the voices of women, Indigenous peoples, people of colour, and other marginalized groups, including their memories and interpretations of historical events, are not present in these published texts. Moreover, these "historians" were influenced by much "cultural baggage" when writing about what they saw. As well, although they looked at events through their own cultural lens, they recorded their interpretation of these events as history. As Pratt (1992) argues, they observed through "imperial eyes" a gaze that they as outsiders exhibited when looking in at Indigenous cultures. Despite this limitation in their objectivity, their written texts are still regarded as valid and are often the only cited historical sources.

To recognize only these historical texts as valid sources of knowledge is to adhere to a Eurocentric bias within Western academia. The view that only the written text is a "good" source subtly shows the sense of superiority the West has felt over those peoples considered to be Others. The written form is the one more often used by the West and has therefore been regarded as the one of higher quality, an attribute of a progressive civilization. This has led to the West's ignorance and dismissal of the long tradition of orality as a transmitter of knowledge for many other cultures. This orality is rich with rules and standards of practice

regarding the identity of the storyteller, the proper space for speaking, and the composition of the audience. Also, orality acknowledges multiple versions of stories as long as the basic principles are maintained. As Mann (2000) notes, there are different types of stories in Indigenous cultures that apply to different contexts and purposes. For example, Iroquoian "keepings" (broadly referring to stories) include: "truly tales," which are historical facts, often told in Iroquoian traditions through wampum belts; "walking tales," which are fictional, often beginning with statements such as "see the man walking" or "it is as if the man was walking"; "spirit stories," popular narratives that describe ghostly happenings; and finally, "traditional stories," in "which strong spiritual leanings are interspersed with human historical actions" (Mann 2000, 30). This last type of story includes the epochal stories that transmit knowledge of the Oneida nation's different historical periods.

In describing Oneida history, I follow an order similar to that of other scholars (Mann 2000; Fenton 1998; Antone 1998; Campisi and Hauptman 1988; Porter 1998) who have surveyed either Oneida or Haudenosaunee history. This order is divided into three epochs, each one containing its own "traditional story": the first epoch begins with the Oneida people's traditional Creation Story, "Sky Woman Falling from the Sky." The story of the second epoch includes the formation of the Haudenosaunee League, focusing more on the Oneida nation, and concludes with the arrival of the Europeans and the impact of the contact between European powers and the different nations of the Haudenosaunee League on the Haudenosaunee peoples' lives; the story of the third epoch covers the time after the late 1700s, beginning with the end of the American Revolutionary War and the division of the Oneida nation. These stories are often dismissed as myths, rather than regarded as comprising a genre equivalent to historical texts, thus confirming the argument that "Western historiography retains its privileged role as the sole purveyor of factual accuracy while Native historiography is effectively evacuated of the capacity for accuracy" (Kalter 2001, 329). Indigenous traditional stories are not and cannot be taken seriously in academia when they are demoted and subordinated to Western written texts.

Some stories are recorded as texts through wampum belts, which Indigenous peoples of North America, especially Haudenosaunee peoples, regard as a medium for exchanging cultural and historical knowledge. These belts are made of beads and record events and cultural teachings, and they are often exchanged as evidence of promises made between

different parties. They contain rich and complex records that offer detailed textual knowledge of cultural traditions and historical events. Each belt is a record of important facts and is kept by persons entrusted with the responsibility to preserve its meaning and teach it to others. These belts were also used to record treaties between nations.

Due to the biases and limitations of "valid" Western historical sources, I have been reluctant to use these for my own work. I have resolved this discomfort by carefully checking their accuracy and by counterpoising them with other sources of knowledge, preferably those coming from Indigenous sources. I do not want to discard all Western historical sources merely because of their written form or because they have been written by Western males. I realize that if I were to do so, I would be guilty of extreme essentialism since there are good and bad texts, regardless of who the writer is; an Indigenous person can be just as guilty of bias and misrepresentation and therefore can also produce bad historical research. Similarly, a Western white male can be a good and reputable source, and in fact there have been such individuals who are quite respected within Indigenous circles (Mihesuah 1998). I have come to the conclusion that you can combine good Western written historical sources with records from oral traditions and that these media can in fact be quite complementary, producing a richer, more diverse, and more complete picture of the history of the group(s) in my work. However, it is still important here to attempt to shift the balance to the oral side, whenever possible, in order to diminish its persistent marginalization in academia. This is my political investment and commitment.

The Oneida nation originally occupied a territory as large as approximately 6 million acres, which is now known as central New York State (Campisi and Hauptman 1988). Therefore, events in the now United States of America and more specifically the states in the north-eastern part of that country directly affected the Oneida people. However, as members of a nation of the broader Haudenosaunee League, the Oneida people were also affected by colonial events that occurred in the area now known as Canada. Because the geographical location occupied by the nations of the league crossed the boundaries of Upper Canada and the northern parts of the United States, they were caught between competing colonial powers. Due to many socio-economic and political factors, the original Oneida nation was subdivided into three different entities. One, now known as Oneida of the Thames, relocated to southwestern Ontario in 1840 after having purchased land from Upper Canada

(Antone 1993, 1999; Campisi and Hauptman 1988; Fenton 1998). As other Indigenous nations had already been impacted by centuries of colonial relations with European settlers and eventually with the Canadian state, this faction of the Oneida people, upon coming to Ontario, entered an already established set of colonial relations. They went to Ontario only after receiving assurance that the rights held by other Indigenous peoples would also apply to them; but of course, this also meant that exploitative conditions inflicted upon other Indigenous peoples would be inflicted upon them as well.

First Epoch: Oneida Creation Story

I begin here by telling once again the traditional story I shared at the end of the Introduction. This story is well-known by the Oneida people and also shared in much similarity by other Haudenosaunee nations: "Sky Woman Falling from the Sky." I retell it here because this story recounts how our Oneida history began on Turtle Island. Also, retelling a story is in line with Oneida traditions, as it highlights the importance of the living character of a story. Each time a teller narrates a story, it is used in a different context so that the listener can learn new lessons from it. This Creation Story is then followed by an explanation of what the Oneida nation is and the location of its original territory. I focus on the points of the story that are connected to the overall themes and arguments of this book: the importance of women in the creation of the Oneida nation itself and the changes that occurred in some parts of the story under the influence of Christianity and other Western ideologies.

> At one time there were no humans in this land, as there was no earth; there were only water animals in the water. In the Sky World lived other species, and there was a big tree. In the Sky World there was Sky Woman, or Otsitsa, the daughter of the chief of the Sky World. Sky Woman had been married to a man. One day Sky Woman had quarrelled with the man, who had been mean to her and was jealous of her, of her beauty, and who doubted that he was the father of the child she was carrying. One day Sky Woman was beside a hole by the big tree when she fell from the sky through that hole. Some say the man pushed her. As she came down, she carried with her the three sisters corn, squash, and beans in one hand and tobacco and strawberry seeds in another. As she was coming down,

some of the animals that were living under the Sky World saw this creature coming down. One of the animals cried out, "Look, a strange creature is falling down. What is it?" They then realized it was a human person. They wondered what to do. One of them said, "She won't survive here, we have to catch her." They caught her. They thought about who would carry her. Finally, it was decided that Turtle would, as he was larger and stronger and flatter, so she could sit on top of him. When she arrived, they put her on top of Turtle. The seeds and the three sisters that she had brought with her grew and spread on top of Turtle's shell, becoming a large mound of earth. So this is how earth was made by Sky Woman, who fell from the Sky World and who brought with her the beginning of life. Later on she gave birth to a female, Lynx Woman. The two became very close until Lynx Woman ignored the warnings of her mother and became pregnant by a sky creature, Wind, and gave birth to twin boys. She died giving birth. Her mother had warned her that it would be dangerous if a union between someone from the Sky World and earth was to happen. And that was true: Lynx Woman died, but she gave life to the first humans made on Turtle Island. The boys grew up, and one became responsible for giving life and taking care of some things on earth and the other for taking care of other things. They would tease each other with different tricks to do on earth. So this is how Turtle Island was made by the first woman from the Sky World when she came down to this land to create earth, where she gave birth to a female, Lynx Woman, who later became the Mother of the Nation, having mated here and given life to the Twins.

This story explains the origin of the Oneida people of this continent, to whom contemporary Oneida people are connected as their descendants. I hope that the reader has not missed a major lesson from the narrative: the centrality of women in the Creation Story. Sky Woman is the first being of human form to come to this continent, and she later produces earth on Turtle's back by bringing with her the three sisters and seeds of tobacco and strawberry. The usage of the name "Turtle Island" among Oneida people when referring to North America comes

from this Creation Story, and one can see the spiritual connection that Oneida people – as well as other Indigenous groups – have with the land, still viewing themselves as the keepers, the guardians, of Mother Earth. The next major woman figure contained in the story is Lynx Woman, who is the giver of human life conceived and born on Turtle Island. By giving life to the Twins, she becomes known as the Mother of the Nation. She is still viewed as the life giver by Oneida people, which explains the persistence of the concept of women as "mothers of the nation" among Oneida people. These two women are examples of the importance women have had in Oneida culture, an importance maintained throughout history by the great amount of respect and power attributed to clan mothers and by the institutionalization of a matrilineal and matrilocal structure in each nation of the Haudenosaunee League.

Another lesson to be learned from the Creation Story is the importance of kinship relations. This is first illustrated in the bond that exists between the two women. The mother-daughter relationship was, and still is, considered to be one of the most crucial and essential relationships within the Oneida nation. The importance of kinship relations is later extended to the mother-son relationship, seen through the relationship that Sky Woman developed with the Twins when she was left as their sole caregiver following the death of Lynx Woman. Kinship and descent through the mother's line did become the foundation of the nation for the Oneida people and other Haudenosaunee peoples.

Twinship is a central theme of the story and exists in many other Oneida stories. Twinship implies two sides in need of each other in order to bring harmony and balance to all life, including the nation. The Twins represent the importance of complementary roles, as they each have different jobs to perform on Turtle Island, being responsible for creating different things on earth (Mann 2000; Antone 1998). European influence, and mostly Christianity, twisted the type of relationship that existed between the Twins and in doing so altered the concept of equal partnership in dual roles. The Twins were constructed and viewed as rivals, paralleling this story to that found in the Christian story of Cain and Abel. This oppositional construction was foreign to the original Creation Story but eventually became a version known by many (Mann 2000). I need to note here that I have never personally encountered this altered version of the Twins when told the story by elders. As Mann (2000) points out, this version represents an example of the distortions of Indigenous cultures that Europeans proliferated. Another change that developed in the Creation Story was the devolution of the woman figure:

the central roles of Lynx Woman and Sky Woman and their bonding relationship became secondary to that of the twin brothers, who increasingly became viewed as the main creators of life on earth. According to Mann (2000), this was due largely to the patriarchal nature of European ideologies and structures that existed at the time of early contact between Europeans and the Indigenous peoples of North America.

The Oneida people, descendants of the first peoples of Turtle Island, came to settle in the territory currently known as central New York State, and they call themselves Onyota:aka, People of the Standing Stone. This name reflects their place of origin, where their traditional land is located. That they named themselves in reference to the land is a good example of the spiritual meaning given to land and how land becomes very much intertwined with the identity of a people. The Oneida nation, then, is a separate community, with its own tradition, stories, and territory. Kinship relations, through the establishment of clans, are a very important mechanism for bonding all members of the nation, as with other nations that came to form the Haudenosaunee League. The twinship principle is extended to the nation itself, as the nation became divided into two separate groups, commonly referred to as moieties, each made of a set of clans. The second epoch of Oneida history comprises the formation of the Haudenosaunee League, made of five nations, the Oneida being one of them. Each nation is independent in its internal affairs but is interconnected through clans to the members of the other nations of the league. From the second epoch onward, the identity of the Oneida people became closely interconnected with the league itself; they viewed themselves not only as part of the Oneida nation but also as part of the much larger Haudenosaunee League.

Second Epoch: The Coming of the Peacemaker and the Making of the Haudenosaunee League

After the creation of Turtle Island and the birth of many different peoples on the continent, various nations came to form a large territory that expanded from what are now known as Ontario and Quebec to Ohio, Pennsylvania, and New York. These nations, Mohawk, Oneida, Cayuga, Onondaga, and Seneca,[1] had been living in a continuous cycle of wars against each other. A man, referred to only as the Peacemaker unless his name is uttered during traditional ceremonies, claiming to have received as a gift from the Creator a message of peace to deliver to the different warring nations, approached a woman, Jigonsaseh, convinced her of the soundness of this message, and asked for her help in persuading the

people of each nation to join in a circle of friendship and to follow the principles contained in the message of peace. Together, they acquired the help of Hiawatha, an Onondaga man, who became the speaker for the Peacemaker, and Jigonsaseh talked to the clan mothers of each nation so that they would ask their men to end the violence and unite together in peace. Eventually, they all did. A circle of all the chiefs of the five nations was formed in a Longhouse where all future meetings of the Haudenosaunee League would take place. In this circle, in front of a burning fire symbolizing the life of the league, each nation was to sit in a particular place, Mohawk and Seneca on one side and Oneida and Cayuga on the other; Onondaga sat by Mohawk and Seneca, and its members were the keepers of the fire, meaning that they were entrusted with the responsibility of mediating and maintaining the peace of the league (Mann 2000; Porter 1998; Fenton 1998; Antone 1998).

The date of the formation of the Haudenosaunee League, or People of the Longhouse – whose name reflects the structure and location of the five nations – is still debated. As Fenton (1998, 5) points out, "the league legend was first noted by the Moravian missionary Pyrlaeus in 1743." According to Fenton, although an exact date cannot be determined, the Iroquois oral tradition shows that the league must have existed at least two centuries prior to its first record by Pyrlaeus in 1743 (5). Therefore, many suggest that the league must have been in existence by the sixteenth century at the latest (69). Robert Porter (1998, 806), a Seneca professor of law, argues for an earlier date. He believes the league to date from approximately the mid-fifteenth century. The differences in opinion about the exact date can be partly due to the fact that one could view the formation of the league not as a single event but as a long process of resolution of the ongoing struggle between different nations, each joining the league at different times and/or having its own oral narrative of the coming of the Peacemaker (Fenton 1998, 73). What I have been told personally by members of my community, Onyota:aka, is that the Peacemaker came before the Europeans arrived, hence supporting Porter's claim.

As can be noted in the story of the second epoch, women were quite influential in the nations of the Haudenosaunee League: the Peacemaker first had to obtain the approval of women, as they were in charge of making peace or war and were the trustees of their lands. They had acquired this influence from the Creation Story. Mann (2000) argues that Jigonsaseh represents a new Lynx Woman, the Mother of the Nation, and the Peacemaker, her son (Mann 2000). Unfortunately, Jigonsaseh

is not mentioned in many available written texts of the Peacemaker's story, hence making men (the Peacemaker and Hiawatha) the principal actors of the foundation of the league (Mann 2000). Another important point to emphasize is that *peace* was to become the law that would guide the Haudenosaunee nations. Each nation was to treat the others as kin and to resolve disputes through discussion by sitting at the circle and arriving at a suitable agreement, mediated by the keepers of the fire, the members of Onondaga, rather than by violence. Although not always easy to accomplish, the league's principles survived until the arrival of the Europeans, at which time they saw themselves caught in competing power struggles and could not achieve consensus on how to deal with the Europeans and the upcoming wars between different European sides. As Fenton (1998, 6) argues, the nations of the Haudenosaunee League "were manipulated by colonial powers and in turn manipulated colonials to their own advantage. Alliances were indispensable for survival and success, and the old men of Onondaga varied their policy between alliance and neutrality according to the way in which they perceived their self-interest."

The early period of contact between the Europeans and the Haudenosaunee nations was focused mostly on trade. The trade period quickly affected the Haudenosaunee peoples, who found themselves approached by both the French and the Dutch for trading purposes (Fenton 1998; Antone 1998). Eventually, the Haudenosaunee distanced themselves from the French, especially after the latter, under the order of Samuel de Champlain, killed three Haudenosaunee chiefs (Antone 1998, 7). Then, in 1642, the Haudenosaunee entered into a formal treaty with the Dutch by exchanging a promise of nonaggression in the form of a wampum belt known as the Chain of Friendship (Fenton 1998; Antone 1998). This treaty put them in a position of conflict with the French. Years later, the Dutch power diminished and the power struggle between the French and the British increased. Both European forces recognized the power the Haudenosaunee League had achieved in the region, and they were rivals for its support in their own war (Fenton 1998; Antone 1998; Campisi and Hauptman 1988; Page 2003). In 1677 the English exchanged their own Chain of Friendship wampum with the Haudenosaunee, a similar wampum to the one first exchanged between the Dutch and the Haudenosaunee. As Antone (1998) and Fenton (1998) argue, the Haudenosaunee attempted to avoid siding with either the French or the English in their wars and, in fact, had encouraged these two sides to join the league and enter into a promise of peace just as the separate

nations of the league had done centuries before. At the height of this conflict, most of the Haudenosaunee sided with the British. In fact, in 1713, the Treaty of Utrecht recognized the Haudenosaunee peoples to be protected as British subjects, although they viewed themselves as allies, not subjects. The Haudenosaunee peoples made this claim because, in their perspective, the Chain of Friendship exchanged earlier implied that each party was viewed as an independent nation (Antone 1998). As Fenton points out, this alliance with the British was made mainly due to the dependence of the Haudenosaunee peoples on British traders, which meant that most of the political decisions made at the Longhouse fire by each Haudenosaunee nation were motivated by each nation's individual need to protect its territory and to survive economically (Fenton 1998). As the conflict intensified, the Oneida nation found itself in a very complex situation: due to Oneida's geographical location, being positioned between the Mohawks and Onondagas and crossing the border of Canada and New York State, the Oneidas found themselves under pressure to fight against the British and their own allies, their Haudenosaunee brothers and sisters. The Oneida nation eventually paid a high price for trying to protect its national interests, as it lost many people and its settlement was burned. In 1696 Oneida's lands were destroyed, together with those of Onondaga, when Louis de Buade Frontenac ordered an attack against them (Campisi and Hauptman 1988, 20). Hence the promise of peace within the Haudenosaunee League suffered a great blow during the wars between the British and the French, as each nation of the league found its own interests to be at odds with those of the others because of the vulnerability caused by their specific geographic locations.

The factionalism within the Haudenosaunee League increased even more when the American Revolutionary War began, testing the league's past pattern of consensus. Because of the Chain of Friendship wampum that had been exchanged in the previous century, most Haudenosaunee nations, after having failed to maintain their desired neutrality, allied with the British Crown. Oneida was the one nation that did otherwise. It has been argued that its decision was heavily influenced by the actions of Samuel Kirkland, a New England non-Aboriginal missionary who had been living with Oneida people since 1766 and had acquired influential power in Oneida (Antone 1998; Fenton 1998). The Haudenosaunee nations met at Onondaga to discuss the war and were unable to achieve consensus, so they covered the fire that was in front of the council of the chiefs. This action meant that each nation was to decide on its own

what to do on this matter. Oneida sided with the Americans (Antone 1998). The American Revolutionary War saw a revival of heavy infighting in the league that had not been present since the arrival of the Peacemaker.

Oneidas fought very hard with their American allies, especially when the British sent a heavy invasion through Haudenosaunee lands, enlisting the help of the Mohawks, Senecas, and Cayugas in 1777 to fight the American Revolutionaries. The final war between them occurred at Oriskany Creek. This was a very bloody war. In this war the Oneida nation accepted the invitation by the Americans to join the war, and it helped the Revolutionary cause by supplying men and by helping to feed soldiers who were going through their territory on their way north to Canada. In return, Oneida was heavily attacked a few times by the British and their Haudenosaunee allies, and in 1780 an expedition led by Mohawk Joseph Brant burned the Oneida settlement. When the Treaty of Paris was signed between the British and the Americans after the war, Oneidas were formally acknowledged for their loyalty to the Americans. In contrast, the other Haudenosaunee nations were treated harshly by the Americans because of their alliance with the British. No provisions were made for them in the Treaty of Paris by their British allies, who left them out of the treaty, thereby dismissing their help during the war. In 1784 the Treaty of Fort Stanwix was signed, in which Oneida was assured the protection of its lands because of its alliance with the American Revolutionaries during the war, whereas the other Haudenosaunee lands were greatly reduced. However, the promises made in the Treaty of Fort Stanwix were quickly broken, as New York State and its investors slowly dispossessed Oneida of much of its land.

Oneida after the American Revolutionary War: Period of Treaties and the Move to Canada

Campisi and Hauptman (1988, 45) refer to the period 1784-1934 as the Oneida "Time of Troubles" because throughout these years the Oneida nation suffered tremendous loss of land after a series of treaties were signed between some Oneidas and New York State officials. According to both Campisi and Hauptman (1988) and Antone (1998), this loss of land, and its negative impact on the nation's overall wellbeing, was the result of three factors. First, Oneidas were exploited by greedy investors in New York State who were able to lobby for support from state officials. Second, the Government of the United States was unable to enforce the previous Treaty of Fort Stanwix, which was to protect Oneida's lands

from outsiders. Third, divisions emergent within the Oneida nation prevented it from effectively resisting the dispossession.

Shortly after the signing of the Treaty of Fort Stanwix, New York State's commissioners met with some Oneida representatives to reaffirm their friendship; however, the true motive of the commissioners was to obtain land from Oneida, in contrast to Oneida's agreement with the federal government (Campisi and Hauptman 1988). What followed this action was a conflict between New York State and the federal government over jurisdiction on Indian lands. New York State passed a resolution in March 1783 that would allow the state to enter into negotiations with Oneida (Campisi and Hauptman 1988). New York State desired to acquire land from Oneida and in return would give land to Oneida that had originally belonged to the Seneca nation. It was important for New York to clearly establish its territorial claim, which was being disputed by Massachusetts through different royal charters (Campisi and Hauptman 1988). To win over Massachusetts, New York had to enter into such an agreement with Oneida and enforce this treaty, even though it contravened the federal government's Treaty of Fort Stanwix. From 1785 to 1846 New York State entered into a series of treaties with the Oneida nation, pressuring its representatives each time by telling them that the treaties would protect Oneida from greedy white speculators.

An important treaty was signed in 1788, which is still disputed by Oneida in the courts today. In January 1788, speculators led by Robert Livingston convinced a few Oneidas to lease all of their land. When the speculators asked the New York State legislature to recognize the lease, the legislature rejected the request and then directed the governor of the state to negotiate directly with Oneida to purchase the land instead (Campisi and Hauptman 1988). Oneida leaders were not aware of these proceedings, as those who initially entered into a lease agreement with Livingston were not authorized to do so by the people. Oneida found itself forced by both the private investors and the state's officials to enter into an agreement, each side claiming it was doing so in the best interests of Oneida. Finally, Oneida agreed with the state's representatives and entered into a treaty. This treaty divided the land into three parts, one leased to the state, one set aside for Oneida to lease, and a small third one for the sole use of Oneidas (Campisi and Hauptman 1988). Oneida still believed that its land was to be protected from future speculators, when, in reality, "the state gained control of a vast territory for less than the amount of the discredited Livingston lease" (Campisi and Hauptman 1988, 53).

This treaty was not the last: slowly Oneida, under pressure, entered into many more treaties with New York State, which resulted in the nation losing almost all of its original territory. Although, in the Treaty of Fort Stanwix, the United States had rewarded Oneidas for their contribution during the American Revolutionary War by ensuring that they could live free and secure on their lands, the federal government failed to be true to its promise, as it was not able to enforce it when challenged by New York.

The first sign of the federal government's weakness came right at the beginning, during the signing of the Treaty of Fort Stanwix. The US Congress, intending to have full authority over Indigenous nations, forced those who had sided with the British to surrender their lands, resulting in the move of many of them to what is now Canada. However, New York State's representatives were also meeting with various Haudenosaunee nations to purchase lands from them, but their efforts failed (Campisi and Hauptman 1988). Later, articles of the New England Confederation clearly stated that Congress was the sole authoritative party in any future transactions with the Oneida nation, and this was claimed again in legislation in 1790. When in 1795 some Oneidas met with New York State's governor, George Clinton, to enter a treaty, they informed the federal representatives of such a meeting, and the federal representatives then instructed New York State that a treaty with Oneida was illegal. But when, in the same year, New York commissioners entered into another purchase agreement with Oneida, the federal government let it pass (Campisi and Hauptman 1988). Hence the protection for Oneida embedded in the Treaty of Fort Stanwix ended approximately a decade after it began.

Oneida's predicament was largely due to deceptive and manipulative actions by New York State, federal inaction, and the greed of individual land investors. However, another important factor cannot be ignored as a contributor to Oneida's situation, and that is the divisions that occurred within the nation itself. As Antone (1998), Fenton (1998) and Campisi and Hauptman (1988) argue, when pressures arrived to enter treaties that eventually ended Oneida's possession of most of its traditional territory, Oneida was divided along many lines. There existed divisions between hereditary title chiefs, who were lifelong chiefs so appointed by clan mothers as the Great Law of Peace instructed, and war chiefs, who were temporary and held status due to their many acquired skills. These two groups through the centuries of wars, before and after the arrival of Europeans, had been competing to achieve influence within

the Oneida nation and the Haudenosaunee League itself. This division between the two types of chiefs was similarly felt throughout the league. The war chiefs were often the ones who signed the treaties, even the Fort Stanwix one, and this was not a customary tradition within the league, but as wars had become more frequent, the war chiefs had acquired more status within the nations of the league.

Another point of division within the Oneida nation occurred along religious lines. By 1805 there were two divided parties within Oneida: a Christian party, led by Kirkland and his followers, who were mostly in favour of the war chiefs; and a Pagan party, which included the traditional title chiefs. This division became more intense as years went by and outside forces negatively impacted the nation. Oneida, no longer united in "speaking with one mind," as the Peacemaker had wanted, could not resist the intrusion of foreigners. As Antone (1998, 18) points out, by the mid-1800s, "there was much dispute and division pertaining to religious affiliations, there was also much dispute and division as to what the remaining six hundred Oneidas should do about the remaining 4500 acres of land in New York."

In 1838 the Treaty of Buffalo Creek made it impossible for the Oneida people to settle in Wisconsin, as some had begun to consider; instead, in this treaty, the United States encouraged them to migrate to a small piece of land in Kansas. However, the conditions in that new territory for those who chose to go were unliveable, so many returned. Upon their return, there was continuing pressure from the state to obtain more land from Oneida, and with the persistent internal political division, the Oneida nation itself split into three separate communities. One remained in the reduced original territory, another went to Wisconsin, and the third settled by the Thames River, in Ontario, Canada. As Campisi and Hauptman (1988) and Antone (1998) remark, it is important to remember that the internal division was a major contributor to Oneida's unfortunate situation. And as of today, some of the resentment is still felt within the nation, as some of the women reveal through their narratives later in this book. It is crucial for the revival of the Oneida nation as a healthy postcolonial nation that some of these wounds be healed, especially given that Oneida is negotiating a land claim with New York State. As Campisi and Hauptman (1988) and others argue (Porter 1998; Fenton 1998), the success of this legal battle, in which Oneida is disputing the legality of the 1788 treaty previously discussed, depends greatly on the capacity of Oneida to forge a united front against the state.

The group that came to Canada did so by purchasing a tract of land from the Government of Canada in 1840. They went to this new territory in order to escape the ongoing division existing in their original territory and in order to be able to survive economically, as it had become extremely difficult to do so since losing most of the land in New York. Also, as Antone (1998, 29) points outs, they were heavily pressured to move to Canada by New York State officials, as reported by oral accounts of that move that have been passed on from generation to generation.

When these Oneidas arrived in their new territory, the group invited the hereditary chiefs of the Six Nations at Grand River to recognize Oneida's new territory and political organization. The Six Nations at Grand River was another Haudenosaunee group that had moved from the United States to Canada, placing in its new home a Longhouse political organization that remained intact until 1924 when the Canadian state forced it to implement an elected form of government. Therefore, in Oneida of the Thames, a Longhouse traditional council was instituted, which followed the guidelines provided by the Great Law of Peace and which tried to work in co-operation with the Indian Agents appointed by the Canadian state. Land was to belong to all, and, according to Oneida traditions, decisions were to be made through consensus.

However, in early 1900, dissension and factionalism resurfaced in this particular Oneida community. According to Antone (1998), this began when a group influenced members of the community to follow the Code of Handsome Lake, which had originated with the Six Nations at Grand River. This code was started by Handsome Lake, a Seneca prophet who wanted to revitalize the Longhouse traditions, which he felt had been forgotten by the people in favour of European values. This code was a very strict moralistic guide, containing a combination of traditional Haudenosaunee and European influences. For example, the roles of women in the code were dismissed. The code was well accepted by some people in Oneida of the Thames, but others maintained a strong alliance to older Longhouse traditions and set their own council.

In 1920 Oneidas became involved in another matter that created more divisions within: as an attempt to initiate a legal land dispute with New York State, there was a movement to reorganize the old Haudenosaunee League and to re-establish the Grand Council at the fire in Onondaga, which had been disbanded at the beginning of the American Revolutionary War. This action would have required the Oneida of the Thames

community to distance itself from the Six Nations at Grand River, which had established its own council. The group wanting to bring back the fire at Onondaga won more support; but this was challenged by another group, and a bitter division intensified to the point that the latter group eventually asked the Canadian government to intervene. The Canadian state, in agreement with this group, instituted a system of elected council, which still remains in place today, with this council being the sole body legally recognized by the Canadian state. However, the other traditional Haudenosaunee political organization is also still alive today and regarded as legitimate by many. This system of governance is being reconstructed and taught by "traditionalists" to the younger generation. Many of the women in my study either follow the teachings of this traditional Haudenosaunee group or are quite familiar with these teachings and believe that they need to be revitalized during the present process of self-determination among the Oneida people. I also belong to the Longhouse tradition and share with many of the women the belief that those traditions that could still be relevant in a contemporary context need to be remembered and put back into practice as we move forward in our journey of healing and decolonization.

CHAPTER THREE

Struggles of Independence: From a Colonial Existence toward a Decolonized Nation

The governments of the day, our legal guardians and fiduciaries, do not want to discuss the transforming of legal or political institutions to include Aboriginal peoples in the nation. They do not want to end their national fantasies, artificial constructs, or myths about their nation, nor do they want to expose the injustice that informed the construction of their national and state institutions and practices. They do not want to create a postcolonial state or sustain these efforts at institutional reform. (Henderson 2000, 164)

It is unlikely that a new relationship can be forged without acknowledging and then remedying historical wrongs. Aboriginal experience of this country's history is not linear; the past is not simply the past. Aboriginal people still suffer the inter-generational consequences of these historical wrongs, in part because Canada has never significantly tried to remedy in full the consequences of colonial imposition. (Monture-Angus 1999, 23)

Indigenous people have successfully engaged Western society in the first stages of a movement to restore their autonomous power and cultural integrity in the area of governance ... Recent years have seen considerable progress towards ending the colonial relationship and realizing the ideals of indigenous political thought: respect, harmony, autonomy, and peaceful coexistence. (Alfred 1999, 2)

Each of the authors quoted above speaks of the historical relationship between the Indigenous peoples of Canada and other Canadians. Even though the Canadian state and many Canadians would like to deny

and/or dismiss the fact, this relationship has been based on unjust practices of colonialism, as Henderson argues in the first quotation. Monture-Angus and Alfred contend that Indigenous peoples still suffer the consequences of those practices but are pushing forward a movement that could build a more equal and peaceful relationship with the Canadian state and the rest of Canadian society. Although I am looking more specifically at the cases of the Oneida and other Haudenosaunee peoples, other Indigenous communities might recognize their own experiences in the events explored here. This should not be surprising since Indigenous peoples of the North American continent, similar to other colonized peoples in the rest of the world, have shared a similar history of colonialism, survival, and resistance. However, I do not intend to homogenize all experiences of either colonization or decolonization. Each Indigenous nation has its own language, history, and traditions, although "today, First Nations in 'Canada' share many problems and experiences largely as a result of the common treatment that comprised the federal policy of civilizing us" (Monture 2008, 156). Ultimately, it is to be left to each Indigenous nation to speak of the similarities and differences of experiences that exist between itself and other colonized Indigenous nations.

In my discussion of the traditional governance of the Haudenosaunee League, I employ traditional stories and teachings together with secondary sources of knowledge that are mainly academic. Indigenous oral traditions were finally recognized as valid forms of knowledge and even as sources of evidence by the courts after the Supreme Court of Canada's 1997 decision in *Delgamuuk v. The Queen* (Battiste 2000).[1] More specifically, I rely on the Great Law of Peace – commonly called the Kaienerekowa by Mohawks and the KayanlΛhslaʔkó by Oneidas – first introduced to the five original nations of the Haudenosaunee League by the Peacemaker. Some of the main principles of self-governance outlined in the KayanlΛhslaʔkó include: (1) balancing social structures and responsibilities, (2) clan as the foundation of each nation and of the whole league, and (3) the roles of Kunathuwi•s'Λ (Oneida for "women") in building and sustaining a nation.

We begin the journey with the story of the gift of the Great Law of Peace given to the Haudenosaunee League by the Creator because, as Leslie, a grandmother, told me, "It isn't going to be easy to rebuild the strong and healthy nations we once had, and one of the hard things is trying to remember what our traditions were and take that first step to

reawakening them and also see how they still can make sense in the world we live in today." And although it might difficult, due to policies of assimilation and cultural genocide over the recent centuries, to remember what the old teachings are, "luckily the elder spirits of Earth and Sky, Water and Air [are] speaking to the children again, telling them of the Old Things: that cooperation, not adversarialism, is the norm ... that the Grandmothers, not any government of men – and salty men[2] at that – determine identity; that the Grandmothers properly direct society" (Mann 2008, xii). Indeed, I agree with McGowan (2008, 53) that if "there is any hope of restoring Native society, of saving our children, our brothers – ourselves – knowing how we once lived may give us some guidance."

AT THE BEGINNING

The Ukwehuwé – the Original Peoples, as Haudenosaunee peoples refer to themselves to stress the point that they were in Turtle Island territory for thousands of years before any European set foot on the land – were living in times of turmoil and wars with each other, threatening the very survival of each nation. During this time, a man, who is always referred to as the Peacemaker and whose name is not to be uttered outside of traditional ceremonies, came to speak of a message of peace he had received from the Creator to spread among the warring nations. He first went to Jigonsaseh and convinced her to stop the tradition of feeding the warriors and to help him to spread the message of peace to the other nations by asking the other women of the different nations to convince the men to put down their arms. He then met with Hiawatha, an Onondaga man who had lost his daughters and was quite distraught but who had not found any people who would listen to his words of grief and return to him words of sympathy and comfort. The Peacemaker understood his grief, and together they built strings of shell that a person would hold when wanting to speak to another and that, when finished, the person would present to the listener. When accepted, these strings would bind people together. So together they went and convinced the other nations to lay down their

weapons and join the circle of peace. But they first had
to persuade Adodaroh, a man who had terrorized all the
people with his cruel cannibalistic ways, to join them so
that a strong union of peace could be built. All the nations,
led by the Peacemaker, Jigonsaseh, and Hiawatha, went to
see Adodaroh and told him he would be entrusted with
keeping the peace. He finally agreed, and when his mind
was finally clean, all of the nations, represented by each
Royaner (chief), established the Kayanlʌhsla²kó, Great Law
of Peace, under the Ohtehlase²kówa, Great Tree of Peace.

The story of the Peacemaker has been told to me by elders, relatives,
and my clan mother over the course of many years. There are various
versions of the same story, and all should be viewed as valid sources of
knowledge within an Indigenous epistemology, as long as the core prin-
ciples of the teaching are maintained in each version. Hence the story
has been written above according to the way that I recollect it from
various sources at different times. I want to acknowledge these teachers
and thank them, and I also want to point out that I have been told that
it is acceptable to put it into this textual form. By writing oral stories,
one can utilize the written medium to transmit important Indigenous
knowledge to others, thereby helping to keep this knowledge alive. Yet
it must be recognized that in moving an oral story to print, some limita-
tions arise. For example, the written text does not show to the same
extent the intensity of the interaction between the teller and the listener
that characterizes an occasion of oral storytelling. Hence, although it is
important to transform the oral story into a written form, the two media
are not of the same quality.

This oral teaching describes how each of the five nations – Mohawk,
Cayuga, Onondaga, Oneida, and Seneca – united into a league to create
peace and harmony with each other, and through their establishment
of the Kayanlʌhsla²kó they were bound together. This unity is exempli-
fied in a wampum belt commonly called the Hiawatha Belt. Wampum
belts, which are strings made of beads, constitute texts that convey mes-
sages, describe treaties signed by different parties, and outline how
ceremonies ought to be orally transmitted and passed to the next gen-
erations. The Hiawatha Belt is likely the most well-known wampum held
by the Haudenosaunee peoples. "A broad, dark belt of wampum ... hav-
ing a white heart in the center on either sides of which are two white

The graphic from the Hiawatha Belt, which records the unity of the Haudeno-
saunee nations under the Great Law of Peace. The heart in the centre represents
the Onondaga nation, which was responsible for keeping the peace. The
squares represent the other four founding nations of the Haudenosaunee
League, which are all connected with the heart and with one another by
the line running between them.

squares all connected with the heart by white rows shall be the emblem
of the unity of the Five Nations. The white heart in the middle means
the Onondaga Nation ... and it also means that the heart of the Five Na-
tions is single in its loyalty to the Great Peace" (Parker 1916, 11-12). The
Onondaga nation's people were selected as the fire keepers of the Hau-
denosaunee League because they occupied the original territory of
Adodaroh, the one man most reluctant to accept the message of peace.
The league was structured around the concept of twin balance, consist-
ent with the Haudenousaunee worldview that everything in life consists
of two sides having specific roles and responsibilities that are equally
valued and thus equally necessary to obtaining and maintaining balance
in all relations between and among all species living on earth.

This principle of twin balance is applied in the Tenth Wampum of
the Great Law, which guides the seating of the Grand Council. It states,
"It is provided thus: the business of the Confederate Nations shall be
transacted by two combined groups of Lords, namely: first, the Mohawk
and Seneca; and second, the Oneida and Cayuga. And all cases and the

decisions and resolutions of the Confederate Council shall be referred to the Firekeepers, 'Ratitsistanon,' the Onondagas, for a final confirmation" (Thomas 1989, 8).

The structure of Haudenosaunee socio-political life was built upon the belief that strength derives from a covenant of equality. This worldview is part of an Indigenous epistemology that regards all life on Mother Earth as constantly moving in a holistic and circular way, whereby everything/everyone is interconnected and thus an equal participant in the harmony of the wholeness (Little Bear 2000, 78). This worldview is evident in the Sixteenth Wampum of the Great Law, also known as the Covenant of the Five Nations Wampum. This wampum sets out the placing of each nation of the Grand Council in a circle, pointing out the strength of unity. It says,

> We are now Five United Nations Lords, "Rotiiane:shon," which are standing together in a circle with our hands joined together and this is the symbol that if any of the Confederate Lords leaves this Confederation, "Teiotio:kwaonhas:ton," his crown of Deer's Antlers, the emblem of his Lordship, together with his birthrights, will lodge in the arms of the Confederate Lords whose hands are joined, so that if his crown of deer's antlers fall off from his head, he forfeits his title ... Be firm so that if a tree falls on our arms it shall not separate us, or cause us to loosen our hold, such shall the strength of our union be. (Thomas 1989, 12)

Peace is indeed one of the three core principles underlying the Great Law of Peace, which provides guidelines on how to live together, both within the Haudenosaunee League and with foreign nations, in accordance with the Creator's intentions. As Alfred (1999, xix) points out, "The Rotinohshonni cultural imperative is to spread the message of peace, power, and righteousness – and to struggle vigorously against those who would impose a disrespectful and unjust order." The principles in the message of peace promoted reflective responsibility for the natural world and for future generations as well as a desire to create and maintain peace (Henderson 2007). The Peacemaker's message was simple yet persuasive, as it relied heavily on the ability of all human beings to reason about the positive outcomes of adhering to peace. "Pursuing peace was fundamental not just to the establishment of the Confederacy, but also its perpetuation. Foremost, the Gayanashagowa[3] was a tool of government and frequently has been referred to as the Haudenosaunee Constitution" (Porter 1998, 817). Moreover, unlike the European model

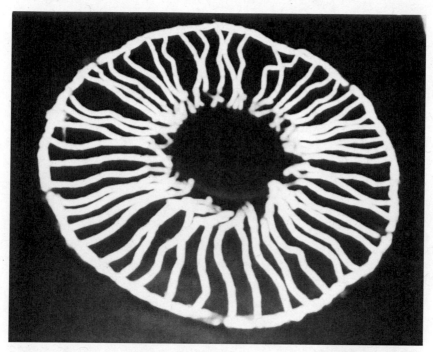

The original Covenant of the Five Nations Wampum, showing the circular placement of the original five nations of the Haudenosaunee League in the Grand Council. The breaks in the outer circle demarcate the individual nations, while the circle itself represents the strength of their unity. Photo taken by author in 2002 in the original Oneida territory.

of democracy, which relies on majority rule, the Haudenosaunee League "relied upon a governing process that was both dependent upon and designed to achieve consensus" (Porter 1998, 817). It also included an imperative for the members of the league to welcome and extend membership to any person of another nation who came to the Haudenosaunee territory and sought refuge and was willing to accept the principles of the Great Law of Peace (Henderson 2007).

Monture-Angus (1999, 41) provides an excellent definition of peace that best reflects a Haudenosaunee system of thought, correctly arguing that "this peace is defined much more broadly than living without violence. Living in peace is about living a good life where respect for our relationships with people and all creation is primary." This definition is commonly shared among the people I talked with for my research, who commented:

The Friendship Belt [a wampum belt exchanged by two different people or nations that symbolizes the friendship that exists between them] we have is supposed to be respected and we should remember that. It meant that we are supposed to follow the teaching of living in a good way, to be of one mind, to try to be in peace with everyone and everything. (Shirley)

We belong to a tradition of peace, of cooperation. (Frances)

There can be balance within one self, with others, with Mother Earth, because we are all one, all related to each other, as long as we remember to practise the teaching of being of one mind. (Anne)

This important teaching of peace has also been passed on to me by my family and community members, and I argue that it still lives on strongly in "Indian Country."

Of course, this notion of peace is not to be viewed in an extreme idealistic or romanticized way, as peace was not always easily obtainable in practice. There were instances where divisions did arise or persist both between the nations of the Haudenosaunee League and between various factions within each nation. Competing interests were held by the two different types of chiefs, the hereditary chiefs and the war chiefs, as each group attempted to achieve more status and influence than the other within each nation. Also, one needs to remember that later in history, when the Europeans arrived and the American Revolutionary War began, the nations of the league warred against each other again. When the national interests of each nation were at odds with those of the other nations and consensus in the decision-making process as prescribed by the Great Law of Peace was not possible, peace as a practice was forsaken, even if as an ideal principle it was remembered through storytelling. Moreover, even though the Great Law of Peace asked the members of the league to strive for a peaceful co-existence with other nations, it is true that there were times when this was not possible and when war, especially in order to protect one's territory, did occur with those nations that were excluded from the league (Fenton 1998).

Nonetheless, one also needs to remember that the Great Law of Peace allowed for war only as a last resort, only after the failure of a series of attempts to reconcile differences through peaceful means, such as treaty making or performing traditional ceremonies to redeem past wrongs.

Engaging in warfare was also seen as appropriate when a nation's members had been killed but no compensation had been received from the aggressor, in which case a "mourning war" could occur in order to restore lost population, ensure social continuity, and deal with death (Magee 2008, 122). In sum, despite the intent of peace contained within the Great Law, instances of conflict and war did exist both within and outside of the league. As Maracle (2008, 40) points out in her analysis of warfare in the context of Indigenous peoples,

> we are not against war under any and all circumstances. War is the inability of humans to come to a creative, collective resolution ... War is seen as an obstacle to the positive internal development of the Nations who engage in it. Hence, after engagement in war, the men who had killed were stood at the edge of the forest and cleaned off before reentering the village. Internal peace was primary.

Power is the second principle of the Kayanlʌhslaʔkó, and its source is not derived from a notion of control and domination over others. Power, in the Haudenosaunee worldview, is a spiritually based empowerment whose source is the Creator and which is tied to the whole wellbeing of the members of each nation of the league. In this sense, then, leaders of the nation do not have a right to control and subjugate others but rather are mentors for the people, and fulfilment of their responsibility rests on their being able to live according to the teachings of the Kayanlʌhslaʔkó. Moreover, leaders are

> not only our politically elected officials or hereditary chiefs; rather, our artists, writers, intellectuals of various sorts (for example, our medicine people and teachers) must also exercise important leadership roles in our communities. In addition, the role of women as social and political leaders is central to the health and well-being of virtually all Indigenous cultures. (Turner and Simpson 2008, 4)

In contrast to a disciplinary form of power administered by the state, which the French poststructuralist theorist Michel Foucault (1980) analyzed and made us aware of, this particular form of power, then, is anti-disciplinarian and is viewed as both an internal and an external force that individuals possess through knowledge of the spiritual traditions and through the wisdom to care for the people (Alfred 1999, 49).

This understanding of power was the subject of a discussion I had with Debbie, one of the women who participated in my research. Having received permission from her to share her thoughts in this book, I offer here what she said about power:

> Is not power to force others, intimidate them to do things that are to your advantage; power is the spark you have inside of you to wake up in the morning and face the world with integrity, pride, because you know you are doing your darnest to live in a good way and do good for others, so they can look up to you and trust you and together big things can happen for the whole community; that's real power.

Haudenosaunee teachings clearly spell out what power means and what the roles of different leaders in the league are. These roles are based upon a sense of balance that requires everyone to work together in order to achieve harmony in the whole of society (Mann 2000, 60). As Mann (2000, 60) points out, balancing roles between the sexes is consistent with Haudenosaunee creation stories, which stress the pivotal necessity of having halves in all our social relations and organizations in order to maintain a "cosmic equilibrium." Furthermore, as Mann (2000, 60) states, "in all spheres – the social and the religious, the political and the economic – women did women's half and men did men's half, but it was only when the equal halves combined that community cohered into the functional whole of a healthy society." The concept of balance implies that in the case of an unequal distribution, some of the tasks and responsibilities can be transported to the other side of the scale so that the whole does not tip over. This means that it can be acceptable for men to do what are considered women's tasks and vice versa if the overall outcome is the desired equilibrium and holistic wellbeing.

The way the sexes share leadership responsibility is through their association with two separate yet equally valued and important councils, therefore ensuring that power is shared among all women and men. The Seventeenth Wampum of the Great Law states that the hereditary line of a confederate lord – commonly referred to as "chief" (Latiyanéshu) – is passed through the females, a system wherein each clan mother (Laothuwisʌ'tslaʔ) appoints a confederate lord. This particular wampum states, "The right of bestowing the title shall be hereditary in the family of females legally possessing the bunch of shell strings and the strings shall be the token that the females of the family have the proprietary right to the Lordship title for all time to come, subject to certain restric-

tions hereinafter mentioned" (Parker 1916, 34). As another example of the specific Haudenosaunee notion of leadership and power, the Nineteenth Wampum of the Great Law provides a way to dispose of a chief when he does not act in the best interests of his nation and of the league. This wampum also exemplifies the power that women hold in Haudenosaunee life:

> If at any time it shall be manifest that a Confederate Lord has not in mind the welfare of the people or disobeys the rules of the Great Law, the men or the women of the Confederacy, or both jointly, shall come to the Council and upbraid the erring Lord through his War Chief ... The War Chief shall then divest the erring Lord of his title by order of the women in whom the titleship is vested. When the Lord is disposed the women shall notify the Confederate Lords through their War Chief, and the Confederate Lords shall sanction the act. The women will then select another of their sons as a candidate and the Lords shall select him. (Parker 1916, 34)

The above-mentioned war chiefs are also to be selected by the clan mothers of each nation. War chiefs do not participate actively in the Grand Council's proceedings, and according to the Thirty-Third Wampum of the Great Law, their titles are not required to be hereditary or to last throughout their lives. Their duty is to watch the proceedings, help the confederate lords, ensure that the lords follow the Great Law of Peace, and more important, protect the land of each original nation and the whole Haudenosaunee League against foreign invaders.

The important contributions that women made to the political, social, cultural, and economic life of Haudenosaunee societies expanded well beyond their authority to appoint and dispose of chiefs. Haudenosaunee women had the self-governing right to exercise sexual autonomy, to divorce, to own property, to approve of war or to order its end, to participate in the production of military supplies, such as tools and food, to decide on the fate of prisoners, and to adopt members of other nations into one of the nations of the league (Monture-Angus 1995, 1999; Alfred 1999; Stevenson 1999; Goodleaf 1995; Mann 2000, 2008; Magee 2008). Women's roles were derived from the fundamental rule that lineal descent within one's clan had to run through the female line. As the Great Law of Peace states, "The lineal descent of the people of the Five Nations shall run in the female line. Women shall be considered the progenitors of the Nation. They shall own the land and the soil. Men

and women shall follow the status of their mother" (Parker 1916, 42). Given the current chaos that the twenty-first century is witnessing across the entire globe, from "the war on terror" to "global warming," the following words make much sense to me:

> I look at the fine fix Native America is in and realize that this is exactly why the old Clan Mothers refused to let men discuss anything that the women had not first canvassed thoroughly ... this upside-down situation will not be righted until women resume taking care of their Mother, which simply will not happen under Euro-American law. (Mann 2008, 960)

Nonetheless, the restoration of women's contributions could perhaps happen again in Haudenosaunee nations, where women once held the right to own property and the right to influence the governance of their nations by appointing chiefs. These rights are derived from the Creation Story. Because Sky Woman was the giver of life on earth, and because later her daughter, Lynx Woman, gave birth to the first humans conceived on earth, among the Oneida people and other Haudenosaunee societies, women came to be treated as life givers, the mothers of the nation. For this reason, a matrilineal system was practised among the Haudenosaunee. The concept of "mothering" within a Haudenosaunee perspective does not necessarily have the same meaning as it does in other cultural contexts. Although one understanding of mothering is related to the literal meaning of biological reproduction, mothering also encompasses other roles, such as caring for all the children of one's clan, caring for the earth, and sharing responsibilities with others for the wellbeing of the community. Hence, because of the broad and inclusionary meaning of the term "mothering," there was a possibility for those women who did not biologically produce children to still be regarded and treated as "mothers of the nation."[4]

Clans were of essential importance to the structure of the Haudenosaunee League (Doxtator 1996, 1). The clan system provided a basis of unity, peace, and harmony among all the nations of the league. Given that a member of a specific clan in one of the nations was considered a brother or sister of the members of the same clan in other nations, peace could be maintained across the league (Alfred 1999, 103). Since a person's membership in a nation was tied to his or her affiliation with a clan, women's pivotal place in the clan structure of each nation of the league ensured that they were vested with a great amount of authority and

respect in their societies, either through their potential ability for bio-logical reproduction or, as in the case of the clan mothers, through their exclusive right to adopt new members into a nation.

The third principle of the Kayanlʌhslaˀkó, righteousness, corresponds to a traditional value of governance that instructed the leaders of the nations to practise kindness, patience, fairness, and justice for all the members of their nation and to keep in mind the interest not only of the present members but also of the next seven generations (Alfred 1999, 97). Within the Great Law of Peace, a leader has to ensure that he uses reason and has a good mind when contributing to the collective decision-making processes (Alfred 1999, 104-5). Alfred (1999, 134) argues that this Haudenosaunee traditional teaching is quite similar to that of other Indigenous cultures, such as that of the Anishinaabeg. These teachings guide Indigenous peoples to be wise, peaceful, and caring, to respect all forms of creation, which Indigenous peoples refer to as "All Our Rela-tions," to be humble, and to be honest.

As Porter (1998, 806) points out, "the Six Nations of the Haudeno-saunee, or Iroquois Confederacy, have existed as separate sovereign nations for hundreds of years despite the perpetual efforts by Euro-American peoples to colonize Haudenosaunee aboriginal territory and destroy their political, social, economic, and cultural existence." The Haudenosaunee peoples had a very sophisticated, strong, and advanced political tradition long before the arrival of Europeans on Turtle Island. I remind the reader that it has been argued that the political structure of the league can be dated back to as early as the mid-fifteenth century (Porter 1998; Fenton 1998). Moreover, Haudenosaunee peoples existed as nations and had a self-conscious national identity, contrary to the arguments of some theorists who insist on locating the origin of nations in modernity (Anderson 1991; Hobsbawm 1992; Gellner 1983). This insistence, Monture-Angus (1999) and Mann (2000) argue, relies on pre-sumptions of European superiority. But some of us Indigenous word warriors, intellectuals who are rooted in our own communities and Indigenous knowledges and who also engage with and often challenge discourses of the state and the mainstream academy (Turner 2006), are continuing to fulfil our responsibility to give outsiders true accounts of the Haudenosaunee peoples' history and their experience of nationhood. We also remind mainstream society that the Haudenosaunee political structure did influence Euro-American political thought, especially its notion of democracy and federalism, which influenced the American Constitution (Monture-Angus 1999, 42).

At the time of their encounter with European traders and colonizers in the seventeenth century, the "Haudenosaunee were for a time the most significant continental power in what is now the eastern United States and Canada" (Porter 1998, 809). However, as Loomba (1998) argues, the power and influence that the Haudenosaunee League exhibited when the Europeans arrived and eventually colonized North America should not be regarded as a form of colonialism. The way colonialism is to be understood herein involves more than merely an expansion of power, which the league, one could argue, also practised vis-à-vis other societies. But the effects of modern colonialism are deeper and more complex than merely an expansion of power. As Loomba (1998, 3) points out, "Modern colonialism did more than extract tribute, goods, and wealth from the countries that it conquered – it restructured the economies of the latter, drawing them into a complex relationship with their own, so that there was a flow of human and natural resources between colonised and colonial countries." More important, modern European colonialism was more distinctive and expansive than any other form of expansion of power, if one considers that eventually it ended up covering under its sphere over 80 percent of the globe while deploying different strategies and methods of control in specific locations throughout the world (Loomba 1998). As with other white-settler colonies, such as Australia and New Zealand, the colonization of Turtle Island by Europeans did alter the lives of the Haudenosaunee and other Indigenous peoples of the continent by transforming them from independent and self-sufficient peoples into "minority populations in our own lands" (Stevenson 1999, 50). Although Indigenous peoples have resisted their colonization and have succeeded in retaining some core elements of their traditional socio-political organization, their lives have been changed dramatically. However, the journey toward decolonization is currently taking place, and an insurgent Indigenous leadership committed to working to ensure their communities are self-determined is becoming increasingly visible on Turtle Island.

Encountering the "Other"

> My Forest Brave, my Red-skin love, farewell;
> We may not meet to-morrow; who can tell
> What mighty ills befall our little band,
> Or what you'll suffer from the white man's hand?
> Here is your knife! I thought 'twas sheathed for aye ...

... Curse to the fate that brought them from the East
To be our chiefs – to make our nation least
That breathes the air of this vast continent.
Still their new rule and council is well meant.
They but forget we Indians owned the land
From ocean unto ocean; that they stand
Upon a soil that centuries agone
Was our sole kingdom and our right alone.
They never feel, think how they would feel today,
If some great nation came from far away,
Wrestling their country from their hapless braves,
Giving what they gave us – but wars and graves.
Then go and strike for liberty and life,
And bring back honour to your Indian Wife.
Your wife? Ah, what of that, who cares for me?
Who pities my poor love and agony? ...

> – From the poem "A Cry from an Indian Wife,"
> by Pauline Johnson (2002), a Mohawk woman

Pauline Johnson's poem reflects the complexity and paradox that characterized the initial encounter period between Haudenosaunee nations and the European settlers of the early seventeenth century. Initially, during the sixteenth and seventeenth centuries, Indigenous people's skills and knowledge were needed in the various economic and militaristic adventures of the Europeans, yet Johnson's words correctly remind us that this relationship was never truly egalitarian and came with a high price for Indigenous peoples.

Stevenson (1999) describes the historical relationship between western Europeans and Indigenous peoples of North America and shows its different phases. Within Canada, for example, initially during the sixteenth century, French-Indigenous relations were restricted to an economic realm where Indigenous peoples were used to ensure successful fishing and fur trading. Together with the economic and survival motivations for relying on Indigenous people's skill and knowledge, the French also needed them as allies in their military adventures against the British on the "new continent" (Stevenson 1999). Even in this initial phase of contact, however, both the intention of French settlers to eventually shift the balance of power in their favour and their colonial mentality of superiority appear evident in their efforts to "Frenchify" Indigenous

peoples so as to convert them into civilized French citizens (Stevenson 1999). Similar to the French, the British initially needed Indigenous peoples in their trading expeditions, and the fur traders were not interested in establishing colonies. As Stevenson (1999, 54) points out, "initially, the fur trade was characterized by mutual exchange and interdependency. As the fur trade became increasingly entrenched, however, the balance of power shifted." As well, even if the initial relationships between the French/English nations and the Indigenous nations of North America were not as brutally violent as those between colonial powers and Indigenous nations in the southern parts of the Americas, the trading relationships formed between Europeans and Indigenous nations destabilized existing intertribal political alliances and increased intertribal warfare; ultimately, this effect also changed the ecology of the land and the way of life of the Indigenous peoples of North America (Lawrence 2002).

With respect to the Haudenosaunee League, it is important to point out that at the time of the arrival of the western Europeans, the territory that the Haudenosaunee nations held crossed the now established boundaries between eastern Canada and the north-eastern United States. In the case of the Oneida people, they "controlled some six million acres of land in what is today central New York State" (Starna 1988, 9). This reality of overlapping territorial boundaries became of crucial consequence when European nations competed with each other for economic and political hegemony on the North American continent. As Porter (1998, 810) points out, "unable to agree upon a common ally during the American Revolutionary War, it [the Haudenosaunee League] was divided and easily neutralized as a potent military threat to the newly established United States ... the Confederacy crumbled and the Haudenosaunee people scattered through what is now New York, Ontario, and Quebec."

What most marked this initial period of contact during the seventeenth century was the Two-Row Wampum, called the Kaswehnta Wampum by Oneidas, which is considered the first treaty between the Haudenosaunee League and European nations. This wampum was exchanged with Dutch traders in 1642, and another was exchanged with the British in 1677. The Two-Row Wampum was later delivered and explained, and finally recorded in a European written style, in 1664 during the proceedings of the Treaty of Fort Albany (Johnston 1986). This wampum outlines the way the respective sovereign nations were to govern in co-operation with each other. It consists of

The original Kaswehnta (Two-Row) Wampum, considered the first treaty between the Haudenosaunee League and European nations. This wampum was exchanged with Dutch traders in 1642 and finally recorded in a European written style during the proceedings of the Treaty of Fort Albany in 1664. The two rows represent the separate and sovereign paths of the Haudenosaunee League and the European nations, which were to govern in peaceful co-operation with each other. Photo taken by author in 2002 in the original Oneida territory.

two rows of purple shell imbedded in a sea of white. One of the two purple paths signifies the European sailing ship that came here. In that ship are all European things – their laws, languages, institutions and forms of government. The other path is the Mohawk canoe and in it are all Mohawk things – our laws, institutions and forms of government. For the entire length of that wampum, these two paths are separated by three white beads. Never do the two paths become one. They remain an equal distance apart. And those three white beads represent friend-ship, good mind and everlasting peace. (Monture-Angus 1999, 37)

The sacredness that for Indigenous peoples characterizes the Kaswehnta Wampum was reiterated in 1983 during a Special Committee on Indian Self-Government when a Haudenosaunee individual explained,

When your ancestors came to our shores, after living with them for a few years, observing them, our ancestors came to the conclusion that

we could not live together in the same way inside the circle ... The agreement was made that your road will have your vessel, your people, your politics, your government, your way of life, your religion, your beliefs – they are all in there. The same goes for us. (cited in Johnston 1986, 11)

In 1998 the then national chief of the Assembly of First Nations, Phil Fontaine, interpreted the Two-Row Wampum in his reply to the Canadian state's "Statement of Reconciliation." During his response, Fontaine reminded the listeners that the intention of this historic wampum was for the respective parties to "paddle their canoes in separate but parallel paths" (cited in Monture-Angus 1999, 37). Alfred (1999, 52) provides another interpretation of the Two-Row Wampum. For him, the principles within this wampum favour a peaceful co-existence between Europeans and the Haudenosaunee peoples that is characterized by respect for the autonomy and freedom of each party. Such principles, if enacted, could lead to a relationship based on peace, harmony, and justice (Alfred 1999, 52). Alfred also reports the view of Atsenhaienton, a well-respected Kanien'kehaka (i.e., a Mohawk from Kahnawake, located near Montreal, Quebec), as another interpretation of the meaning of the Two-Row Wampum in a contemporary context. For Atsenhaienton, it broadly means that the Haudenosaunee peoples are free to determine for themselves their relationships with non-Haudenosaunee peoples. This does not necessarily mean their "independence" or complete separation from other groups; rather, it implies that they and non-Haudenosaunee peoples are to share resources with each other. We need to apply the Kaswehnta Wampum to our contemporary situation and experiences by being self-determined, by having rights to our lands and resources, and by co-existing with non-Haudenosaunee peoples (Alfred 1999, 113), which could mean sharing with them some values and ideas that do make sense in our own contemporary Indigenous reality. For this to happen, however, all need to be responsible and remember that the Kaswehnta Wampum never involved any surrender of Indigenous autonomy or title to Haudenosaunee lands: the wording of the wampum clearly states, "on our part," thus emphasizing Indigenous autonomy and the two-sidedness of the relationship (Henderson 2007, 158). This component of duality is well grounded in the Haudenosaunee philosophy, after all, as "the idea that nations can be of one mind and without becoming subsumed one by other is drawn from the Kaienerekowa

principles of respect, friendship, peace and unity of mind" (Henderson 2007, 177).

In 1763 the Royal Proclamation was passed. This document, from an Indigenous perspective, reflects the relationship that ought to exist between Indigenous nations and the British Crown, similar to that portrayed by the Kaswehnta Wampum. Borrows (1997) notes that the Royal Proclamation was to serve as a foundation for maintaining the autonomy of each side of the relationship. As with the Two-Row Wampum, Indigenous nations recorded the event of the proclamation through speeches and symbols (Borrows 1997). Accordingly, the proclamation "attempted to convince First Nations that the British would respect existing political and territorial jurisdiction by incorporating First Nations understandings of this relationship in the document" (Borrows 1997, 159). Monture-Angus (1999, 34), agreeing with Borrows's analysis of the meaning of the proclamation, argues that the Royal Proclamation of 1763 ought to be considered a treaty that recognized "Aboriginal" title and the nation-to-nation relationship between Indigenous peoples and the British Crown. Yet the intentions of the Kaswehnta Wampum and the following treaties to share this land in a peaceful, respectful, and equal way were not honoured; rather, centuries of colonialism characterized the later relationship between Indigenous peoples and Euro-Canadians. During this process of colonialism, the meaning of the Royal Proclamation was transformed. Although the proclamation recognized Indigenous peoples' communal title to their lands, I would argue that it also came to be interpreted to mean that Indigenous peoples were subjects under the "fiduciary" responsibility of the Crown and that through them purchases of "Indian lands" could take place.

Nonetheless, the strength of the wampum belts is still present, as their shells, together with the words that the shells represent, still exist. Even more so, our oral history is passed on to each generation by our elders, either when they tell us stories under a tree or during the traditional ceremonies that have continued to take place despite colonial oppression. We must be thankful to our elders for continuing to teach us the stories and for keeping the wampum belts sacred, even when threatened with force and violence. Due to our elders' responsible ways of being Indigenous, these teachings have not been completely destroyed. Today, Indigenous peoples and non-Indigenous peoples have a responsibility to learn the history that contextualizes the wampum belts, a history that restores the principles that formed them.

Centuries of Colonial History on Turtle Island

We also hear your relations say, "The white race is going to extermin-
ate you." We feel that Shongwayadihs:on is very fond of His creation.
He cares even more for the red people, especially the ones that are
poor. He protects the red race from the white race. He has the power
not to allow danger to prevail. (Thomas 1994, 41)

The messengers said to Handsome Lake, "Now look and watch." They
pointed toward the east where the sun rises. So he did look that way.
Something black was coming slowly. It looked like a man coming.
The object in black was coming closer this way. The messengers
asked, "what did you see and observe?" He replied, "there is some-
thing black coming this way. It looks like a man in black clothes who
is coming." Then they replied, "It is true, you are right in the way you
observed and understood. There are missionaries coming and bring-
ing Christianity and education. So we think when they arrive they
will try to persuade your people to accept their religion and that is
going to cause many different opinions among your people. So this
will happen when they arrive. So now the chiefs should encourage
your relations and warn them to be cautious about this important
matter and not to accept it." (Thomas 1994, 91)

These quotations from *Teachings from the Longhouse,* by the late Chief
Jacob Thomas of the Six Nations, highlight the dangers that confronted
Haudenosaunee peoples and other Indigenous societies in Canada after
the development of colonial relations. These dangers were present in
the forms of imposed religion, unequal distribution of power, dispos-
session of lands, and cultural genocide. What is colonialism? How can
one best describe and define this practice that has had so much impact
on different groups of people in lands such as Canada, the United States,
Mexico, Australia, and New Zealand? Many definitions of "colonialism"
have been provided by scholars. To begin with, one can search the Web-
ster dictionary (1997, 133) for the commonsense definition that coloni-
alism is "the system or policy by which a nation seeks to extend or retain
its authority over people or territories." Without a doubt, such a brief
definition cannot suffice to explain the multitude of ways that settler
nations came to assert their authority over the Indigenous peoples who
occupied the territories that were colonized. The word "colonialism"

comes from the Latin root "colonia," which means "farm settlement" and which originally referred to Romans who settled in other lands but retained their Roman citizenship (Loomba 1998, 1); therefore, in the Webster dictionary (1997, 133) the word *colony* is defined as "a group of people who leave their native country to form in a new land a settlement subject to, or connected with, the parent nation." However, as Loomba (1998) argues, such a definition neutralizes colonialism's adverse effects on the territories and peoples against which it exercised its power. In practice, colonialism contained forms of conquest and domination, and it did not follow identical processes in all parts of the world (Loomba 1998). Therefore, colonialism should be understood as the conquest and control of other people's lands and resources by a powerful nation.

In the context of the lives of the Indigenous peoples of North America, colonialism takes on a particular meaning. Its modern form can be distinguished from earlier forms by the fact that the modern form was an expansion of European over non-European powers and that, in addition to extracting goods and wealth from non-European societies, it also "restructured their economies, drawing them into a complex relationship with their own, so that there was a flow of human and natural resources between colonised and colonial countries" (Loomba 1998, 3). Moreover, these "flows and profits and people involved settlement and plantations as in the Americas, trade as in India, and enormous shifts of populations" (Loomba 1998, 4). Ultimately, this modern colonialism produced the economic imbalance that was necessary for capitalism to grow and flourish. As I stated earlier, a remarkable feature of modern colonialism was that approximately 80 percent of the globe came under the domination and control of western European powers. Given the enormity of the colonial phenomenon, colonialism was obviously an imperialistic project. Similar to Loomba's (1998) definition of modern colonialism, Stevenson's (1999) well-articulated definition represents the historic situation of colonized Indigenous peoples. Whereas Blauner (1987, 157) defines "classical" colonialism as a practice that occurs when metropolitan nations establish new territories, which is "distinguished by economic exploitation, forced entry, and cultural imperialism through the imposition of new institutions and ways of thought," Stevenson further qualifies the specific nature of colonialism that took place in countries like Canada and other American nations, Australia, and New Zealand. In these specific places of the world, a concept of "Fourth World" best defines the processes of colonialism. Fourth World colonialism is

the process by which Indigenous peoples became the minority popula-
tion in their own territories, lost political power, became economically
exploited, and were culturally defined as inferior. Fourth World colonial-
ism is practised "within nation-states that make little or no provision
for the exercise of rights beyond those provided by legislatures in the
form of citizenship" (Stevenson 1999, 50).

In the case of white-settler colonies like Canada, we must understand
that race, colonialism, and imperialism/capitalism are inseparable, as
"doctrines of racial superiority evolved in response to the needs of an
expanding European empire" (Wallis and Fleras 2009, xv). Having con-
structed an idea of Indigenous peoples as an inferior, uncivilized Other,
Europeans were able to justify their pursuit of expansion of territories,
accumulation of wealth, and global economic dominance by treating
"Native lands" as undeveloped and "Natives," to whom they could bring
"enlightenment," as not being progressive like Europeans. Hence, in this
period of our history, "with imperialism, various European nations ...
assumed an inalienable right to conquer, colonize, and exploit overseas
territories" (Wallis and Fleras 2009, xvi). In other words, the intersection-
ality of racism, colonialism, and imperialism resulted in the theft of land
from Indigenous nations (Lawrence 2002), which means that we must
challenge the notion that colonialism was at all benign. In sum, the
characteristics of both modern colonialism and Fourth World colonial-
ism best apply to the type of colonialism experienced by Oneida and
other Indigenous nations of North America. It is of crucial importance
to rewrite the history of Canada with a focus on how the theft of In-
digenous peoples' lands and other racialized forms of violence are linked
to imperialism and were vital to the foundation of the Canadian nation-
state, despite the desire of some to view Canadians "as a fundamentally
'decent' people innocent of any wrongdoing" (Lawrence 2002, 23).

Hawaiian Indigenous scholar Poka Laenui (also known by his Angli-
cized name Hayden F. Burgess), drawing on his own experience as an
Indigenous individual and consistent with the scholarship of Virgilio
Enriques, argues that colonization is both a social process and a political
one. As a result, it is characterized by different processes, including denial
of Indigenous peoples' cultures as being socially valuable, destruction
of the physical elements of their cultures, denigration and belittlement
of their traditional practices, tokenistic tolerance of their cultural re-
mains, and the transformation of any surviving parts of their cultures
that can be accommodated within the mainstream cultures (Laenui

2000, 252). Similarly to Laenui, Loomba (1998, 24) also speaks of the intellectual and cultural dimensions of colonialism, arguing that an analysis of colonialism must contain an understanding of the relationship of culture and ideology to the material aspect of colonialism. In this understanding, one must investigate, for example, the ways that colonialism changed the cultures of the colonized through coercion and domination but at times also through partial consent (Loomba 1998, 31). In summary, then, colonialism must be analyzed by "examining the intersection of ideas and institutions, knowledge and power" (Loomba 1998, 54).

The impact of colonialism on Turtle Island can be considered from several angles. To begin, the physical consequences include the dispossession and displacement of Indigenous peoples. The mental consequences include those arising from the misrepresentation of Indigenous cultures. The emotional consequences include the effects of internalized colonialism on Indigenous peoples' emotional wellbeing. Lastly, the spiritual consequences involve the transformation of Indigenous spiritual traditions due to Christianization and other assimilation policies, such as residential schools, that were intended to break the spirit of Indigenous peoples and to sever their relationships with the Creator and with all of creation. In this chapter, each of these realms of colonialism is dealt with in relation to the nation-building project of "Canada," which was originally constructed as an imagined white nation, whose "Natives" were constructed as Others (Mackey 2002). As Miles (1989) points out, representations of these culturally different Others led to a construction of "races" that linked cultural differences to perceived biological and physical differences. It was during the time of modern colonialism that scientific discourses of "race" became predominant in order to explain arbitrarily perceived differences and to provide "objective" evidence that race was real, natural, and inherent (Miles 1989, 70). The process whereby social relations between people became structured by attributing significant meaning to human biological and physical characteristics is referred to as racialization. This process helped to categorize colonized peoples as "races" that were "naturally different" from the colonizers. Of course, this categorization was never neutral but was closely linked to the formation of the unequal social and economic power relations inherent to colonialism. The constructed concept of "race" helped to justify the colonization of those "races" that were viewed as naturally inferior to the "civilized races."

The material changes that occurred in Indigenous nations of eastern Canada began in the nineteenth century. This period can be classified as one marked by domination and control over the lands of Indigenous peoples and by a transformation of their economic system from a communal to a capitalist one (Lawrence 2002; Wotherspoon and Satzewich 1993). Distinguished from the earlier period of semi-equal co-operation that existed between European traders and Indigenous peoples, this particular phase witnessed European settlers' negative view of Indigenous cultures and social organization, which they saw as impediments to the nation-building project and to their intent to establish a capitalist economy on the land (Stevenson 1999; Wotherspoon and Satzewich 1993; Mackey 2002). Given that the success of establishing first an agricultural economy and then a capitalist one depended heavily on acquiring vast amounts of land, this meant that a series of practices of dispossession had to be implemented. As Porter (1998, 891) points out, "with the loss of almost all lands and military capacity by the beginning of the nineteenth century, the Haudenosaunee people [as well as other Indigenous peoples] were virtually defenseless against the onslaught of cultural, social and economic change that was to follow."

The dispossession of lands during the colonial project went along with an attack on Indigenous knowledge. As Simpson (2004, 377) states,

> When Indigenous Nations were an obstacle toward establishing European sovereignty over Indigenous lands, the foundation of Indigenous Knowledge was attacked by the invading culture as a mechanism to annihilate Indigenous nations and assimilate Indigenous Peoples ... Our knowledge comes from the land, and the destruction of the environment is a colonial manifestation and a direct attack on Indigenous Knowledge and Indigenous nationhood.

But it is important to remember that this attack is still going on in the twenty-first century, as the environmental destruction of Indigenous territories in the pursuit of "profitable" capitalist development projects are threatening the capacity of Indigenous peoples to live and practise their Indigenous knowledge, which is deeply rooted in the land. When lands are attacked, whole communities are attacked since Indigenous peoples' cultures and philosophies are based upon the principles of natural law, which confirm the interconnectedness between all relations. Hence "to recover Indigenous Knowledge, Indigenous Peoples must

regain control over their national territories, and they must be self-determining particularly when it comes to land" (Simpson 2004, 379).

The dispossession of lands was justified by the colonizers' assertion of the terra nullius mythology, which maintained that the lands that they were to possess were empty. However, this notion of emptiness could not be easily believed since Europeans had found original occupants in the "New World" and had traded with them as well as engaged them in military activities. Thus a reimagining of emptiness was necessitated. In practical terms, the myth was expanded to imply that "non-European people are empty, or partly so, of 'rationality' – that is, of ideas and proper spiritual values" (Henderson 2000, 61). This part of the myth included the idea that Indigenous peoples were mobile, nomadic people – with no claim to territory (in European terms), no understanding of private property, and hence no property rights – and that they were to be "improved" by the introduction of European ideas and systems (Henderson 2000). Mackey (2002, 14) makes an insightful contribution to the terra nullius myth, arguing that in the Canadian case, "the construction of Canada as a terra nullius is not consistent ... Canada's mythologised kindness to Aboriginal people was an important element in developing a national identity based on the notion of difference from the USA." However, it is important to emphasize the mythologized character of such "tolerance" and "kindness," which "coexisted with brutal policies of extermination and cultural genocide" (Mackey 2002, 14).

The Canadian state's establishment of reserves, the pieces of land "reserved" for use by "Indians" – initially enacted through the 1857 Act for the Gradual Civilization of the Indian Tribe and the 1859 Civilization and Enfranchisement Act and then reaffirmed in the Indian Act of 1876 – facilitated the removal of Indigenous nations to small restricted lands, where they could be under the control of colonial agents. Reserves became a new reality that also shaped a new formation of Indigenous identity that still lingers in Indigenous lives today. Whereas before colonization Indigenous notions of national identity were derived from traditional teachings and oral traditions (e.g., the KayanlʌhslaꞋkó, or Great Law of Peace), the colonial legislation imposed by Euro-Canadians on Indigenous peoples instituted a racialized and essentialized identity. This "Indian" identity was associated largely with reserve residency, something that, as Monture-Angus (1999, 9) argues, must be recognized as foreign to an Indigenous way of being and must be seen as a colonial construct. Simpson (2000, 126) elaborates on this point, stating that

even today "it is through the provisions of the Indian Act that ... those Indians belonging to reserve communities in Canada, receive their right to reside on reserves ... Their names appear on a federal registry of Indians in Canada as well as a band-controlled registry that accords them the rights of status Indians in Canada." Hence each Indigenous nation originally had its own definition of national and cultural identity, which was tied to one's affiliation with a clan acquired through either a male line, as in the case of many Anishinaabe societies, or a female line, as in the case of the Haudenosaunee peoples. Also, a person could be adopted into a nation if so desired by the persons entrusted with such adoptive practices. In the case of the Haudenosaunee, this responsibility rested with the Laothuwisʌ'tsla?, or clan mothers. However, under the Indian Act, one's registration as a member of an "Indian" band was instituted through a very essentialist discourse of identity based on blood quantum, a phenotype physiology, and an assumed "Indian" lifestyle tied to a reserve-based residency. All of these categories served the purpose of establishing very rigid boundaries for Indigenous cultural and national identities, boundaries that still linger in many present-day Indigenous communities. We must keep remembering that such laws are far removed from any Indigenous traditionalism, in that "traditional culture sought to include as many people as possible ... [whereas] governmentally created elites erect false walls of caste and 'blood.' This behaviour is not the measure of Indian authenticity but, I regret to say, the seal of collaboration with colonialism" (Mann 2008, 88).

I now turn my attention to the mental dimension of colonialism's consequences for Indigenous peoples, looking at the intellectual construction of "Indianness" and at the impact of policies of assimilation such as the Indian Act on Indigenous societies.

The colonial project in the "New World" could not have evolved as it did if it had relied exclusively on transforming the material reality of Indigenous peoples. Indeed, the colonization of what is now called North America involved a process of colonizing the mind of both the oppressors and the oppressed. As Said (1978) has eloquently demonstrated, Western colonizers relied on their construction of a binary representation of "us" – meaning the Western civilized nations – and the Other. In this construction, two opposite "races" came to exist. Whereas the "white race" was constructed as civilized, refined, intellectually superior, and at a higher level in human evolution, the "Natives" were seen as savages, uncivilized, inferior, and always opposed to what the Western "self" was.

Maori scholar Linda Smith (1999) argues that in this binary construction, the "Natives" lost their humanity, meaning that "ideas of what counted as human in association with the power to define people as human or not human were already encoded in imperial and colonial discourses ... In conjunction with imperial power and with 'science,' these classification systems came to shape relations between imperial powers and indigenous societies" (Smith 1999, 25). Another Maori scholar has elaborated on this point, arguing that "in the nineteenth century, the 'us and them' mentality mutated into the concept of an upper and lower race. Racism sanctioned a discourse of purification based on biological differences; it legitimated the hierarchy of power, and consequently, justified violence directed towards the Other" (Hokowhitu 2002, 24).

In eastern Canada, where Oneida and other Haudenosaunee nations are located, once Indigenous people's labour and knowledge were no longer needed for the economic activities of the European traders/settlers, the basis for representations of Indigenous peoples changed from a view of their "differences" that was positive and tolerant to a view that was negative and disparaging (Mackey 2002). By the nineteenth century, the stereotype of Indigenous peoples as savage and sexually promiscuous became predominant, as did policies to encourage their "civilization" (Stevenson 1999). The initial intellectual proliferation of this racist discourse was greatly influenced by the early stories of missionaries and travellers. In diaries and letters sent back to their homelands, they described Indigenous people as "children," "foolish," "depraved," and "filthy in the extreme" (Wotherspoon and Satzewich 1993, 16). By the mid-nineteenth century, a paternalistic attitude toward the Indigenous population of Canada was well ingrained in the colonial mindset, and the Indian Act of 1876, a consolidation of previous statutes, served only to further justify and enable the colonizers to control every aspect of Indigenous life.

The Indian Act gave the Canadian state jurisdiction over the administration of affairs on the established reserves. Above all, it defined unilaterally who was an "Indian" under the Act: "The term 'Indian' means: first, any male person of Indian blood reputed to belong to a particular band; secondly, any child of such person; thirdly, any woman who is or was lawfully married to such person" (c. 18, s. 3[3]). Until the most repressive components of the Act were removed through amendments in the late twentieth century, this piece of legislation provided the state with the tool to deny Indigenous peoples the right to practise

traditional ceremonies, to assemble in large groups, to leave the reserves without the permission of an Indian Agent, who was nearly always a white person, and to vote in federal elections. Of a peculiar nature was the stipulation that if an "Indian" obtained postsecondary education, he or she became an enfranchised Canadian citizen and lost Indian status. This obviously implied both that having a higher education was contradictory to being "Indian" and that such a person would welcome this path to assimilation and "civilization" (Stevenson 1999).

Indigenous women were particularly affected by the traits that Europeans attributed to them and by the policies that followed such representations. Most Indigenous women, especially those who lived in matrilocal and matrilineal societies like those of the Haudenosaunee nations, enjoyed a relatively egalitarian status in their societies prior to their colonization by Europeans. In fact, "as women, they once had all the rights and powers that American women today are struggling to obtain, including economic and political power; spiritual equality; the right to proper health care, up to and including abortion on demand; the right to divorce on demand; and the right to call – and call off – war" (McGowan 2008, 65). However, their situation was quite altered by the forces of colonialism that shaped their lives for several generations, and today we find alarming statistics to demonstrate this: "Native women find themselves at high risk for health-related problems from diabetes, heart disease ... [and they have] been sterilized without their consent ... Whereas the average life expectancy for Euro-American women is eighty-one years, Native American women can expect to live little more than half of that, or fifty-two years" (McGowan 2008, 66). Moreover, Indigenous women in Canada are at an alarming risk of being targets of all forms of violence, as shown in the case of the over five hundred missing/murdered women highlighted in the Amnesty International Report on Canada's "Stolen Sisters" (2004). As Beverly Jacobs, past president of the Native Women's Association of Canada, reminds us, "everyone should know that the negative issues of the poverty, alcoholism, drug addiction and the cycle of violence can be traced back to Canada's policies. We can even trace the issue of the missing and murdered Aboriginal women to the residential school system" (Jacobs 2008, 224).

The first indications of colonial representations of Indigenous women can be traced back to accounts of the ways Indigenous women corresponded, or not, to an ideal of womanhood that existed in Europe at the time European settlers came into North America and projected their

ideas onto Indigenous societies. This ideal of womanhood, which has been labelled the "cult of true womanhood" (Riley 1986, 68), associated appropriate female status and behaviour with the domestic sphere, where women were subordinated to men and characterized by "virtues of piety, purity, submissiveness, and domesticity" (Stevenson 1999, 55). This Victorian ideal of womanhood was seen as proof of civilization, whereby European women had been "liberated" of their burden of hard public labour and could now reserve their labour for a docile, feminine role (Stevenson 1999). In contrast, Indigenous women, at the time of European arrival, were not constrained to the domestic sphere; they shared economic and political responsibilities with men within their societies. Hence Indigenous women, judged according to European standards of morality and womanhood, were portrayed as "squaws," as "savages," or as being burdened by the physical demands imposed on them (Stevenson 1999; Acoose 1995; Lavell-Harvard and Corbiere-Lavell 2006).

As Stevenson (1999) points out, Indigenous women suffered the contradictions that marked the slippery stereotype of savagery. They were portrayed either as squaw drudges, an ugly, unfeminine, dirty, sexually promiscuous entity, or as noble princesses, such as the popular Pocahontas, who were virginal, pure, childlike, and submissive both to Indigenous men and, more important, to European patriarchs. Moreover, these characterizations were intertwined with racist ideologies of colonialism, connecting the representations of Indigenous women with the portrayals of their "races," which depicted all Indigenous peoples as inferior beings who came close to achieving the status of "good" Europeans only when they adopted their values and were docile to Europeans (Stevenson 1999; Acoose 1995; Ouellette 2002; Lavell-Harvard and Corbiere-Lavell 2006).

In the pursuit to cleanse Indigenous women of their savagery, missionaries played a great role, first by negatively interpreting women's liberty and authority and then by attempting to change the assumed gender relations of Indigenous societies so that they paralleled the patriarchal relations of their European counterparts (Stevenson 1999). Christian teaching and attempts at conversion were put into place, although both were resisted by many Indigenous women, who quickly recognized the losses they would endure if such programs were successful; they saw no gains in becoming more monogamous, or abandoning divorce practices, or giving up their right to hold land and manage its use (Stevenson 1999).

The deterioration of Indigenous women's status was accomplished by statutory regulations imposed by the Canadian state through various Acts. In 1867 the British North America Act gave the Canadian state jurisdiction over the administration of Indigenous peoples and their affairs. In 1869 the Lands and Enfranchisement Act defined who an "Indian" was in a very oppressive and restrictive way, introducing the criteria of blood quantum and the patrilineal principle that a person was an Indian only if his or her father or, in the case of a woman, her husband was a registered Indian (Stevenson 1999, 67). Therefore, sexism against Indigenous women was fully institutionalized by the Canadian state. For matrilineal societies such as those of the Haudenosaunee nations, where membership in the nation was based on affiliation with a clan and transmitted through a female line, this translated into a complete change of social organization that had impacts on gender relations.

In 1876 the Indian Act reaffirmed this patrilineal principle by stating that an "Indian" was any male person of Indian blood, or any child of such a person, or any woman married to such a male person (c. 18, s. 3[3]). In 1951 sexist changes to the Indian Act had even further implications for Indigenous women. Specifically, it terminated the Indian status of Indian women who married non-Indian men and prevented these women from passing Indian status to their children (c. 29, s. 12[1][b]). As Gehl (2000, 64) argues, what this "type of policy did was subjugate women to the status of chattel to their husbands. It stripped women of their rights socially, politically, and economically and made them dependent people." Voyageur (2000) similarly argues that the Indian Act officially discriminated against Indigenous women by assigning them fewer rights than men. In practical terms, these discriminatory policies meant that Indigenous women could not fully participate in the political and cultural activities of their communities, as they lost the right to live on reserves, to vote in them, and to own land.[5]

Hence, as Monture-Angus (1995) points out, Canadian law is a central focus of oppression for Indigenous women, and the patriarchal nature of relations within their communities is directly related to the racist and sexist colonial practices imposed on them by the Canadian state. As I have argued elsewhere, "in order to fully understand how patriarchy works in Canada, we must look at the oppressive role that the Canadian state has had, and continues to have, in the everyday lives of Aboriginal women" (Sunseri 2000, 146). The legacies of such oppressive colonial policies still persist in the way gender relations are presently structured. As Monture-Angus (1999, 32) states, "the spirit of colonialism now also

sadly vests in some Aboriginal people and Aboriginal organizations." Division and oppression within our own communities are living reminders that the negative consequences of colonialism are embodied in the material reality of the everyday lives of Indigenous nations. Some of the divisions that do exist are between men and women in respect to what constitutes "traditional" gender roles; conflict also exists between groups that are following the system of elected band councils and those that want to re-establish a traditional government; and conflict exists over the issue of extending band membership to urban Indigenous individuals or to people of mixed ancestry. These are just some of the pertinent divisive elements that are present in many communities, making the decolonization project quite complex, as the women who took part in my study pointed out to me.

The attempt to break down the spirit of Indigenous peoples was supported by the establishment of residential schools run mainly by Christian churches and approved and legislated through the Indian Act. To get rid of the "Indian" living within the child and thereby assimilate Indigenous children into mainstream Euro-Christian society, these schools were maintained until the 1980s. Coerced by force, children were removed from their families and often put into schools far away from their original communities. Once in these schools, the children were forbidden to speak their languages, their long hair was cut to conform to European standards of civilization, and they were forbidden to practise any of their traditions and made to feel ashamed of their "Indianness." Many of these children didn't return to their families; of those who made it back, many no longer fitted as easily into an Indigenous lifestyle. As these "laboratories" were never intended to successfully integrate Indigenous children into Canadian society anywhere other than among the labouring classes, they were given very little academic training; rather, the boys were instructed in menial physical labour and the girls in domestic work (Coates 1985; Barman, Hebert, and McCaskill 1986; Haig-Brown 1988; Monture-Angus 1995, 1999; Stevenson 1999; Anderson 2000; Hodgson 1992).

The effects of residential schools are still being dealt with in contemporary life. When the children became adults and were released from the schools, they were left with tremendous emotional, physical, and spiritual scars. They had not learned healthy parenting skills, they had internalized racist and sexist practices, they had learned self-destructive behaviours in the course of attempting to deal with their painful reality, and they often projected their pain onto their fellow family and com-

munity members. "This terror of residential schools is not a terror of the past alone; it constantly recreates itself and continues to transform Aboriginal communities. The loss of parenting skills in one generation, for example, impacts on generation after generation until the loss is fully addressed" (Monture-Angus 1999, 24). Another example of the legacy of residential schools was domestic violence, where power became intertwined with or misrepresented as love, shaping the experiences of those children and of the generations that followed. This cycle of violence is indeed connected to the violence that the Canadian colonial state and its apparatuses transmitted to Indigenous peoples. This is not to excuse the violence inflicted by some Indigenous individuals on themselves and others but rather to better understand its true roots so that proper healing can occur and healthy ways of relating can be re-established. The spiritual violence that colonialism has inflicted on the Indigenous population over the centuries will take considerable effort to overcome, and the process of decolonization, which recognizes the multiple layers of colonialism and strives to achieve Indigenous self-determination, is the road that has been taken by many Indigenous peoples in Canada and elsewhere.

Processes of Decolonization

I thought a lot in the last few years how to create change in First Nations communities. I know that in many Aboriginal communities, from reserves to urban enclaves, Aboriginal people have been surviving a number of traumas. Despite this, I do not think that change is that difficult to come by. I am influenced by the teaching of my friend, Leroy Little Bear. Leroy teaches that change will come out of the flux. Flux is a softer word, as I understand it, for chaos. This makes a lot of sense to me. Colonialism is about, among other things, controlling the lives of the individuals who comprise the people. When, for generations, a people have been controlled, their ability to make decisions and advance change is impaired. In order to shake up our communities and get them thinking as communities again, relying on themselves instead of bureaucracies, all that needs to be done is to shift the pieces so the "common" answer, depending on the colonizer, is no longer available. It is out of this chaos, that the change will come. I am quite certain that this is a gift brought to the people with the return or continued presence of the trickster. (Monture-Angus 1999, 160)

I too believe that although colonialism has controlled the lives of most Indigenous people for many centuries, the time has come for changes that will ensure their freedom to determine how they are to govern their communities and will end their dependence on an imposed Euro-Canadian system.

I understand decolonization to mean that process by which colonial relations between Indigenous peoples and, in the case of Canada, the Canadian state and mainstream society are interrupted and new relations are built that recognize the Indigenous right to self-determination. The damage done to Indigenous peoples due to centuries of oppressive assimilation policies has been recognized, at least on paper and in some public speeches, by Canadian political leaders, like the apology in June 2008 by the state in the House of Commons to Indigenous peoples of Canada for the establishment and abuses of the residential schools. However, transforming these words into practice still requires much effort, dialogue, and planning by both Indigenous and non-Indigenous individuals and institutions.

Laenui (2000) suggests some phases that might occur during the process of decolonization. The first step involves Indigenous peoples' rediscovery and recovery of their history and cultural traditions. Colonization included attempts to destroy Indigenous cultures and to inculcate in the people of those cultures a feeling of inferiority. Thus rediscovering one's traditions and ways of governing is quite difficult and requires a great deal of effort and action. But, as Laenui (2000, 153) argues, "this phase of rediscovering one's history and recovering one's culture, language, identity, and so on is fundamental to the movement for decolonization." This chapter, which begins with a review of the formation of Haudenosaunee culture, can be argued to be a manifestation of this first step. Mourning is the second step in the process of decolonization. This step acknowledges that Indigenous peoples need time in the process of healing to mourn their victimization by expressing their anger in many forms, such as through art or protest. However, Laenui (2000, 155) warns that caution must be exercised so that "people don't get stuck in the awfulizing of their status as victims." Laenui argues that dreaming, the third step, is the most important part of decolonization. This phase takes place when Indigenous peoples "explore their own cultures, experience their own aspirations for their future, and consider their own structures of government and social order to encompass and express their hopes" (Laenui 2000, 155). This step might need some time to fully develop because, as Monture-Angus notes in the

quotation that begins this section, colonialism has meant that the ability of Indigenous peoples to decide on their own course of development and change has been impaired. For decolonization to happen, Indigenous peoples need to re-evaluate current political, social, and economic structures, identifying those that need to be changed if they are to be culturally relevant and empowering for Indigenous communities. Non-Indigenous people need to respect this process of re-evaluation, to become allies in the process of decolonization, and to see Indigenous rights as a *sui generis* form of group rights and not merely as a class of minority rights (Turner 2006, 31). Steps for a practical process of decolonization must be formulated. Once plans are formulated and consensus is reached, action can finally be taken to make the changes that will achieve decolonization. Laenui argues that the steps toward decolonization are not as linearly demarcated as they appear in this written form, as circumstances determine the order of each step and and the space between them. Often one step might have to be revisited, and sometimes action might be taken earlier in cases of urgency (Laenui 2000, 159).

Overall, decolonization means that there must be a commitment to removing the systemic oppression of Indigenous peoples that still exists; it also means that "Canadians must learn to live free of false assumptions of superiority" (Monture-Angus 1999, 35). Of course, one must be careful not to overgeneralize by regarding all the non-Indigenous peoples who exist in contemporary Canadian society as having experienced inclusion in the category of "superior" Canadians. Historically, not all peoples who came here to settle enjoyed the same sense of superiority, nor were they all equally positioned within the socio-economic structures of Canada. Many groups, such as African slaves and their descendants as well as Asian labourers, came by force or because of their need for economic survival, and the host society viewed and treated them as inferior.

A part of the mindset of superiority that privileged Canadians have historically possessed is the fear that Indigenous self-determination might mean a loss of territorial sovereignty for the Canadian nation-state. This fear includes the feeling that Canadian national identity will be challenged. As Monture-Angus (1999) argues, this fear is based upon an assumption of territoriality strongly derived from a Western epistemology. Within this notion, sovereignty is understood to mean "individualized property rights" (Monture-Angus 1999, 35). An alternative notion would be one that views sovereignty as "really a question of identity

(both individual and collective) more than a question of individualized property rights. Identity, as I have come to understand it, requires a relationship with territory (and not a relationship based on control of that territory)" (Monture-Angus 1999, 35). This notion is very much interconnected with an Indigenous philosophy, which maintains that people do not own land as property but are simply a part of creation, being users and caregivers of the land and spiritually related to it, as land is our Mother Earth. Within this context, then, the relationships one has with land, resources, and people are based not on exclusive possession but on a spiritual and sacred connectedness with "all relations," where respect, reverence, and reciprocity are the central values (Dannenmann and Haig-Brown 2002; Little Bear 2004). "On the land [are] many sacred places and sites where religious ceremonies, both tribal and individual, [are] conducted. The land, in addition to the plant and animal life it supports, provides sites for vision quests ... sacred rocks for medicine wheels and sweatlodges" (Little Bear 2004, 33). Therefore, a capitalist attitude toward land, which treats land as though it existed for the sole purpose of profit and private ownership, is contrary to a traditional Indigenous philosophy (Dannenmann and Haig-Brown 2002). Sovereignty ultimately demands that as Indigenous peoples we communally take care of our lands and all the species living on them. "This Aboriginal definition of sovereignty is a definition which is about responsibilities and not just rights" (Monture-Angus 1999, 36). This definition is quite different and separate from the one found in European traditions and discourses, where "sovereign" meant the "king, or the sovereign, [who] was thought to have inherited the authority to rule from God" (Barker 2005, 138). Later, in European discourses, the concept of sovereignty was applied to mean that "individuals possessed rights to personal freedoms that informed their collective rights to rule themselves as nations. In other debates, sovereignty was linked to the 'law of nations'" (Barker 2005, 2), but this right was tied only to the peoples of Euro-Christian civilizations, who perceived themselves as having reason, progress, and civility: "Nations possessed the full measure of sovereignty because they were the highest form of civilization" (Barker 2005, 2). Given that the Eurocentric definition of the term "sovereignty" is now the accepted one, I must clarify that my Indigenous usage of the term is quite different from the European usage.

Aspiring to Indigenous sovereignty, therefore, does not necessarily mean aspiring to national separation and independence. As Morris (1992,

145) argues, because of its practical difficulty, many Indigenous nations might not opt for a separatist choice but rather would prefer a type of autonomy in some areas of governance and an overlap of authority in others. Alfred (1999, 59) argues that as it is currently defined, the term "sovereignty" is neither consistent with the needs of Indigenous peoples nor beneficial to them because sovereignty "is an exclusionary concept rooted in an adversarial and coercive western notion of power." Alternatively, allowing Indigenous peoples only a small amount of autonomy and providing some monetary compensation for past wrongs is not a truly liberatory form of decolonization (Alfred 1999, 60). In these cases, the authority of the Canadian state over the management and control of the terms of decolonization is not fully challenged, and Indigenous peoples are still viewed and treated (and in turn treat themselves) as inferior, as "wards of the state."

In the dreaming phase of decolonization, dialogue about what decolonization means ultimately involves the difficulty of reconciling diverging views of self-determination and of how Indigenous people can re-establish traditional ways of governing that both reflect today's realities and help to repair the disunity that has occurred through colonialism. For some, practising a form of "self-conscious traditionalism" might be a useful method of achieving such goals. This approach would mean that "to be Native today is to be cultured: to possess culture, to exercise it, to proclaim it, to celebrate it. But we cannot have just any culture; it has to be 'traditional' culture – defined, isolated, reflected upon, relearned, and then perfected" (Alfred 1999, 66). This form of traditionalism involves a rejection of colonial premises and structures; it also requires a commitment to reconstructing traditional communities, to relearning Indigenous teachings and selecting those that are still relevant in today's world, and to establishing a form of government that is more in synchrony with an Indigenous way of being (Alfred 1999). This approach furher means (re)building an Indigenous warrior ethic, which would strive to "restore connections severed by the colonial machine ... evoking cultural and spiritual connectedness in this land and the Onkwehonwe struggle for justice and freedom, and the political philosophy and movement that is fundamentally anti-institutional, radically democratic, and committed to taking action to force change" (Alfred 2005b, 45).

Of course, this form of decolonization must recognize that cultures are not static entities; that Indigenous cultures, like others, have changed, often unwillingly; and that Indigenous identities are no longer – if they ever were – bound to essentialist criteria. Due to social, material, and

economic forces, contemporary Indigenous identities are complex, and efforts must be consciously made to ensure that "traditional" governance does not merely mimic colonial systems and practices. It is not sufficient merely to put "Indian" faces and clothing on new leaders; rather, leaders must remember the foundation of leadership, nationhood, kinship, and so forth if they are to contribute to establishing more just and peaceful decolonized Indigenous nations. As Monture-Angus (1999, 35) argues, we must not become frustrated on the challenging road ahead but must remember that "there are no immediate or simple answers. The commitment required involves understanding that change will come in small steps, much like a young child learning to walk. Final solutions cannot be fully articulated as the walk has just begun."

Women, Nation, and National Identity: Oneida Women Standing Up and Speaking about Matters of the Nation

My commitment to giving a respectful space to the words of the women who participated in my research for this book is reflected not only in my inclusion of their voices throughout the book when relevant to specific themes and concepts but also in this chapter's almost exclusive focus on the discussions we had together. I asked them specifically how they wanted this book organized and how they wished to have their voices integrated herein. As I worked through the revision stages of the book, it made sense first to contextualize their experiences by having a theoretical discussion of the link between women and nation and then to look at how the women themselves saw that relationship vis-à-vis the existing theories. This approach was chosen by almost all of them, only a few having no preference. Through their narratives, one can see that these women recognize the complexities and paradoxes embedded in being Oneida women. They walk toward a decolonial future aware that only when the powerful spaces that their female ancestors enjoyed are reclaimed can a free and just nation be truly rebuilt.

Linking Women, Nation, and National Identity

Some feminist theories have been useful in showing how the work of earlier male/mainstream theorists of nation and nationalism is andro-centric. Despite the various ways that women have always participated in nationalist movements, their presence has been made invisible in the mainstream theorizations of nation and nationalism. Moreover, these theories have also ignored that nationalisms are gendered through the silencing of women's experiences, as well as, perhaps more crucially, the ways that women have been influenced by and in turn have influenced nationalist projects. In correcting the male bias of previous theorists of nation and nationalism, Anthias and Yuval-Davis (1989),

Yuval-Davis (1997), and Yuval-Davis and Stoetzler (2002) illustrate the various ways in which women have historically participated in nationalist processes in their roles as biological reproducers of the collective, as reproducers of ethnic and national boundaries, as transmitters of culture, as symbolic signifiers of national differences, and lastly as participants in nationalist struggles. In a somewhat positive way, it can be argued that during some nation-building processes, especially those involving a nationalist liberation campaign against imperial and colonial states, women have been strong agents of change and sometimes have become empowered through these processes. Abdo (1994), for example, shows how Palestinian women have been very instrumental in the struggle against Israeli occupation, and this involvement has given them a chance to voice their specific issues as women in the Intifada movement. Jayawardena (1986) has examined how in the "Third World," in the context of resistance against imperialism and colonialism, women linked their specific issues as women to those of national resistance, as in the cases of India, Indonesia, Turkey, and Egypt. Throughout her overview of the different nationalist struggles that occurred in these formerly colonized (or imperialized) locations, Jayawardena (1986) examines how the women participated with their male counterparts in these struggles by organizing and joining demonstrations, by becoming freedom fighters, and by participating in peasant and labour movements. Most of the nationalist discourses of these national liberation movements included "modernizing women" among their principles (Jayawardena 1986, 12) because the status of a "liberated" woman could be seen by others, especially the colonial masters, as a marker of civilization and progress, thereby reinforcing the nationalists' assertion of sovereignty by rendering insupportable the ideology of inferiority and savagery that justified colonization (Jayawardena 1986).

Additionally, one can look at the Algerian War of National Liberation and see how women's participation was both needed and crucial for its success. Bouatta (1994) discusses how women were involved in the war as nurses and fighters, popularly known as *moudjahidates,* the term used for militant women fighters during Algeria's war of resistance against the colonial state. Fanon (1965) argues that Algerian women were indeed instrumental in masking arms and messages under the veils that concealed their bodies. He notes that since the colonizers of Algeria perceived the veiled Algerian woman to be the symbol of nativism, of uncivilized "native" men oppressing their women, they aimed to "defend this

woman, pictured as humiliated, sequestered, cloistered ... After it had been posited that the woman constituted the pivot of Algerian society, all efforts were made to obtain control of her" (Fanon 1965, 37). Fanon argues that during the nationalist liberation struggle, both the unveiling and the veiling of Algerian women were turned by the colonized into effective forms of resistance. In the first instance, the colonized used to their advantage the colonizer's mindset that the unveiled Algerian constituted a "Westernized" woman who was thankful to the colonizer for her liberation and therefore would not join the struggle. Using this construction of herself, the unveiled woman could then enter the "Western" world and act strategically against the colonizer. Alternatively, as the veiled woman was believed by the colonizer to be submissive and to lack agency and autonomy, she could use this perception against the colonizer by performing the part while carrying on acts of resistance such as hiding weapons under the veil that concealed her body. The Algerian woman, according to Fanon, became a nationalist agent by using the veil in the name of the nation.

Feminist scholars (Loomba 1998; McClintock 1995; de Mel 2003; Silva 2003; Yuval-Davis 1997) have warned us not to prematurely applaud these examples and not to declare them always progressive and emancipatory for women. Even women's participation during nationalist struggles is quite contradictory. As an example, de Mel (2003) has critically examined women's militant roles during the Sri Lankan liberation struggle of the Tamil Tigers, questioning whether their involvement has translated into full agency, whether their recruitment has been a result of autonomous choice, and whether their active involvement has radically transformed their society. Although the woman combatant in this case has been transformed "into a public figure, engaged in 'masculine' activities, repudiating patriarchal norms of womanhood" (de Mel 2003, 57), when we look very closely at the different discourses used in the recruitment of these women, we see that their agency is still limited since the men refer to them as "our women" and since, overall, their empowerment has been contained. This containment is due to the fact that although notions of motherhood and war have at times been combined, where "the mother-warrior pushed the woman into the public from the private and empowered her in an idea of militancy" (de Mel 2003, 65), the discipline and chastity of women fighters are still persistent notions in the ideology of the guerrilla movement. As well, sexual taboos that apply to women outside of the movement are replicated inside the

movement. Nationalistic politics are closely tied to gender politics, and nationalism can be used to regulate women's bodies and sexuality, as we have seen in the case of the shaping of nationalism in Romania and the rest of the Balkans, where subjugation of women's reproductive lives to the demands of the state occurred through family laws and bans on both abortion and contraception so that the nation could be reproduced (Eglitis 2000). In a similar way, Yuval-Davis (1997) has also questioned the possibility of empowerment for women during their active roles in militarist activities. This empowerment can be questioned when one looks at the persistent reluctance to have women in active combat roles and also at the way their subordination is maintained within the military by means of their submission to demeaning activities pertaining to their sexuality and bodies. Perhaps this submission is demanded because their presence in the military and in war is perceived as a threat to masculinist ideas, values, and behaviours within militaristic movements (Yuval-Davis 1997; Enloe 1993).

More often than not, after successful campaigns for national independence, women's involvement in the struggles has not become part of the narratives of nationhood, and their roles in the postcolonial nation have been restricted to the private domain (Abdo 1994; McClintock 1995; Cherifati-Merabtine 1994). In the example of Algeria, although the war of liberation shifted women's position from one of anonymity to heroism, the postwar period witnessed the delegitimatization of women's roles in public life and a reaffirmation of strict patriarchal relations (Cherifati-Merabtine 1994). This reactionary nationalism was accompanied by the insurgence of Islamic fundamentalism, which has become a strong presence in Algeria, as in other parts of the Middle East. While recognizing that identification with an Islamic identity can be an affirmative action of resistance against Western Orientalist discourses and against racist practices suffered by Muslims and "Arab" diasporic subjects, we also cannot remain silent about any regressive practices of some Islamic fundamentalist nation-states. As Moghissi (1999) argues, we must be careful that in the process of validating the voices of "Muslim women" and acting against the racist imageries that inform representations of the Middle East and the Muslim world, we do not neglect the negative consequences that Islamic fundamentalisms have had on the women who live in those regions. It is true that we should avoid viewing Islam and feminism as inherently opposite to each other and Muslim women as always oppressed victims with no agency or voice (McGinty 2007).

In Sweden, for example, an increasing number of women are recent converts to Islam and have integrated Islam and feminism into their everyday lives by criticizing not only Western ideals of femininity and racism against Arabs/Islam but also rigid, traditional, patriarchal readings and practices within Islam (McGinty 2007). In so doing, they have formed alternative femininities based on an Islamic feminist consciousness that strives to struggle against patriarchy and gender inequality by conducting a rereading of the Qur'an and by refusing to treat as opposites their religious identity and their belief in social justice and equality (McGinty 2007).

However, we must also recognize that some practices portrayed as forms of Muslim women's agency, such as the choice of some Muslim women to wear the *hijab* (veil) in the diasporic context, have had very negative effects on women in fundamentalist Islamic nations, where there is forced compliance with the same "cultural" practices. Undoubtedly, when Islam is used as the source of a political ideology and of laws that are oppressive to and discriminatory against women, major issues of human rights and gender equality do arise, and we must ally with those women who are struggling to have their voices and rights respected, even when doing so is interpreted by reactionary fundamentalists as a betrayal of their religion and nation. But one must be able to differentiate between the possibilities of revolutionary nationalist liberation movements and the more reactionary ones (Bannerji 2000). As Bannerji (2000, 3) notes, "the newly invented cultural nationalisms, such as in Iran or Afghanistan, speaking in the name of religion and tradition, have rooted epistemological as well as political-economic relations with global capitalism. Their invented ethnicities mirror those employed by racist/colonial discourses of modern western nations." In agreement with Bannerji, I also argue that discourses and practices of tradition are not gender-neutral and can often be used to both silence "our women" and restrict them to submissive and subordinate roles in the name of the nation. Some of the women's accounts in this book do take such a critical position toward the concept of tradition when it has been moulded to serve the interests of a few males and has excluded women's full and equal participation in the nation.

In reference to the first role of women in nation-building processes discussed above by Anthias and Yuval-Davis (1989), that of biological reproducers, it can be argued that women hold a paradoxical position. On the one hand, their capacity to literally give birth to future members

of the nation can be a medium for their status as "mothers of the nation"; on the other hand, as some feminists have argued, this same capacity can also become a justification for oppression and control of women's bodies and sexuality. Especially in cases of very exclusionary ethnic-nationalist discourses, wherein membership in the nation is intimately connected to blood affiliation, women's sexuality is severely controlled to ensure that their biological children are not "infected" with "impure blood" (Yuval-Davis 1997; Charles and Hintjens 1998). As well, there can be links between discourses of nationalism and racial purity, as Dua (2000) and Valverde (1991) point out. Canada's nation-building project was connected to a discourse of racial purity, where Anglo-Saxon women were constructed as the desirable mothers of the nation and women of colour were constructed as the "outsiders." Dua (2000) points out that South Asian women were not allowed to enter Canada because Anglo-Saxons feared that they would reproduce "undesirable" future citizens within the Canadian nation.

In times of nationalistic wars, this interconnection between gender and national identity becomes quite frightening, as women become intermediary tools in militaristic power relations. As we have witnessed in the widespread images of the Balkan wars, the rape of women was conducted as symbolic of military superiority and as a method of ethnically dirtying the "wrong" side of the nation. This can be seen in the proliferation of the discourse of "protecting our women" even as rape against the "other women" was practised as a lesson to the enemy that they (i.e., men) could not protect their women and their nation. What has also become evident through reports by survivors of rape is that after the rape they were treated in a stigmatized way by their co-nationals and that their rape was used as an explanation for the perpetuation of hate against the "other" and therefore as a justification for the continuation of war (Enloe 1993; Giles et al. 2003).

I do not intend to imply that women's role as biological reproducers is always and necessarily a negative one; in fact, if nationalist liberation movements do not abide by strict and exclusionary criteria of belonging, such as purity of blood, the concept of "mothers of the nation," as both a biological reality and a cultural metaphor, can be empowering. As an example, the role of Oneida women as "mothers of the nation" has historically not always translated into restrictions and oppression. Moreover, when their role as mothers of the nation has resulted in negative consequences, this has often been due to the legacies of colonial practices, which have also influenced the relationships between men and

women in Indigenous communities. In other places, like Turkey, women have politicized their mothering roles by protesting in public places the disappearance of their sons under the police (Baydar 2006). By their actions,

> a naturalized motherhood identity with universalist claims was mobilized for specific, local political ends ... Throughout the Saturday Mothers phenomenon such binary opposites as masculine versus feminine, male versus female, and motherhood versus fatherhood are effectively dissolved and mobilized in unprecedented ways ... elements of motherhood were articulated in relation to elements of public and private realms. (Baydar 2006, 691-92)

However, I do not intend to disregard the analyses provided by feminist scholars who point out the possible negative consequences of notions such as "mothers of the nation" and "purity of blood," which have the potential to oppress women, men, and children when they become the basis for regarding women as violating the principles of purity.

National projects often rely on well-defined ethnic and national boundaries, meaning that boundaries are constructed and maintained in order to define who belongs to a nation (the "us") and who is excluded from it (the "them"). Women occupy a crucial position in this construction, as they constitute border bodyguards who ensure that the genetic pools of the nation are maintained (Yuval-Davis 1997). In this process, women's sexuality becomes of the utmost importance as nationalists regard women as the vehicles for reproducing future citizens of the nation. Particularly, when "nationalism is ethnically based and defines ethnicity as something that runs in the blood, then it necessarily involves a tight control of women's sexuality in order to define and maintain the boundaries of the ethnic community" (Charles and Hintjens 1998). As one can imagine, the repercussions for people when they cross the boundaries and have intimate relations with "the enemy" can be quite detrimental. Such people are viewed as traitors of the nation and as no longer deserving of any protection and citizenship rights.

Anthias and Yuval-Davis (1989; 1992), Yuval-Davis (1997), and Yuval-Davis and Stoetzler (2002) point out that women's role as transmitters of culture is quite connected to their role as biological reproducers. As noted above, nationalist ideologies are closely tied to cultural discourses, and as we might recall, most modernist and ethno-symbolist theorists argue that an essential criterion for the building of nations is

the construction of a homogenous culture. Indeed, in the imagining of nationhood, cultural reproduction becomes a vital component. Yuval-Davis (1997, 39) argues that in such "culturalized discourses, gendered bodies and sexuality play pivotal roles as territories, markers and reproducers of the narratives of nations and other collectivities." In many national projects and processes, culture is often viewed as homogenous, static, and distinctively different from that of Others. In such views of culture, Yuval-Davis (1997, 43) further argues, gender relations are portrayed as "essences" of cultures, a way of life that must be taught to future members of the community. Given that women are viewed as the most capable and natural transmitters of culture, they are obligated to practise the "proper" cultural ways and in turn to transmit those ways to the younger generations. A negative result of such a construction is that since they are viewed as carrying the honour and tradition of their nation, women are often patrolled and controlled to ensure their moral purity and proper behaviour. Another danger of such static and essentialized notions of culture is that members of national collectivities, in search of the pure, authentic, and traditional "Native," exclude some members of their communities and even violently oppress them. As Stuart Hall (1994) argues, culture cannot be seen as a reified entity but is always fluid; therefore, cultural identities are not stable, contrary to what some nationalist narratives would have us believe.

Because women often play such an important role in the transmission of cultural traditions, they acquire much importance as symbols of the nation. In many nationalist discourses, the nation itself is portrayed as a female in need of protection, and the males are ready to die in order to defend it. Of course, this ideology is also accompanied by the regulation of women's bodies to ensure that they do not breach the honour of the nation and that they maintain the strict boundaries outlined above.

Obviously, feminist critiques have shed new light on nationalist processes. Although one must recognize that some women can gain status and power from some nationalist movements, one must also acknowledge the dangerously gendered elements contained in some nationalist ideological practices. It is crucial to more deeply analyze the gendered elements of these practices. Women's participation in nationalist movements has been pivotal, yet often it has not been acknowledged. Although I agree that women's participation in liberation movements does not always translate into real gains in the postliberation period, I wish

to temper the argument that all nationalisms are dangerous for women (McClintock 1995). For example, can a decolonizing nationalist movement in a nonpatriarchal context be linked to the emancipation of colonized women? Already some feminist theorists have analyzed this possibility, arguing that such liberatory movements have opened up some spaces for (once) colonized women (Loomba 1998; Jayawardena 1986; de Alwis 2003) and that their empowerment might reside in the removal of oppressive colonial conditions that affect their existence. A deeper knowledge of the subjectivities of some women directly involved and impacted by national processes could better inform us of the many relations at play, including those of gender. As well, this would help us to understand the forces that motivate individuals to mobilize in nationalist liberation movements. This is important work that needs to be continued so that through the voices of some women – and men – who have participated in nationalist movements, we can comprehend why these individuals have resorted to such projects and what we can all learn from their experiences. It is to these subjectivities that we now turn our attention.

Oneida Women Talking about Matters of Indigenous Identity

Thus far I have most often opted to use the term "Indigenous" to refer to the Indigenous peoples of North America, but in this chapter I sometimes use other terms (e.g. "Native," "Aboriginal") whenever they are the ones that the women more often used during our conversations. These women consider an Indigenous identity to be very important to their sense of self, and they deem it to deeply affect their everyday lives. This view was evident both when they talked about the meaning of being an Indigenous person in contemporary Canadian society and when they pointed out some of the persistent issues that Indigenous people face. Mary, a twenty-one-year-old woman, said that to her, "being Aboriginal means that you know where you come from, you haven't forgotten. You know that your ancestors were the original people of this land. To me, that is what's at the centre, you know? That is what makes us unique, special from the others in this country ... [pause] We have a very old connection." When I asked for clarification on this notion of "connection," Mary explained,

> It is a spiritual connection, you know. A connection with the land, the waters, the animals that share this land with us. It is a spiritual

connection because ... [pause]. It is hard to put into words what's inside my heart ... I guess that is because it is a spiritual thing, can't be really explained [laughter]. We are connected to this land in a special way. Our stories teach us how Turtle Island was started, and we are always supposed to say thanks to this land, to Mother Earth, for giving us life, giving us the food we eat, the medicines, and we are never supposed to abuse Mother Earth and the gifts she gave us. We are supposed to take care of the land, like our ancestors did hundred of years ago. It is our responsibility as Aboriginal people. Our ancestors' spirits live on the land, they have returned to the spirit world and protect us, watch over us.

Similarly, Darlene, a forty-five-year-old woman, stated,

Being Aboriginal is always going to mean much, always has and always will. It isn't something that can just die like that! As long as the Earth is alive, we, the Native people, will [be] too. That's because to be Native in this land means you have a bond with this land, with Mother Earth, and with the ancestors that were here before us and are there watching us, to make sure we live in a good way, we don't forget where we came from, the old ways and know we are Natives and be always proud of that, no matter what ... Well, I guess to be Native means that we are the descendants of the first peoples that lived here before any white man came. That is why we say we are the First Nations. That is something very important, I think.

When I asked Darlene why she believed this First Nations status to be important, she replied,

It is important! Very important. Because it means our ancestors lived in this land for thousands of years, had their ways of doing things, had their own ways to hunt, farm, had a very strong culture, and these things were working well, they took good care of each other and were free. And they passed on these ways to us, and these things are still important to us. We have a right to practise our own ways. No Canadian government can tell us what is good for us.

Another woman, Kim, shared with me what it means to her to be Aboriginal and stressed that a specific history shared among Aboriginal peoples on this continent is crucial in the formation of an Aboriginal identity:

All Aboriginal Peoples of Canada, whether you are of London, of Toronto, or BC, or even Nunavut, share a lot in common. Originally we all came from independent Aboriginal nations of this country, so we have some strong connection with this territory, and that goes way back! Now, that is something that not too many people can say they have, right? We have this history, this relation with the British and the French that came here. Most is not a good relation, but that is not our fault; it is because of the way they treated us. That is our history, too, and has been told to us from our grandparents and they had it told by theirs. [short pause, deep thoughts] I still remember my grandmother telling me about her stories about being in boarding school, about when they came to get her from the reserve and she had to go so far away from her parents. She always had tears when she remembered that day. She was scared, you know, to be taken away. She yelled for her mom and dad to get her back, but they couldn't. I really get angry when I think about what our people had to go through. But we survived. My grandmother used to say to me that the people at that school could beat her every night, but she at night always repeated in her mind Indian words, so she wouldn't forget. At night she would think about what her mom had taught her, about how her parents showed her things in the bush, about the plants, about our stories, speaking to her in Indian. So, no matter what they did to her, my grandmother never became white. But, come on, they really thought that just because they put us in these schools we would just wake up one day and be white? [laughter] The Creator made us Oneida, that spirit inside of us can't be killed. They still don't understand that.

Indigenous identity is not something frozen in the past but is lived daily by these women and is tied to shared experiences and knowledge of cultural practices. Mary's, Darlene's, and Kim's narratives reveal the experiential aspects of identity. These women's words support the argument that Indigenous people's cultural and national identities are greatly affected by the historical experiences of their nations (Simpson 2000). The Oneida people's historical connections with the land called North America have shaped how these women understand their relationships to Oneida territory, to Turtle Island (Canada), to other members of the Oneida nation, and to other Canadians. Stories of creation, of cultural traditions, of past ways of governance, of dispossession of land, of formation of reserves, and of forced assimilation affect how these women see themselves as Oneida and as Indigenous people. Such

experiences have formed in their consciousness a strong sense of cultural and national identity.

The persistence of this identification with an Indigenous identity and with the Oneida nation challenges positions such as that of Fanon (1963), who argues that a consequence of colonialism has been the death of precolonial cultures. Although we must recognize that colonialism has affected issues of identity in some negative ways, it cannot be concluded that Indigenous traditions have disappeared or cannot be revitalized. The experiences shared by Mary, Darlene, and Kim show that these traditions have been remembered and passed along, together with recent ones, from one generation to the next. Examples of this can be seen in Mary's statement that "being Aboriginal means that you know where you come from ... We have a very old connection ... Our ancestors' spirits live on the land." I want to draw attention to Stuart Hall's argument (1994), which I feel reflects the voices of these three women. The cultural identities of colonized subjects are composed of a sense both of being and of becoming, meaning that these identities are fluid and yet formed by a strong connection to past experiences and cultural traditions that link colonized subjects to their ancestors and provide them with a spiritual connection to their land. According to this understanding of identity, the past is part of the present, and for these three women, knowledge of the past does play an influential role in their present, affirming a strong identification with the Oneida nation and with a broader Indigenous identity.

This identification matters to these women not only because it informs their present experiences but also because it shapes their vision for future relationships in their community and with non-Oneida people. This point was revealed to me by Nancy, a thirty-six-year-old mother of four:

> Being Aboriginal means, most of all, that I never forget who I am, where I came from, what our culture is all about. It isn't enough that you have Aboriginal blood, you have to feel proud of your heritage, to be proud of your culture, your history, and believe that is just as good as any other one. Even when people put you down, want to believe that our culture is dead or not important anymore, you must be strong and stand proud about who you really are. So I really feel that it is important that we learn our language, and speak it as much as we can. I know it is not easy, because we are so busy these days, but we have to really try. We owe that to our ancestors, who fought for us, many died so we could

keep our ways. So we have a responsibility to learn our traditions and practise those that are still good for us and teach the new generation.

Anne-Marie, a nineteen-year-old woman who lives a fair distance from her Oneida community, is indeed attempting to do what Nancy suggests the young generation should do. She feels that her

identity depends on me wishing to know about the history of our people. I have always been curious to know about the teachings, the stories our elders know. I think that if we want to keep our Aboriginal ways and want our rights to be respected by all Canadians, we need to know these things. And we have to do it now, because a lot of the elders who know the language and the culture are passing to the Spirit World, and before you know it, unless we take steps now, we will lose it. I try hard to go to the ceremonies, I try to learn the language. It is hard. Have you tried it?

To this question I replied that I know a few words, and I agreed with her that Oneida is a difficult language to learn. I said that I too feel the need to learn it and that I do believe knowledge of the language is important in our efforts toward self-determination.

Kerri, a twenty-two-year-old woman, explained,

Being Native is very important to me. It means that I belong to a community of people all over the country, people who have shared many things for centuries. We have a way of looking at the world that can be different from other people. We feel that all things are interconnected, like a circle. See, the circle is important to us, it means we are all equal and need each other in order to survive. It means that all things are connected, the spiritual, the physical, the emotional, what's the other? Oh yeah, the mental. My grandmother was telling all this to me. The whole extended family is very important to us, the little ones and the very old ones. We believe that the children are special gifts, we always love them, we never put down any woman if she has children without being married, for example, because she has done something very sacred, she has given life. That is a Native way of thinking. We are very spiritual people, we believe all things are given to us by the Creator, so they are to be respected, taken care of, never put down. We also believe that we have to think of the future generation, so we don't take more than we need, must make sure the future generation will have enough to

survive too. This Native way of thinking is still pretty strong. Actually, now even some white people are curious to know our ways. I see that on TV sometimes, or at schools. My cousin, for example, she is at the university and she was saying to me that some of our knowledge, now they teach it at the university, in a class she was taking. Imagine that now, eh? Whoever thought others would become interested in what we know, so I guess we aren't some stupid, lazy Indians, after all, ah?

"I consider myself Native of course ... Then what you have is that I am Haudenosaunee, and then also Oneida": On Being Oneida and Haudenosaunee

Indigenous national identities are quite complex and contain many layers. Broadly speaking, as descendants of the original peoples of Turtle Island, Indigenous individuals belong to a large community that includes various groups on the American continent. Indigenous peoples share with each other some historical experiences that have shaped their identities, such as being people who have resisted colonization for centuries. As well, they might share some cultural beliefs and practices, such as a claim to be land-based people who have a spiritual connection to the lands they inhabit. In addition to this broader identity affiliation, each Indigenous group has its own communities that its members belong to and identify with. The twenty women included in this research belong to the Oneida nation, one of the six nations of the Haudenosaunee League, also known as the Iroquois Confederacy. As well, they are members of the Oneida of the Thames community, located in south-western Ontario. They trace their history to the Creation Story, wherein the creation of Turtle Island by Sky Woman represents the first historical phase of the Oneida people, who were originally located in what is now New York State. The Oneida nation's second historical phase began with the formation of the Haudenosaunee League through the message of peace carried to the nations of the league by the Peacemaker.[1] Later, the historical experiences of the Oneida nation and the other nations of the league included the arrival of Europeans and the colonization of North America. Within this later period, due to dispossession of land and internal divisions, the Oneida nation divided itself into three communities, one being the Oneida of the Thames. The changes that occurred throughout the different historical phases have produced a number of layers that constitute specific elements of the women's identities and therefore challenge any simplistic and essentialist notions of boundaries and community.

The combination of these various layers forms what Alfred (1995) calls a "nested" identity. By nested identity, Alfred means a multilayered identity that incorporates different communities, such as those that an Oneida of the Thames person inherits, namely the small, localized community in south-western Ontario; the broader Oneida nation, which provides members of the community with a sense of connectedness to and membership in the whole nation; and the Haudenosaunee League, through which members of the community are connected to members of the other nations of the league by clan affiliations. The women represented in this research also share a sense of identification and affiliation with all other Indigenous people of North America, with whom they are united by shared racial and other types of experiences. A final sense of identification is a pan-Indigenous one, through which these women understand their global relationship with other Indigenous peoples.

Lori quite lucidly elaborated on the points mentioned above:

I consider myself Native, of course, because that is what my ancestry is. Like other Natives, my ancestors were Natives for many generations. Actually, for all generations, I have only Native ancestry. Then what you have is that I am Haudenosaunee, and then also Oneida. All these matter to me. Being Native in general makes me similar to other Natives in this country. I have specific rights because I am Native. I have status, for example. But I belong to a specific group, Oneida. That means that we have [our] own language, own history too, because for example we come from Oneida territory, from New York. We have even our own Oneida stories and teachings. We have [our] own clans, own Longhouse. We are part of the Haudenosaunee, so we are connected to the Mohawks, Cayugas, for example. The Peacemaker united us, so we are tied together, have to help each other when needed, but Oneida people take care of [our] own affairs and Mohawk for example take care of their own. But when we get together, we feel connected to each other. When we are at gatherings, and there are other Haudenosaunee people, we go, "Oh, you are Haudenosaunee." We know they are like family to us.

Another woman, Debbie, similarly said,

Well, I feel like I have many families I belong to: I am Oneida, from here [Oneida of the Thames], but I am also connected to Oneida from New York, that is where our original territory is actually, I have some family there too, so everyone from the Wolf Clan[2] is my family there too. Then

we are of the Longhouse,[3] so all Iroquois people are my family too, especially all Wolf. Then I feel connected to all Natives, because at the end we are all Natives, so we are pretty much the same, but the others have their own Nations.

Being Haudenosaunee is a crucial component of these women's identity and is something they feel very proud to reveal whenever possible. As Barbara said,

> I always feel proud to say I am Haudenosaunee. To people that don't know much, when you say you are Iroquois they seem to know and admire that. You know, Haudenosaunee people, we have a very good history, we have the Peacemaker, the Great Law of Peace that he gave us, we had [our] own government even before white people came here. We have wampum belts,[4] and like when I see someone wearing the Friendship Belt at powwows, I feel something so warm inside. I am very proud to be Haudenosaunee.

Other women shared this pride in and knowledge of their own history. For example, Debbie said, "Being Oneida means that you are part of something bigger, the Iroquois Confederacy and that is something very big. I am very proud of that. People know that Iroquois were strong people in Canada and [the] US. Still are. We still have [our] own Longhouse, own teachings, own songs and dances." In agreement with the other women, Frances remarked,

> There is so much to feel proud to be Oneida. We belong to a very good Nation, where women were central to everything, and a very equal society. Also we belong to a tradition of peace, of co-operation. That is because we belong to the Haudenosaunee. We were united by the Peacemaker and we are supposed to love each other, but also respect each other's freedom. So each Nation has its own way of doing things internally, but we have the Grand Council where we discussed things that affected all the nations in the confederacy. Being Haudenosaunee is so very important. That is how we survived, by living in peace and respect[ing] each other, all being equal in the council.

While discussing this matter with my clan mother, I indeed learned that being Oneida and Haudenosaunee are very much interconnected. She taught me that "being Oneida means to belong to the Longhouse,

to the Iroquois Confederacy. It is very important to be of the Long-house. This is still very strong." She then explained the existence of three different factions of the Oneida nation: "You have the Wisconsin, the New York and the Oneida of the Thames, ours." She admitted that some division and animosity exist among these three communities:

> The New York ones feel they are the ones who can claim that the land they are on is the original land of Oneida. That is true, but we had to leave and come here. So, you can see the divisions, but we should be united, because we are all Oneida, of the Haudenosaunee. We, the Oneida of the Thames, are the ones that have the fire, so we are rich in that we have the ceremonies, the language, the songs, the medicines, and have a Longhouse with the fire. In fact, we send sometimes some from here to the other two, to share our knowledge, to teach. By having the fire, we make sure that our ways stay strong, our governance is continued on.

Some of the other women also pointed out the existence of some degree of division between the different Oneida communities and also between the Oneida nation and the other five nations of the Haudeno-saunee League. For example, Tracy said,

> It is sad, but you hear sometimes someone here putting down Mohawks, sometimes calling them the violent warriors. Maybe the things we hear in the media, we start to believe them too. But then, some put us Oneida down. When my sister was with a Mohawk man, some would say, "Oh, stay away from those Mohawk men!" So you hear things like that. That is not good. Not the way [it] is supposed to be. We gotta get along.

Shirley agreed with such statements, pointing out,

> We get along most of the times. For example, during the Oka thing, well lots of Oneida and others went to the Mohawks in Quebec to show support. But sometimes we make fun of each other, or the Mohawks think they are better, stronger, and the Oneida think the same. But the Friendship Belt we have is supposed to be respected and we should re-member that.

These narratives of divisions between Oneidas and other members of the Haudenosaunee League reflect the lived experiences of nationhood

that Simpson (2000) has discussed. Stories of unity between the nations because of the message of peace that was delivered to them by the Peacemaker have been told to these women by their ancestors and have formed their experiences of nationhood. As well, stories referring to different experiences of nationhood are remembered that recount historical experiences of disputes, tensions, and eventually wars between the various nations of the league that occurred as a result of colonial conquests and wars over territory between competing colonial groups, such as the British and the French. After failed attempts to remain neutral in the wars between the French and the British, the nations of the league found themselves divided about which side to support. Since this disunity could not be resolved, each nation was free to choose which European side to ally itself with. This split increased during the American Revolutionary War. The Oneida nation chose to ally itself with the American Revolutionaries and fought against the other nations of the Haudenosaunee League, which had chosen to ally with the British Loyalists. Hence the divisions narrated by these women need to be analyzed by taking a look back at history. As Simpson (2000) points out, historical experiences such as those just reviewed are shaping current discourses of nationhood and nationalism; yet, as Simpson (2000, 136) and the women above further argue, on the path toward decolonialization and assertions of nationhood, members of all nations must find ways to heal and unite, and this implies a process of both remembering and letting go. As Indigenous peoples, we must remember that many of the divisions between us are due to colonization while also letting go of the pain of our colonial experiences. We must also remember that just as centuries ago the message of peace created unity among the nations of the Haudenosaunee League, that message can be the source of healing once again.

On Matters of the Clan

At the very heart of each nation within the Haudenosaunee League is the clan system. An individual becomes a member of one of the six nations of the league by birth or adoption into one of the nine clans of the league, and this affiliation is carried through the female line. Correspondingly, specific traits, qualities, and responsibilities characterize each clan. Mine, the Turtle Clan, for example, is known as the symbol of the earth, consistent with the name Turtle Island. Turtle people are characterized as shy, consistent, patient, and loyal. They are also known for being the organizers in any league matters. As I have been told by

my elders/teachers,[5] specific responsibilities were conferred on each clan so that each person had a role to play in one's own community, in one's own nation, and in the whole league. This is done in accordance with our cultural value of establishing balance for the overall wellbeing of the collective as well as the individual. This means that each responsibility and role is equally valued, for it has a specific task to fulfil in achieving holistic balance on Mother Earth. I have also been told that most of the "personal" characteristics of each clan were so attributed by looking at the general pattern of behaviour of the animal to which each clan is symbolically tied.

Except for one, all the women here claimed that their clan membership is important to them.[6] Mary said,

> I am of the Bear Clan. I was told that it means we are the healers. So, especially the women are all very familiar with the medicines and are responsible about the health of the members of our community. Many Bear people are involved in different ways with the healing of the people, like they are medicine people, knowing which medicines work for what and teaching that. Or with taking care of children, as teachers. There are many ways to make sure you carry your responsibility as a Bear.

Likewise, Karen, also of the Bear Clan, stated,

> Us Bear people are the ones who are responsible for the healing of our own families; the whole clan and nation really. We are taught all about the medicines and how to take care of those that are not well. We get involved in things about healing the community, either with abuse, like alcohol, or violence, or to make sure that when one dies, the funeral is done in a proper traditional manner. So all sorts of things like that.

Anne, of the Wolf Clan, spoke of the specific traits of her clan, which is responsible for protecting the nation and for teaching:

> Wolf Clan is the protector. Some times this is talked bad about it, given a bad name as warriors. Some people, if they don't understand about the teachings and the old ways, they don't get that Wolf people have the responsibility to deal with the outside, and being warriors is a very responsible thing to do, a spiritual thing, where you take care of the people and deal with the outsiders. Not an easy thing to do.

Leslie also spoke of the Wolf's traits and responsibilities:

> As Wolf, we are the brave ones, the ones who take care of things with other people, we are the ones who watch over the nation, protect it. Some say we are aggressive, violent. Well, I guess if it came down to do that to protect the nation, we will do it, but in general we tend to go for peaceful negotiations with the outsiders, find a solution that is good for everyone concerned.

The importance of the clan system in the establishment of regulations for membership in the Oneida nation has been reinforced for me by the teachings of my clan mother:

> If a mother is Oneida, it means you have a clan, a line, and you are automatically Oneida. If a mother is not Oneida, the child can still belong to the community, people will take care of him or her and can participate in things, come to ceremonies, but has no voice in the Longhouse because has no clan. It means that outsiders can't run our businesses, interfere with our ways. But if the clan mother adopts a person, then that person is given a clan ... Being of a clan means you belong to a whole family, not only your own little family, but the whole line. You have responsibilities, have to relate in a good way with everyone of that clan. So if one needs help, the whole clan has the responsibility to help that person ... Each clan has different roles in the Longhouse, in the council meetings too. Turtle Clan is to make agenda.

The expectation that one will help anyone who belongs to one's clan is well understood by the women who participated in my research. For example, Debbie said, "You have to help everyone of your same clan, because it means that they are your brothers and sisters. That makes sure that everyone is connected and is part of a big family. You can't marry for example someone from your same clan, because you are related. You have to marry outside the clan." Children belong to the clan line of their mother, as one participant noted:

> The children always go with mother's clan. So when we sit at the Longhouse, the whole clan sits together, and the children sit with the mother, not the father. Sometimes the children want to sit with the father, so they can go there for a little while, but we try to encourage them to sit

with their own line. Even when the mother is not there with them, they still go with the side of their mother's clan.

On the Meaning of Nation

There are few matters as contentious and complex as that of membership in an Indigenous nation, as membership can be based on rules that can be quite divisive and exclusionary. The criteria for membership have been greatly altered since colonization, as the Canadian government, through the Indian Act, has been a major player in defining Indian status and has imposed its interpretation of membership on Indigenous peoples. Haudenosaunee people have experienced a significant change from life in an independent matrilineal society to life under an imposed patrilineal system. Moreover, through the Indian Act, the Canadian government has imposed elected band councils, which are accountable to the Department of Indian Affairs regarding all matters that deal with bands, including band membership.

As Indigenous nations take steps to reclaim control of and autonomy in their own affairs and thereby move toward decolonization, the significance of nationhood and membership in a nation is becoming even greater and more complex – and at times a point of division and conflict within nations. The following questions need to be addressed during the process of self-determination: Who decides on how membership is to be defined? Are those decisions in agreement with the needs and opinions of the members? Are traditional definitions re-established or are they discarded in current practices?

Similar to many other communities, Oneida of the Thames has an elected band council in place that follows rules established by the Indian Act for determining one's eligibility for band registration and for inclusion on the band list. In addition to the band council, there is still the Longhouse government, which follows the traditions of the Longhouse on all matters, including membership in the Oneida nation. The women who participated in my research were familiar with the two different governments and shared with me their opinions and concerns on the topic of nationhood and membership.

Kim shared what the word "nation" means to her and how it is associated with reserves:

When I think of the word "nation," I think of Oneida, that we are Haudenosaunee, we come from the Oneida territory in New York State,

but came to live here in late 1800s,[7] I believe it was. Now, Oneida of the Thames is the community I think [of] when I think of home. It is the place where we can live with our own kind, have our school here, our Band Council, and our Longhouse. The reserve is a place I feel comfortable, but you don't have to live here to be Oneida. Oneida is a way of being really, and just because you live away from it, it doesn't just die away. You are still Haudenosaunee. Reserves were set up by the Canadian government, to keep us in control, but now we think of them as our home.

Similar to Kim, Mary said, "Oneida Nation is part of the Iroquois, and this particular reserve is where we can live and have [our] own schools, own government here, but being Oneida is more than that. Being Oneida means you are part of all Oneida, whether here, or in New York, or if you live in a city, you are still Oneida." Sheri discussed the feeling of security and safety she experiences living on a reserve:

I feel happy when I am in Oneida, at the rez. I am with my own people. I feel nobody looks down at me. When you go to the city, others often look down at you because of what you look like. I feel safe here, even if there is fighting and things are not running good, I still like it better here, I feel at home, it is my community, my nation here.

Experiences of racism like those mentioned by Sheri do play a role in shaping the consciousness of women like her – and like me to some extent[8] – giving them a sense of nationhood that is tied to Oneida. Being reminded through repeated experiences of racism based on negative constructions of "Nativeness" that they do not belong to mainstream conceptions of "Canadianness" only reinforces in them a sense of Oneida identity and a commitment to reaffirming a positive and autonomous nation where they feel they can belong and be justly treated.

This sense of home was also experienced by other women. One participant commented,

I know I will be taken care of in here, I know people here, it feels like a big home. You don't get that in a big city. Here also I am closer to nature, and it is important to me to be close, connected with the land. In a huge city I would die. Too many people, too many big buildings, life is too fast there. Here I feel like I belong, I feel right here.

For some of the women who live in a distant city, an Oneida identity still means something, as Wendy said:

> I still feel Oneida, no matter what. I think of Oneida all the time, I go to see relatives when I can, and in the city I know other Oneida and we do things of our culture. I do some beading; I go to some dances. Some think that because you live in a city you don't feel Native or Oneida, and I don't think that is true. I still feel proud to be Oneida, I still care about what goes on in my community, and it doesn't go away. You still have Oneida blood in you and it is in your heart.

Mi'kmak scholar Bonita Lawrence (2004) has explored the tensions and complexities that surround the politics of identity for urban (and mixed-blood) Natives in Canada. One salient argument made by Lawrence is that although the experiences of most urban Natives can be considered in terms of a diasporic identity, as they have been severed by colonialism from their land-based "home" communities, such as Oneida of the Thames, many of these individuals still feel quite connected, through what she terms a "blood memory," to those Natives who still reside on their reserves and to other Natives of the same "home" community in the urban setting. This blood memory is derived from shared historical experiences that they have been told about by their families; it is also derived from continuing participation in many community activities, as Wendy stated about herself; therefore, their national identity is still embodied in them, even if they are living in the city.

Among the women I talked to, there were different opinions regarding membership in the Oneida nation. Those women who are very familiar with the Longhouse teachings and who participate to some degree in the ceremonies share the opinion stated by Karen: "As long as the mother is Oneida, then that is all that is needed. That is the way it was before, you know, before the Canadian government got involved, but we still believe that is the way that it should be, that it is through the mother's line." Stacey added,

> We should go back to the way the Longhouse taught us, because it was our way of doing things, it was said so by the Peacemaker, it was the way it was meant to be. The Peacemaker said that the line belonged to the women, and they were the heart of the nation, those who gave life. I don't think we should change that. Or follow the Canadian way. The

Band Council, they really just follow the white man's laws, we should change that and go back to the way we used to do these things.

This opinion was also expressed by Nancy, who said,

The way I was told is that it is through the female line, our stories say that, even our creation stories. Because Turtle Island was created through Sky Woman and women can have children, give life. That is the way then you belong to the Iroquois. Some other nations followed the men's line, our way was through the woman, but then we started to change that, and then it was the man that mattered, but that was not our ways originally, you know. Now, if we really say we want to be free and want to have self-government, then we should remember our own ways and follow them, especially those things that can still be practised today and are good things.

Some of the women spoke of an alternative to the re-establishment of firm matrilineal descent as the criterion for membership in the nation. Recognizing that there have been many changes throughout the years and frequent intercultural/international unions, some women believe, as one said, that "anyone who has Oneida ancestry can be, as long you have some, then you are, you are made Oneida by the Creator that way, so you should be welcome," whereas others agree with the participant who said that "if you have some Native background, and you want to be involved, belong to Oneida, then that should be enough. We always included people and should not have hard rules."

Regarding the issue of mixed ancestry, most of the women quickly pointed out, as Tracy said, that "there isn't anything like half, a quarter, whatever blood, either you are or you are not. If you have ancestry, then you are, that's it." Another woman commented,

You know, I really think it was the white government that wanted to set up these rules about mixed people, not our way. I think they did that to get rid of a bunch of Natives, so they wouldn't have to deal with them. It really worked against us, and now some want to follow those ways. I think it is a mistake, a big mistake. We should include people, welcome people to be part of the nation, not to push them away.

Lisa offered a further comment:

The Iroquois way, it was what the Peacemaker wanted, that if anyone wanted to join the confederacy they could, as long as they obeyed the teachings, they were welcome to join under the Pine Tree of Peace. So if anyone who has Oneida ancestry wants to be part, why not? We should become more united, stand together, be proud of who we are. So I believe those that want to be part of our nation should be made to feel good about it, instead some say, "Oh, she is only half" or "Oh, she is not full blood." It is in your heart whether you are Oneida, and we should encourage people to want to return to our nation, not the other way around. My goodness, we need all the people we can get, that have different skills, gifts to share with everyone so that we have a strong nation.

The views expressed by these women can be juxtaposed with those of some members of some Indigenous nations who are introducing a rigid form of blood-quantum criterion for membership in their nation, requiring potential members to have 50 percent or more "pure" Indigenous blood. Most of the women included in this research believe this requirement to be too exclusionary and essentialist. For many of them, as long as a member can trace some ancestry to an Oneida clan line, that individual should be accepted into the nation, as he or she has an established kinship relation with those of the same clan. Traditionally, affiliation with a clan is derived through a woman. Within Haudenosaunee traditions, this can be accomplished by being either born to or adopted by a Haudenosaunee woman. Earlier in this chapter, I pointed out the problematics that I see in some of Alfred's (1995) arguments when he analyzes discourses and practices of nationhood that claim to be decolonizing and rooted within Indigenous traditional practices, such as the principles of the Great Law of Peace for the nations of the Haudenosaunee League. Yet these discourses and practices sharply distance themselves from some central founding Indigenous notions of nation traditionally held by the members of the league. If decolonizing is meant to be a movement away from colonialist structures, practices, and discourses, why is it that some Haudenosaunee people use notions of membership that were not at all traditional for Haudenosaunee nations but were imposed on them by colonial institutions?

Works of Bhabha (1994) and Chatterjee (1986) are crucial here to our understanding of the problems that can occur during anticolonial nationalist movements. Bhabha (1994) points to the mimicry aspect of some nationalist discourses that claim to be opposed to colonialism

and yet adopt some colonialist concepts. Also, he expresses concerns about who speaks for the nation in those constructed discourses. Indeed, we must ask who is speaking for the Oneida nation to outsiders and insiders in a time when discourses of nationhood are not constructed on traditional Indigenous principles yet are portrayed as anticolonial or decolonial? The power dimension inherent in such discourses cannot be escaped; such discourses perpetuate forms of exclusion and gender inequity and are ultimately oppressive. Chatterjee's (1986) analysis of the derivative aspect of some anticolonial discourses of nation does reflect well, I believe, the direction of some decolonizing movements. Yet, as Simpson (2000) argues, on the path toward decolonization, new discourses and practices of nation must involve a process of healing, of remembering our traditional ways of governing (and asking whether they can be revitalized and whether they could still work in light of current realities), and of unification rather than division, exclusion, and simple mimicry.

Some of the women I spoke with shared the view that there should be different rules for those who reside on the reserve and those who do not, as Nancy pointed out:

> You can be part of the nation, be Oneida, but if you don't live there, and there are some specific things that have to be decided, then only those that live there should get involved. But you can still be a member in all other things, still welcomed in the ceremonies, still registered, only that when some specific things that will really affect only those that live in the rez they should have more of a say, because they are the ones who know better, they live here, they are the ones who have to live with what decisions are made, eh?

Putting such a view into practice could work to remove the current divisions that exist between urban and nonurban Oneidas and between status and nonstatus Oneidas, divisions that are direct results of policies mandated by the Indian Act.

Among the responses of Indigenous peoples to colonial legacies, we might include such efforts to accommodate experiential differences and to recognize that for many people, experiences such as moving off the reserve have resulted from forced dislocation, as seen in the case of those Oneida women who, until 1985, lost the right to be members of the nation and to live in the community upon their marriage to a non-status individual. Also, such recognition could open up ways to entitle

urban and other excluded individuals to national citizenship, hence ending the discrimination that many individuals still suffer following centuries of colonial policies that have robbed them of their status as members of the Oneida nation, at least in "legal" terms. The Indigenous lawyer and self-proclaimed feminist Sharon McIvor has challenged the Canadian state in the courts about the ongoing discrimination against the children of women who regained their Indian status, as the status of these children is not guaranteed under the Indian Act's rule on the so-called second-generation cut-off respecting Indian status. In April 2009, the BC Supreme Court agreed that discrimination against these children persists and called upon the Canadian government to change the Act by 2010. The government finally decided not to appeal the decision and will review the Act's status rules. On 10 May 2009, an article in the *Toronto Star* reported on the many impacts that the current rules are having on our communities, one being that "Canada's Native people are facing what [Alderville First Nation member] Beaver calls a 'legislated extinction of status Indians' ... Because of [the current rules on] intermarriage some communities will see their last status Indian born as soon as 2012" (Keung 2009). I personally do not view the Indian Act's rules on Indian status as a legitimate representation of me or my people, as Indian status is a colonial invention and a mechanism of oppression; nonetheless, the Canadian state recognizes and deals with only status Indians in matters such as land claims and tax exemptions, and many band councils have adopted rules that align with the Act. Therefore, the impact of the current rules and the planned re-examination do have real consequences for many individuals and their nations. But we cannot forget that the Indian Act has never reflected our traditional ways of governing ourselves, and given the ugly reality of a possible "legislated extinction of status Indians," we must ask whose benefit is served when Indigenous peoples follow such rules? When speaking about the Indian Act, a number of the women agreed with Carol, who pointed out, "By adopting it, we are allowing whites to kill us, at least in paper." Karen added, "It was not in our ways to exclude people, we welcomed them in our nation. The clan system allowed that. This blood thing got rid of lots of people, and who knows what good things they could have done for our community?"

On Matters of Indigenous Womanhood

How do these women understand the concept of womanhood within an Indigenous context, how do they connect issues of gender with those

of culture, race, and nation, and how do they view colonization to have altered gender relations? Overall, for these women, the concepts of women as "mothers of the nation" and women as the "heart of the nation, the centre of everything" are central to their own identities. They hope and/or believe that the path toward decolonization will include a reconstruction of such notions and a reaffirmation of the powerful roles and responsibilities women held in Haudenosaunee societies prior to the imposition of Euro-Western (hetero)patriarchal norms.

These twenty women spoke of their gender identity within a deeply rooted Indigenous context, always connecting their racialized identity and culture with their womanhood. This is exemplified, for example, by the fact that they often qualified their experiences with phrases like "as a Native woman ...," "us Aboriginal women ...," and "Oneida women, we ..." Moreover, they believed that "our issues are different than those of other women, we are Native, have special issues," as Karen stressed. As well, these women shared Karen's belief that

> Oneida women have a different culture, history than other women. All Iroquois women did, our culture was very woman-centred, and to get things right again we need to look back, remember our ways, that is the answer to many of our problems. Other people can't teach us that, we have to teach ourselves, and ... [laughter] we sure need to teach our men again, it looks like they have forgotten or don't want to remember, eh?

Indigenous womanhood is a very powerful component of identity formation for the women I spoke with. For example, Carol said, "Being a woman is a special thing, a powerful way of being. I was taught to take pride in being a woman, because in our culture being a woman means you have a very deep spiritual power inside: we are strong, caring, patient beings." Lisa also spoke positively about womanhood:

> In the Oneida ways, women are very important for the wellbeing of our community. Women are the strength of the community really. We women must feel good about being Native women, being a woman is such a beautiful thing, a very powerful thing. It is a sacred thing, women are supposed to be respected because they are the ones who can give life, who take care of the community.

Many of the women repeatedly pointed out the centrality of womanhood in the cultural traditions of Oneida and other Indigenous nations.

For example, Debbie said,

> In the Iroquois, and I think in other Native societies too, women were really important. If you look at our Creation Story, for example, who was the Creator of Turtle Island? Sky Woman. Then, since she created the earth, women are considered the mothers of all life on earth; women are the ones who can give life, know what is good for the nation. This is why clan mothers are so important, you see? But not just them, all women are.

Similarly to Debbie, Kim said:

> In our traditions, women had lots of power and responsibilities. Women, being as they are the mothers of the nation, because of the way the Creation Story says about Sky Woman and because the Great Law of Peace also says that women are the ones who pass the clan, therefore really give life. Women were the ones who decided all things about the land, taking care of the land, the food, the farming, naming the chiefs, making sure they [the chiefs] did what was good for everyone. Women had all these responsibilities. That's a powerful thing!

Power was not interpreted by these twenty women as meaning that women or any other group controlled or dominated others. In fact, these women often cited equality and balance when they spoke about the responsibilities women held in the nation. The way that power is conceptualized here is derived from the founding principles of the Great Law of Peace. Power is one of the principles intended to guide the Haudenosaunee nations in matters of governance. Power is stripped of concepts usually associated with it, such as domination or control. It is, instead, a spiritually based empowerment given to people by the Creator so that they can carry out their tasks for the wellbeing of the whole community. It is a spiritual quality that people possess in their inner self, which guides them to live in a good way with themselves and with others. For example, Kim said,

> Women had powers. Power to decide on things that were important for the whole community. They had power about the use of the land, they had power, but that doesn't mean that they were better than men. No, that is not what I mean, that is not the way it was or is. Nobody was better than another. Men also had power, they were chiefs, for example,

and they could also share the responsibilities of the land, of the family. Everybody was equal, all was in balance. At the end, what really mattered, was not who did what, but that things got done, and that the nation was strong. That the children were looked after, that the land was taken care of, that the hunting gets done, etc.

Mary agreed with Kim:

Women had respect, power over some things, like the land, the clan. Men had their own responsibilities. The elders, they keep saying that things were done more equally in the traditional ways. Nobody was after the power, the money you know. The teachings say that everyone is equal. We have different jobs to do maybe, but they are all important, because we all depend on each other to make sure things go okay, you know.

Balancing is a recurrent theme in the way these women spoke about the responsibilities and powers attributed to each member of the Oneida nation. Some referred to balancing when they discussed the way a small family unit is organized, as Karen did when she recalled her own family:

You see, I am the one that usually takes care more of the children, to make sure they eat right or do their homework. Don [her husband] does things outside the house, but if he sees that some things need to be done inside, he does, he's not going to wait for me. If I see that he needs help outside, I do it. That's the way my parents did too and my grandparents. What we need to do is balance everything. One day I might do more outside, he does the inside, but it all balances itself out at the end. What is more important is that all is done, everyone is taken care of, and things are going good. And no job is more important than another. It is all about balance.

Just as balance within a small household is important for a healthy environment, so is balance between other parts of a community. Mary, for example, remarked,

The way I see it, it is all about finding a balance. That is why in the Haudenosaunee way, some clans have responsibility for some things about the running of the confederacy. That is why we had women's council and men's council, we had chiefs and clan mothers, and faith keepers. When you divide things that way, you have a balance, but

nobody is treated like a king or queen, it's about getting the jobs done so there is balance, and we have a healthy community then.

Similarly to Mary, Lisa said,

Women are more involved with some things in the community, like family, or teaching, most of the teachers are women – I think I know of only one man involved in teaching our children – or being healers, faith keepers, or running things in some circles, for example the centre here. Men get more involved with outside stuff, dealing with the government, for example, or other business things with outsiders. But all these different things are all equal at the end. I mean, you can't run things well with the outside if you don't take care of things in the inside first. They all have to work together so that there is balance. And it works like a balance, some things are done in the one side, others in the other, but they all stay equal or there is no balance and eventually everything will break down. Everything in life is like that really, that is the way we believe. You have, for example, the Sky Woman and the Great Spirit; you have the twin brothers that came from the Sky Woman, those two had different responsibilities, but this was supposed to teach us that things have to work together, co-operate, depend on each other for a good balance on earth.

Deerchild (2003, 101) views this notion of balancing to mean that

Aboriginal societies walked in balance with the earth, with the spirit and with one another. Although the woman was seen to be the strength, she was by no means at the top of the hierarchical structure. In fact there was a natural equality between the sexes. Each had their ceremonies, roles and purpose in the community and within the order of life. Neither was less or more important than the other.

Today, many Indigenous women acknowledge that things have gotten out of balance: men have acquired more power over women in many communities, and cultural traditions are being used not to empower women but to push them into unequal, submissive roles. Therefore, "tradition" must be critically examined and adjustments made to bring balance back into communities.

The cultural teachings of the Longhouse, the Creation Story, and spirituality as the bases for a positive understanding of Indigenous

womanhood were evident when speaking with these women. They recalled, for example, the importance of some ceremonies that are centred on the identity of Indigenous women. Anne-Marie talked about the importance of menstruation:

> Moon time is a very important time for women. In our traditions, being on the cycle is not something we should think like is dirty or something bad. I hear sometimes people say it's a curse, because you have cramps maybe. But being on moon time is a sacred thing really. It reminds us of our sacred power inside of us as women. It is a time when we are cleansing ourselves inside, our spiritual side is so strong at this time, we are even more powerful inside than in other times. It is all part of being a woman, of reminding us of our roles as life givers.

Another woman, Karen, said,

> When we are in our cycle, we are even more connected with Mother Earth, are more in touch with our spiritual powers, our powers as women. It is part of our traditional culture, about being Oneida, being Native. When we are in our moon time, we know we have so much power that, for example, we don't do corn soup, or other jobs, like make berry drinks, or go to ceremonies. It is because our powers are too strong at this time, that it would put things out of balance. Others, people or food, can't take our powers. We take power out of them, my grandma used to say.

Other cultural traditions that symbolize specifically Oneida and Haudenosaunee womanhood include the belief that berries, especially strawberries, are women's medicine. The roots of this belief are in the Creation Story, which teaches that Sky Woman brought strawberry seeds, along with tobacco seeds, when she fell from the Sky World. The strawberry became one of the first foods introduced to humans on Turtle Island, hence its sacred significance for Oneida and other Haudenosaunee people. Mary pointed out this significance and its relation to womanhood:

> Strawberries are women's medicine, our responsibility. They are very important for us women. For example, when we need some healing, physical or emotional, we eat them. Also we are responsible for them, so we make strawberry juice for ceremonies, for everyone in the Longhouse

to drink. Some women take the responsibility to make it. Also, there is the berry fasting that we women go through when we become women, or when we need to do it for some healing.

Lori also spoke about the power of strawberries:

> Strawberries are like the blood of our people, my grandma used to say. And Sky Woman introduced that to us. So that is why they say that strawberries are women's medicine. My granny said that other berries are important too, they are like cousin to the strawberry. But strawberry is more spiritual, powerful. When we drink we are becoming stronger, healthy, like connected to the earth too, to life. And women are the ones who hold the strawberry as medicine. Very important role.

The sacredness of the strawberry is evident when one considers that for all ceremonies at the Longhouse and for various feasts, strawberry juice is made by some of the women – often the faith keepers of each clan – and each person drinks a glass of it so that everyone can be given the gift of life and the healing that comes with the original medicine of Sky Woman.

On Mothering the Nation

Thus far the concept of women as "mothers of the nation" or as "progenitors, or life givers, of the nation" has been encountered a number of times. For Haudenosaunee people and most other Indigenous peoples, this concept has a specific cultural meaning and historically has been a positive aspect of their lives. However, the women I spoke with for this book and other individuals in my community shared with me their concerns that such a positive concept has been altered under colonialism, and they are wary that a misguided revival of "traditional" women's roles, such as their role as mothers of the nation, can be used to further oppress them.

As I have argued elsewhere (Sunseri 2008),[9] within an Indigenous context, mothering refers to more than bearing children. It is an empowering role for Oneida women, as it plays an important part in sustaining the community and in women's achievement of self-empowerment. The way motherhood is understood here stands against the mainstream, dominant ideology of patriarchal motherhood. Patriarchal motherhood is an ideology that has controlled, constrained, and degraded women (O'Reilly 2004). This is because such an ideology constructs "good"

mothers as ones who are "naturally" willing to put their family's needs ahead of their own needs (O'Reilly 2004). Within an Indigenous worldview, mothering does not imply subservience and submission but gives women the strength to be types of women that the whole community can look up to. An alternative to patriarchal motherhood has always existed in Indigenous nations, as Indigenous women "have historically, and continually, mothered in a way that is 'different' from the dominant culture, [and this] is not only empowering for our women, but is potentially empowering for all women" (Lavell-Harvard and Corbiere-Lavell 2006, 3). This empowered mothering recognizes that when mothers practise mothering from a position of agency rather than of passivity, of authority rather than of submission, and of autonomy rather than of dependency, all mothers and children become empowered (O'Reilly 2004; Collins 1990). Consequently, mothering becomes a political site wherein mothers can effect social change and reduce the patriarchal nature of institutions (Collins 1990). Recent feminist theories of mothering have conceptualized the empowering potential of such mothering, identifying it as feminist mothering,

> a conscious political strategy to bring about social change in their lives and in the lives of their children ... through contesting notions of motherhood and practices of mothering, as well raising children to be critical thinkers ... these mothers value relationships with their children that are not intimidating or domineering ... Rather than exercise power over children, they strived for relationships based on respect, responsibility and accountability. (Green 2006, 8-12)

Of course, we must recognize that the discourses and images of motherhood associated with such feminist mothering and overall maternalist politics, although ideally potentially empowering, can be easily manipulated and that representations of motherhood can be co-opted for other regressive political and social purposes (DiQuinzio 2006). DiQuinzio (2006, 60) points out that "in the 2004 presidential election in the US both the Bush and Kerry campaigns claimed mothers groups as supporters." Moreover, as Middleton (2006) argues, many women under duress, those whose lifestyles are not accepted by society and whose motherhood is questioned by society's moral norms, find it difficult as mothers to manage their own lives and those of their family members while also achieving autonomy and independence. Hence we must always distinguish between an ideal conceptualization of empowered mothering and its actual reality.

Just as African American women have used community-based mothering to reaffirm a positive conception of self and community, Oneida women also see mothering as a political act, as a way to participate in the sustainability of the self and the community by bearing children, taking care of "other" children, regardless of whether or not they are related by blood, and taking care of the whole community in order to resist forms of racial discrimination and cultural genocide (Collins 2000). Similarly, an Anishinaabe's ideology of mothering includes the belief that Anishinaabe women have a responsibility to "raise up and nurture the next generation ... not dependent on whether, as individuals, we produce children biologically ... producing and raising children is understood as the creation of a people, a nation, and a future" (Bédard 2006, 66). Doing various mothering activities ensures that these "mothers" participate in the political dimension of their nation. By being surrounded by strong and independent yet still gentle and caring women, children can learn to value the feminine spirit and to respect and treat women, our mothers, as equal to men (O'Reilly 2004). From an Indigenous standpoint, this kind of mothering contains a responsibility to "prepare and equip the next generation to bring about an indigenous resurgence based on indigenous interpretations of our traditions" (Simpson 2006, 26). In this type of mothering, then, the space of home and family is not oppressive for women but a space where our identity is affirmed and valued and where healthy lives are constructed (Collins 1990). Indeed, for Indigenous women, families are our "foundations of resistance" because they give us the strength needed to defy oppressive experiences (Anderson 2000). It is within this context that mothering for these women represents a positive political act and is traced back to the original Creation Story, where Sky Woman created Turtle Island and where her daughter, Lynx Woman, gave life to the first humans on earth.

Kim commented on the concept of "mothers of the nation": "The role, power, comes from the Creation Story really. In that story it is said that there was no earth, and this woman came from the sky and later gave birth to twins, the first humans born on earth." Lisa also talked of the concept's origin in the Creation Story: "For us, the one that created the earth was a woman, not a man. It is because she is the one that gave the life, not just humans but everything, on earth that we then said that women are the life givers of the earth, of the nation." Anne-Marie said,

Mothers of the nation is a very powerful and a good role. Or at least it should be so. It was so in the beginning, and it is connected to the way

our creation stories talk about the power of the women, they were the ones who first came on earth, gave life to earth. And that is why we say Mother Earth. It all goes back to the Creation Story really and the powers that went to women because they were the life givers. You still hear that said all the time. I don't think it has gone away. Maybe changed a bit, but still is a strong thing. As long as our stories are told, and we teach the right way, mothers of the nation, Mother Earth are going to stay with us, guide us to the right way.

The importance of the role of women as mothers of the nation was transferred into the Great Law of Peace, which outlined the principles of governance for all Haudenosaunee nations, among them the Oneida. Mary pointed to the Great of Law of Peace when she said,

In the Great Law of Peace, the Peacemaker knew well that women were, because of the Sky Woman, the ones that gave life. They were the ones to take care of the nation, to be the mothers of the nation, and that is why the clan mothers are very important, they decide who is chief, they had final say, helped the nation to be strong.

Another woman, Carol, also connected the Great Law of Peace to the Creation Story:

Women became the ones who pass the clan, they became the ones who named chiefs because they were already for a long time known to be mothers of the nation, the life givers, because of our Creation Story. So already before the Peacemaker came, already there was the knowledge that women were mothers of the nation, so they should be involved in all important areas about the community. And that is what the Peacemaker did, included women's power in the Great Law of Peace.

For Oneida and other nations of the Haudenosaunee, mothering the nation involves much more than merely biologically producing children, the new generation of the nation. Moreover, it is not considered mandatory or necessary to biologically produce children for women to become mothers of the nation. According to Debbie,

To be a mother means you take care of your family. For one thing, it can mean that if you have your own children, you take care of them, be a nurturing, caring mother to them. Teach them the right way, to be

strong, caring people, to share with others, respect the elders, etc. That is to be a mother, not only to make sure they have food, clothes, is to take care of all their needs and raise them good.

Lori also talked about this dimension of mothering, noting that to be a good mother, one needs to

be there for your children, for your family. When they are small, they come first. You know, when they are little ones, they need lots of caring, love, and you have to be a good model, you know. Little ones are pretty smart; they watch everything. That is how they learn. So if they see that you are good to others, they will be good too. If they see you are not honest, lie, they pick up on that and think lying is ok. We want to teach the little ones to be good people in our community.

Of course, mothering one's own children does not stop at a young age, as Mary pointed out: "A mother is always a mother. The children grow up, but they always depend on their mothers for advice, to show the right way to be a wife, a parent, for example. Or they need someone to help them when things get tough in life. A mother's love is never finished they say. And isn't that right?"

The women also discussed other dimensions of mothering; for example, Sheri said,

All women are mothers. Not only those that have their own children. Well, in our culture, children are considered gifts of the Creator, and a gift that needs to be cherished, protected, taken care of by all. Sometimes it is not the woman who gave birth to a child that ends up being the "real" mother. It can be the grandmothers, the aunties, the sisters, the fathers, the neighbour. As long as that child is taken care of, given love, support, guidance. In our culture, all the extended family is responsible for the caring.

This dimension of mothering is an example of "other" mothering, or community mothering, which Collins (2000) has examined in the lives of African American women. There are indeed many similarities between Collins's conceptualization of mothering and the dimensions of mothering referred to by Sheri and other women in this research. Stacey gave a similar example, describing herself as

the mother of the children of my sisters, my brothers, my cousins. It means caring about the wellbeing of everyone in the community. That is what "mother of the nation" means, I think. It means that we have to take good care of each other, caring for the future of our community. I am a mother when I see a child in the street alone and crying and I make sure I give him my love. If he needs food, I give him food. If he is not treated right at home, I talk to his family, do something about it. When there is a problem in the community, to be a mother means you want to do something about it.

Darlene talked of the role of aunties as an important dimension of mothering. Herself an auntie, she said,

> To be an auntie is very important in our community. The way I see it, I am there to help my sister with taking care of the children. I spend lots of time with them, almost every day. They often eat at my place; I sit and play with them. I tell them stories, try to teach them things about the Oneida culture. My sister knows that I will always love them, care for them, she can count on me.

Tracy also sees her role of auntie as a form of mothering. She said,

> To be an auntie is to be part of the whole thing about women are life givers, healers, mothers of the nation. So when you say "mothers of the nation" to me, I don't just think of my mother, or giving birth. Of course, that is also part of it, but it is bigger than that. Being an auntie is also being that. An auntie has responsibilities too; she also is part of the bringing-up of children in our community. I am responsible for whenever my nephews need me, I am there and they know that. I think that is the great thing about our ways: you have a big family you can count on. This makes sure that no one has to worry to be alone.

Elderly women have a lot of status in Oneida culture, regardless of whether or not they have had children. Carol spoke of this status:

> In our culture, the very old women, man, they really are the ones who we respect. They have wisdom, they have knowledge, they have survived lots in life. They have lots to teach us, they are patient, strong and are the true mothers of the nation. You can see that kind of respect when

we get together, at meeting, at ceremonies. Whenever an elder speaks, we listen!

Similarly to Carol, Frances said that elder women

are the ones who really care about the nation. They always want to help in every way, they treat all children like their own, they want to make sure that when they leave this world to go to the Spirit World, the nation is strong again. They always have the seventh generation in mind when they speak. You can really see that.

Leslie, an elder, called herself "a grandmother," adding,

That is what we are. And we are grandmothers of everyone. Grandmothers are the ones that sit with the children and slowly teach them the way. We have seen so much, good and bad and we are responsible to pass that on to the new ones, to you. Grandmothers are there for people to ask for information, about the teachings, about the language, about how things should be done, how to fix problems, to help people to make sure this community stays strong. We are the mothers of the nations. Even if you don't have children, oh, that doesn't mean you don't do the job, in the caring of the community. You have a responsibility to others; you see something is wrong, needs to be done, go there and help. Mothers of the nation, well ... is about helping others.

Leslie's comment embraces the various dimensions of mothering the nation, which, above all, contains the elements of helping others and of sharing responsibilities in order to maintain balance and wellbeing in the nation. Another aspect of mothering that some of the twenty women spoke about was that of being a teacher. For example, Shirley said,

Teachers are mothers. They have a very hard, responsible job to do here. We trust them to take care of our children, to make sure they learn all they need in order to be good members of our community, of our Oneida nation. Teachers need lots of patience, caring, they have to be patient because kids aren't always quick to learn and know that the teacher is trying to teach them the right ways. Teachers have the kids with them a long time, sometimes longer than the parents, so they do lots of the job that parents do too.

I view my role of a university teacher as a form of mothering. I attempt to do my best to ensure that my students can grow as individuals and critical thinkers and that they can develop the skills they will need outside of the classroom. I also try to inform my students of Indigenous history and issues so that they can better understand the current realities of Indigenous lives. I feel that, like a mother, I am honest, caring, respectful, and a guide for my students. I also know that when students come to me to discuss a personal matter or to tell me that they have learned something new about a topic, I feel a warmth inside, a gladness in knowing that these students will walk out of my class perhaps a bit more knowledgeable and wise. Biologically, I have not yet had a child, but I sense that my feelings are similar to those of other women who have given birth and who have seen their children grow. As an auntie myself, I take the auntie's job of mothering very seriously. I assist my brother and sister in providing their children with love, support, and care, and I am always consciously aware that these children are sacred gifts.

Mothering the nation, as shown by the women I spoke with, is a very powerful and positive aspect in the lives of Oneida women. The concept of women as "mothers of the nation" has a long history within Oneida and other nations of the Haudenosaunee League. It is a concept that can be traced back to the Creation Story and other teachings and one that was later incorporated into the political structure of the league through the Great Law of Peace. However, these women also commented on the ways that such concepts have changed, talking about the negative changes that have occurred in Indigenous women's lives and discussing what they feel needs to be done in order to address their issues and challenges.

Oneida Women Speaking about Their Contemporary Challenges

Each day Oneida women personally face many pressing issues and challenges, some specifically tied to their gender and others more generally tied to their Oneida identity. The women in this book often named colonialism and racism as major factors either in the origin of these issues or at least in their persistence. The issues they most often cited included poverty, domestic and youth violence, loss of the Oneida language and loss of other cultural elements, divisions within Indigenous groups (e.g., between status and nonstatus groups and between urban and reserve groups), alcoholism, gender inequality, and loss of lands and ongoing land-claim disputes with the various levels of the Canadian government.

Barbara described the current situation within Indigenous communities as

> quite sad, very upsetting. It is really an injustice, think about it, from very healthy, equal nations we became poor, dependent on the Canadian government, got lands taken away from us, lost pretty much the language, or very close to it. We got put in residential schools, where many got abused, lost their culture, so then was hard to function well in the community again. How do you expect that when someone has been put down, abused, learned to hate herself, when she comes out, how can she be a good person, a good mother? We changed so much, not because we wanted, we were forced to give up so much. We resisted of course, but it has been hard and so much destruction has happened.

Leslie also spoke of the destruction in Indigenous lives due to centuries of colonialism:

> Well, I don't know what would have happened if we didn't have to go through all the bad things we had, you know? Maybe eventually women, one example here, would still have lost a lot of the good powers they had, but we would never know what would have happened, no? Change would still happen, I know that, but maybe, just maybe, would have been a good change. But that is not what happened, eh? Bad changes came. You name it, we have it: lost lots of lands so that the government and businesses would get rich, lots of people got put in residential schools where they learned to hate themselves and others, and came out angry, confused and took that hate on their families, on women, on children. To make Indians happy, the Europeans gave the alcohol and now, we have all these alcohol problems, because people are poor, desperate, have lots of anger, hate, don't know what to do and turn to do bad things. So many things, Lina, so many. We got to do something, we got to fix things.

Anne-Marie said,

> Colonialism has done lots of damage to our communities. Not only did we lose lands, a very huge deal to us because we needed them to survive, but also because our cultures are very connected to our lands. So when people stripped us from our lands, they also took our spirituality away, our connection to our ancestors, and that is a damage that I think white

people, the Europeans that came, didn't understand. Or maybe they did, who knows? I don't want to believe they were that mean. Ok, maybe so, after all, they did lots of mean things to us, right? With colonialism, you have that others came and started to control us, to tell us how to run our own communities, you know? Wanted to change us into becoming like them. They called us savages, wanted to save us, they said. But we didn't get salvation. If you ask me, we got what? Hell, that's what we got. We got stripped of our rights, our freedom, tried to destroy our culture. And we still are trying to recover from that. We have been fighting ever since. Even fighting against each other.

Kim also said that divisions and conflict within Indigenous communities are results of colonialism:

The Europeans that came to settle here, and the government were pretty smart, you know? What better way to control, oppress people when you have them fight with each other? So, for example, they start changing the way women and men related with each other, gave some power to men and not women. For example, no longer the women controlled the land, the way the food was divided, no longer women could divorce, then later on, they said that women had no say in the politics of the reserves, only men. What do you think that did to our communities? Women, they lost a lot because of colonialism, really lots. We are getting things a bit better now, but it is taking lots of fighting, time, patience.

By closely listening to these women's words, we can see that they understand that transformations in gender relations have occurred through processes of colonization in their own communities. Prior to colonization, and the eventual introduction of a patriarchal hierarchy, Haudenosaunee women had many rights, such as sexual autonomy, ownership of property, decision-making power in matters of peace and war, and authority to appoint and remove traditional chiefs (Monture-Angus 1995, 1999; Stevenson 1999; Goodleaf 1995; Turpel 1993; Mann 2000; Anderson 2000; Lawrence 2004). However, these rights and roles were diminished during the process of colonization, and Indigenous women lost a great deal. Their autonomy was judged negatively by the Europeans, who played an influential role in implementing unequal patriarchal relations in most Indigenous societies (Stevenson 1999; Monture-Angus 1995, 1999; Turpel 1993; McIvor 1999). Due to this historical relationship, many Indigenous women feel that colonialism

is often to blame for the situations they face (Monture-Angus 1995, 1999; Stevenson 1999; Anderson 2000; Ouellette 2002; Lawrence 2004). Indeed, as Barbara, Anne-Marie, Leslie, and Kim said, most of the conditions faced by Oneida and other Indigenous women are directly linked to an ugly colonial history.

Changes both in the image of womanhood and in gender relations are among the negative legacies of colonialism still affecting Indigenous communities. As Lisa expressed,

There is a saying, I am not sure where it originally came from. I know it is a Native saying: "You can't kill a nation until their last woman is destroyed." Well, I believe that's exactly what colonization tried to do. For the Iroquois, for example, the Europeans saw how women had power in their nations, and what did they do? They changed it all. No more power to the clan mothers, no more clan line through the women, they gave more authority to the men. For example, they started only to deal men with men. Slowly, women started to become oppressed, not only by the Europeans, but now you have that within our own communities, our men started to want to run the show. I think that is one of the big problems us Native women face. We have to fight with the Canadian system, with our men, and we have to, if we want to be strong, free again. But we also sometimes have to fight with our own men.

Another woman, Mary, also tied the present conditions of Indigenous women to colonialism:

The bad result of hundreds of years of control, oppression, by a government that had not our interests in mind is that before, men and women had equal rights in our society, Oneida that is, and other Native ones too, I think ... So, to me it looks like that we have forgotten our ways, our teachings, the way the Longhouse was structured. We forgot to be equal, have equal responsibility, a balance. Men, it seems they have forgotten all about the teachings, about the importance of clan mothers, and other women. They started to want to control us. They want us to stay quiet when things are not right. They say it is their job to do things. But they have forgotten, have forgotten, yes, that you can't have a healthy nation if the women are not respected, healthy.

Similarly to Mary, Frances talked about the community's loss of balance, equality, and harmony:

From women having real power as mothers of the nation, now what we have is that we still do lots of the work, in our own homes, in the community, but we don't get the same respect. Some men really get me angry. They are supposed to be good leaders, well, in the old days, leaders had to listen to the women, they couldn't decide on things without talking over with the women and get their okay. Now, we are lucky if we get asked anything. And things us women want to have done, it is hard to get them to listen that these are important things, things for the whole community. I think that the way things are now in a way is the fault of the white government, but they really influenced our men to become like that. But I don't think we have to now excuse how men behave, I don't want to always have to hear from them that excuse. But yes, colonialism is part of the problem.

As discussed earlier in this chapter, some women spoke of tradition in a positive way. They pointed out the potential strength and power that exist in those cultural traditions that view and treat women as central to the foundation and sustainability of the nation. Debbie, Carol, and Kim, for example, said that these cultural traditions provide a foundation for a strong construction of Indigenous womanhood, as the beliefs that women are the "centre of everything" and the "heart of the nation" once facilitated their equal participation in all spheres of Indigenous societies, especially matrilineal ones like that of the Oneida nation. Despite the positive elements of tradition, however, as Mary and Frances mentioned, some aspects of its current interpretation and usage are misguided. Some women spoke of the way that tradition is at times used to restrict and demean them. For example, Kerri said,

We hear all this talk about "mothers of the nation" here, "mothers of the nation" there, but then the same men treat their wives real bad. Now, tell me, how can you say that you know the culture, know that women were the mothers of the nation, you say that clan mothers are important, and then you go home and beat your wife?

Another woman, Anne, said that she considers herself

traditional, but when you have men who think that traditional women means that we stay quiet, stay in the home and take care of the children, well, that is not what tradition is. So we have to be careful about how men use tradition to put us down. And you get that here sometimes.

And, for example, if it is an elder or a leader that tells you, "Oh, but that is our traditional way," you get scared, you know, it is hard to stand up against that. But I was taught tradition to be a good thing.

The (mis)reconstruction of traditional customs and teachings has had very negative impacts on the lives of these women. We must be careful not to overlook or ignore some potentially negative and reactionary outcomes of "cultural" practices that on the surface appear to resist Western imperialism and colonialism but in reality further perpetuate and oppress women, who in the name of "tradition" are asked to step aside and accept roles that are secondary to those of men. For example, Debbie said,

> One traditional thing that gets used bad against us is the mothers of the nation thing. Now, some think that maybe it only means that to do your duty as a member of the nation, you gotta have lots of children, even if you can't support them, there is no support there. Then you are stuck at home, by yourself, taking care of all these children, while the father is nowhere to help out, and you have no energy to get involved in the community, in the politics, where things get decided, things that will affect you and your children. Well, that is not what mothers of the nation is meant to be. So we have to be careful, very careful, that this good, positive thing that is meant to give power to us women doesn't now get used in a wrong way! We want things to get better, and yes, I think to get our traditions back is part of having self-determination, but we have to make sure it is done the right way.

Just as Debbie is wary of how the concept of mothering the nation can become a tool to control and further oppress women, some women spoke of other traditions that, instead of empowering women, can be misused to further victimize or oppress them. For example, Lisa spoke of the misinterpretation of "moon time":

> Now, I know that it [is] something that is supposed to be powerful, because it is part of the whole female power and our connection with Mother Earth and so on. But, I get upset when I see some men, when they know that you are in your moon time, in front of people they remind you not to participate in ceremonies. Now, actually by talking to an elder, she said that no, you can take part in some if you want. There are certain things you don't take part, maybe the berry thing. But some

don't even know how to even teach young women and men what the protocols are, the teachings behind it. They just say, "You women, if you are in the moon time, you can't sit here, you can't stay around the drum." Well, that is just wrong. Because then you think you are being excluded, that you are dirty. We have to find a way to, yes, bring back the traditions, and those are just some that I can think about right now, there are others, I am sure. But these traditions, have to be brought back in a right way, so that we get the power back, not the other way around.

From the above comments, it is clear that these women do recognize that a revival of traditional ways of governing is important if Oneida is to become a self-determined nation again, yet they also recognize that some traditional discourses, when not justly practised, can be used as tools to further oppresss and victimize them. It is true that traditions can be empowering and a source of personal and collective strength in the face of cultural genocide and oppressive colonial structures, yet caution must be exercised to ensure that tradition does indeed liberate women from these structures. When tradition no longer does that, instead further dispossessing women of the power given to them by the Creator, one must be ready to question tradition. As LaRoque (1996, 14) argues, "we must ask ourselves whether and to what extent tradition is liberating to us as women." If tradition becomes a tool to submit women to patriarchal structures, all of us need to question its function and usage. We must question how patriarchy and sexism have found their way into "traditions" and see whether they have been reshaped so that women are no longer the "centre of everything," the "heart of the nation," but have lost the true traditional roles and responsibilities they once held in Indigenous societies (Deerchild 2003; Martin-Hill 2003; Green 2007). Moreover, we must loudly speak against times when "the perversion of traditional beliefs strips women of their historical roles and authority, transforming their status from leaders into servants" (Martin-Hill 2003, 107). Colonialism has had many legacies in most Indigenous women's lives, including poverty, violence, loss of culture, and a transformation of gender relations. Therefore, although it is true that most Indigenous societies do not share Western societies' history of patriarchy, "we have not escaped these social and political structures and ideologies ... colonization has included the imposition of western and Christian patriarchy on Aboriginal people" (St. Denis 2007, 45). Throughout their conversations with me about tradition, colonialism, and the challenges that they currently face, the women in this book indicated that self-

determination is their best option for addressing their present issues and challenges, including those that are gender-based.

Oneida Women Speaking about Decolonization

Like their ancestors centuries ago, contemporary Oneida women are very much involved in a variety of the nation's political activities, either as members of organizations and band councils or as elders, clan mothers, faith keepers, and advisors. A central part of their political involvement includes their participation in the decolonizing of the nation through efforts to become a self-determined people. These women see decolonization as a necessary and empowering undertaking, and they view their participation as an extension of their role as mothers of the nation.

Mary described decolonization as

the answer we need to take back our power, not just Oneida people, but all First Nations peoples. Colonialism has hurt us in many ways. Assimilation didn't work; Canadian government's ways don't work for us. It is time that we take back our power, that we have final say on decisions that happen in our nation, rather than having people in Ottawa deciding for us, people who know nothing about our ways, our culture, our systems, never been in a reserve but pretend they are experts. We need to show to everyone that we can take care of ourselves. I mean our ancestors did, and did a better job than the white government has done.

Like Mary, Debbie said,

It is time, way overdue actually, that we become free again, free to choose. We will probably make mistakes from time to time, but it will be our mistakes, and we will learn and do better with time. But we need to take our power back, that is the only way we will feel proud of who we are, because we will be independent again, not treated like children or savages. We were never savages, we had a good way to relate to each other and for me, self-determination means that: to take back our powers, have our Indigenous rights recognized and respected.

Reviving traditional forms of governance is a necessary component of decolonization and, admittedly, not an easy task. For example, Lisa said,

When I hear the words "self-government," "self-determination," I think that we mean trying to recover parts of our traditions, the way things

were organized, the way we governed ourselves that still can work today. To me, it means that the Haudenosaunee ways must be a big part of that movement and I think it can be done. We still have lots of people that know the teachings of the Great Law of Peace and we can practise those ways again. If there are some parts that don't apply anymore, then we need to sit and discuss and decide what can work for us. But very important, though, it's that we decide for ourselves, just like an independent nation is supposed to be. We won't disturb the Canadian government with their own things; they should leave us alone in running our own ways. To me, that is to change a lot of things, like the Indian Act, but we decide.

Similarly to Lisa, Anne said,

We have to change the way things are being done right now. We need to be confident that we have a rich history, a rich culture, we have the knowledge of what the solution is. I believe that we have to remember what were our own ways, what it means to be Oneida, what made us unique, what were our own traditions and law and put them in place again. We need to stand up for ourselves, to take our power back. Maybe something needs to be adjusted a bit, because we don't live anymore in the 1500s, but lots of things of our tradition still apply, they are just as good today as before.

For these women, part of decolonization also involves taking responsibility for their own actions and roles. Debbie spoke about this aspect of decolonization:

Colonialism, unfortunately, has resulted in our people not taking responsibility over the community, over ourselves. We have become dependent on others to do things for us, dependent on the Canadian government for our economy, for solving our problems, for managing our affairs. We need to change how we think. We have to learn to be self-sufficient again, you know. We have the ability, but I think that oppression, colonialism has stolen our confidence. We need to take action, to be responsible for ourselves, to share our work, to share again, to learn the values of our traditions and be responsible. When there is something that needs to be done, we need to find our own ways to do them, find people in our community that can contribute, have skills to help out.

Similarly, Karen said,

> We need to co-operate, respect each other again. We need to respect the
> elders again, see what they have to teach us, then go to the young ones,
> see what they have to say, how they can help out, go to the women and
> have them take responsibility over the managing of the nation. In other
> words, we need to change our mind too, believe in ourselves, be proud
> of our traditions, include everyone in the discussions that happen about
> the community. Reach consensus, like the old days.

According to one of the women, Kim, "we will never reach self-determin-
ation, we will never be free of colonialism until we learn again what it
means to be Oneida, what the strength of our nation is, and to me that
is the people. We need to live in peace again, in harmony with the earth,
practise our culture, learn the language, have jobs in the community."

Most of the women said that learning again to be Oneida means re-
membering that Oneida people are also People of the Longhouse, Hau-
denosaunee. Leslie, for example, expressed this when she said, "Becoming
self-determined also means to remember the principles of the Haudeno-
saunee: sharing, peace, and leadership. We need to live by these ways
again, then we will have strong, healthy nations." Likewise, Lisa said,

> Colonialism has tried to make us forget the teachings of the Longhouse,
> which were ways to make sure we lived in a good way, and that needs to
> come back. We need the elders to tell us how to do that again, and we
> need us, the women, to be involved in all of that. We have much to lose if
> we don't get involved. Our roles of mothers of the nation demands we
> do, and it is better for us that we do, that way we make sure we help our
> nation to be good again. We leave a good legacy to the next generation.

Decolonizing movements are important and empowering for many
Indigenous women. Lori, for example, said,

> Women need to be involved as much as they possibly can in the move-
> ment, in the struggle for self-determination. There is a lot of stake in
> that. We need to make sure our voices get heard, our issues as women
> are part of the change, so that our lives really improve. We need to tell
> what we feel needs to be changed in our community, how to do it and
> participate in making our nation better. We can't sit and let men decide
> for us, or the government.

Similarly to Lori, Frances said,

> We can't just complain about how things are, we need to take action,
> have to help in every way we can to make sure our Native rights get
> recognized, we have to make lots of noise, be out there with others. We
> have to get involved in the politics of our nation, we have to be involved
> in bringing education to our children, and we have to be involved in
> getting rid of violence in our community. We are part of this nation,
> and at the moment, while the struggle for self-government is happening,
> we have to be involved so that we can help to reach a good result.

Mary saw this participation to be a big part of the role of mothering,
part of the overarching roles that women once held and still partly hold
in the nation. This is obviously a culturally specific concept of mothering
the nation. Different from some non-Indigenous ones, it is not restricted
to producing citizens of the nation or to transmitting culture to members
of the nation but also involves an active and equal participation in all
social and political aspects of the nation. Following the examples of Sky
Woman and Lynx Woman, mothers of the Haudenosaunee nations are
entitled to powerful roles and responsibilities in their individual nations
due to this broad concept of mothering. As Mary told me, there is a need
to revitalize this specific meaning of mothering:

> If we want others to respect us, to treat us seriously as mothers of the
> nation, as life givers, then we need to show what that means. And that
> means doing the dirty work of fighting, fighting against the government,
> against Canadians that want to keep us down. And we also need to fight
> against some within our community who don't want women to have
> the power they had before. We need to be involved in the healing of
> the nation, and that to me is very important, powerful and difficult.

Barbara spoke about one of the difficulties of doing this task:

> Now that men got a little of power in our community, but I mean it is
> a little of power if you think that we still depend on the Canadian gov-
> ernment, and in the outside society they have pretty much no power,
> they aren't going to like us women coming and want to have equal say.
> But when we bring back the fact that women in our traditions are the
> ones who hold the clan line, and so on, they really have little to say. I

think we need to take that power we had back, and we have a chance. I hope we don't lose that chance.

The women often expressed the urgency of decolonization. They spoke of the pressing need to take action and felt that presently there is a revival of Indigenous nationalisms in the country. Debbie referred to this urgency when she said,

NOW is the time to do something.[10] We have waited long enough, and our youth are tired, frustrated of talk and no action from the governments and our Band Councils and leaders. They want things to change, want to be self-sufficient, want disputes to be settled, want language schools to be available and so on. In other words, they want freedom and justice. We demand that our right to be self-governed is respected.

Having good leadership was much desired by the women. They shared Nancy's concern that

The leaders are not really listening at times. We need leaders that know the tradition, are really involved in the communities. We need women leaders too. That is part of being mothers of the nation. To show the children, and I don't mean only children in the real sense, I mean the rest in the communities, they need to show how to be good people, respect each other and live responsibly.

Debbie also expressed a wish likely shared by many Oneida and other Haudenosaunee people:

Maybe the Peacemaker will come again and speak to another person who will speak to the rest and show us again how to go forward. Show us how to bring back those traditions that looks like got lost. Maybe the Peacemaker will also speak to non-Natives about peace, co-operation, sharing, and justice. And then maybe this ugly thing, colonialism, will really go away.

The return of the Peacemaker is a good dream, and dreaming is part of a decolonizing process. Dreaming means remembering our traditions and putting into place those that are still useful and that can liberate Indigenous nations from the many forms of oppression they still face.

It means ensuring that women have a rightful place in the decolonized nation that is to come, one where they are heard, respected, included in important decision making, and conceded autonomy to control their bodies and lives. Indigenous women share in this dream by participating in the decolonizing nationalist movement and by enacting their empowering role of mothering the nation, but they also see in the movement many complexities and challenges, which must be faced with determination.

Dreaming of a Free, Peaceful, Balanced Decolonized Nation: Being Again of One Mind

Clearly, Oneida women have lost a great deal as a result of the changes introduced by colonization. One such change has led to their decreased ability to actively and equally participate in the decision-making activities of their communities. As a result of colonialist structures of governance imposed on "Indians" by the colonial Canadian state, Oneida women have witnessed the transformation of their matrilineal and matrilocal society into a patrilineal and patrilocal one. For example, the Indian Act did not permit women to vote in the electoral system imposed on "Indian" bands by the Canadian state until the mid-twentieth century. As well, "Indian status" was defined according to strict and essentialist criteria stipulating that such status be exclusively derived from a registered Indian male. Until 1985, if an "Indian" woman married a nonstatus male, "Indian" or otherwise, she lost her own status and could not pass it along to her children. These are only some of the changes experienced by women that have had specific gender elements and consequences.

Of course, in addition to these specific changes, most Oneida women, along with their male counterparts, have suffered years of colonialist and racist practices, including dispossession of lands, cultural genocide, removal of children from their families, experiences of residential schools (either as students or as descendants of survivors of such schools), and the imposition of a foreign system of laws and policies. Given the specific colonial dimension of these women's conditions, it is not surprising that for them the central source of oppression that needs to be addressed and altered is the persisting colonial system. As Mary said, "colonialism has hurt us in many ways. Assimilation didn't work; Canadian government's ways don't work for us. It is time that we take back our power, that we have final say on decisions that happen in our nation." Another woman,

Lori, directly linked women's positions and conditions to the need for decolonization:

> Women need to be involved as much as they possibly can in the movement, in the struggle for self-determination. There is a lot at stake in that. We need to make sure our voices get heard, our issues as women are part of the change, so that our lives really improve. We need to tell what we feel needs to be changed in our community, how to do it and participate in making our nation better. We can't sit and let men decide for us, or the government.

Both of these women's statements exemplify the current promise of decolonizing nationalist movements to empower women so that they can reclaim the powerful spaces they enjoyed in their nations before the arrival of Europeans and centuries of colonialism. Yet this promise is jeopardized by divisions that have resulted in imbalanced relations among many groups in each nation, such as between men and women, status and nonstatus "Indians," full-bloods and mixed-bloods, and reserve and urban residents. I see these divisions as having a strong connection with colonialism since it is well known that a colonial power can better achieve its domination and control over the colonized by employing measures intended to "divide and conquer." I view a decolonizing nationalist movement as containing both empowering and challenging possibilities for women. A nationalism rooted in the founding principles of the Haudenosaunee League's traditional form of governance, the KayanlΛhsla²kó, or Great Law of Peace, can be less divisive and healthier and more empowering for women, as well as for men and children. This form of decolonizing can be inclusive, can recognize and accommodate differences, and in accordance with the teachings of traditional stories, can return women to the centre of their nation. In contrast, there could exist a more exclusionary and divisive decolonizing movement based on essentialist criteria of membership in the nation, on a lack of integration of gender in analyses of colonialism, and on a perpetuation of the divisions and oppressions introduced by colonialism.

Indigenous Rights Equal Women's Rights

Oneida women, similar to many other Indigenous women, view their primary responsibility as members of their nations to be participation

in ongoing struggles for land rights, for revitalization of traditional cultural and political systems, and for other changes related to notions of "self-determination," "indigenous rights," and a "decolonizing nationalist movement." By giving central attention to colonialism and by being primarily concerned with finding ways to solve the continuing oppressive conditions that have resulted from colonialism, Indigenous women may at times distance themselves from mainstream feminist theories and movements. As they view the latter to be concerned mainly with male oppression of women and with a disregard for Indigenous rights, some Indigenous women may

> shun feminism and will not associate with people who claim it ... Many of these Indigenous women argue that white women have enjoyed the power privileges that come with being white at the expense of women of colour. Why, they might ask, should Native women align themselves with white feminists to denigrate men, when many white women denigrate Natives? (Mihesuah 2003, xx)

Some well-known Indigenous women activists have given examples of such sentiments. For example, Lorelei Cora Means, a member of both the American Indian Movement and the Women of All Red Nations, states,

> We are American Indian Women, in that order. We are oppressed, first and foremost, as American Indians, as people colonized by the United States of America, not as women. As Indians we can never forget that. Our survival, the survival of every one of us – man, woman and child – as Indians depends on it. Decolonization is the agenda, the whole agenda, and until it is accomplished, it is the only agenda. (Quoted in Jaimes and Halsey 1992, 314)

Hawaiian scholar Haunani-Kay Trask (1996, 910) shares this view of what she terms "First World feminism," arguing that it "is incapable of addressing indigenous women's cultural worlds ... feminism seems more and more removed from the all-consuming struggle against our physical and cultural extinction as indigenous peoples."

Some Canadian Indigenous scholars have similarly argued that colonialism and its many destructive consequences – such as internal violence (some of which is directed toward women by their male partners),

internal divisions, substance abuse, and poverty – are the central concerns for Indigenous women and that although patriarchy and sexism are important matters to address and to solve, they are only two of the crucial issues within a longer list of specific concerns for Indigenous women. For this reason, it is arguable whether feminism can adequately represent Indigenous women's rights, which are so closely tied to colonialism and Indigenous rights (Monture-Angus 1999; Monture 2004; Anderson 2000; Ladner 2000; Ouellette 2002). This view was shared by some of the women with whom I conversed during the development of this book. For example, Lisa commented that "self-determination is the most important battle for us Native women to fight right now. I don't think most feminists really care about our Native rights. It is not their concern really. This is why I told you before that I don't see how feminism is our solution." Similarly, Debbie said, "I just don't see that what we worry about – getting our land rights, protecting our Mother Earth, keeping our children safe from violence, drugs, just surviving really – is what a women's movement cares about."

In the process of decolonization, Indigenous women are formulating a political discourse that is woman-centred and that draws upon women's past practice of their powerful traditional roles within their nations. This discourse recalls the teachings of stories like "Sky Woman Falling from the Sky" and the delivery of the message of peace to the Haudenosaunee nations. These stories have symbolic importance for women of the Haudenosaunee League because they are the foundation of the concept of women as the "mothers of the nation," the "heart of the nation," and the "centre of everything." This concept once translated into material reality for Haudenosaunee women. For example, clan mothers became the ones to hold title to the lands and to the line of descent; as well, they had the responsibility to appoint and remove chiefs, to hold women's councils on matters that concerned the collective, to initiate or stop wars, and to adopt new members into their clan and nation. Hence Oneida women are aiming to bring the symbols of Sky Woman and Lynx Woman to the forefront of the discourses that contextualize decolonizing movements in order to ensure that women are central players in the decolonizing movement and that they have concrete authority and power parallel to that of men in the envisioned postcolonial nation. In short, they are calling for more than just the rhetoric of women as the "centre of everything" and the "heart of the nation."

However, there seems to be a contradiction between the rhetoric of respect for women's traditional roles and a practice that often marginalizes

and further silences them in the name of "tradition." This contradiction is lucidly demonstrated by the words of one woman who participated in my research:

> Women, they lost a lot because of colonialism, really lots. We are getting things a bit better now, but it is taking lots of fighting, time, patience. Many have forgotten the teachings that say that women are the heart of the nations. Sometimes they say the words, but they don't want to really listen to what we have to say.

This concern is shared by Indigenous scholar Lee Maracle (2008, 29), who states that she is

> ultimately concerned about the political direction that the struggle of all our peoples to decolonize takes. Before I can begin to take up the banners that many Native men uphold as the ultimate goal – self-governance, an end to home rule by Canada and the United States – I need to retrace my own steps, the steps of my mother, my grandmother, my great-grandmother, right back to our original selves ... I need to know how it came to pass that women's issues exist separately from men's ... Native women have been asked to back-burner their issues as though the rematriation of our governing structures were somehow separate and secondary to nation building.

Indeed, rematriation is not a back-burner issue! What is needed is a true application of the traditional discourse of women as the "heart of the nation" and an assurance that women will not have to bear their labours in the nation without having an equal voice in the decision-making processes of the decolonization movement. An equal voice will allow Oneida women to be self-determined and to carry out their responsibility as "mothers of the nation," a concept that within an Indigenous context means not only biologically producing children for the nation but also, most important, being active, responsible members of the nation in whatever ways they can by using the special gifts and abilities they have received from the Creator. In decolonizing ourselves, if we are "to claim cultural integrity, national separateness, national identity, we [will] have to reclaim our knowledge of the past and take charge of the institutions that were originally our realm of governance" (Maracle 2008, 31). In the Oneida nation, women once held real power in such institutions of governance and were decision makers in the political, cultural,

social, spiritual, and economic realms; their issues did not sit quietly on the back burner.

For many Indigenous women, decolonizing the nation mainly means revitalizing and reaffirming our own ways of governing, free from impositions by the Canadian state, and reintroducing the founding principles of the Great Law of Peace in order to heal, to unite, and to re-establish "good relations" among our peoples. Underlying this revitalization is the recognition that the clan system could be a good basis for moving forward. The clan system provided the Haudenosaunee League with a mechanism for bonding all members of each nation and all nations of the broader league while also establishing a way to balance responsibilities. "Gender balancing" represents a core component of our system of governance. The balancing of roles and responsibilities allowed all to participate in activities pertinent to the wellbeing of the community and for all to be equally valued. Within this context, responsibility toward one another was the main principle of governing ourselves; this means, as Turpel (1993, 180-81) points out, that

> we are committed to what would be termed a "communitarian" notion of responsibilities to our peoples ... [In this communitarian context] our communities do not have a history of disentitlement of women from political or productive life ... Women are at the centre. We are the keepers of the culture, the educators, the ones who must instruct the children to respect the Earth, and the ones who ensure that our leaders are remembering and "walking" with their responsibilities demonstrably in mind.

Colonization disrupted this balance by disempowering women and keeping them from performing their responsibilities of "mothering," thereby shifting the balance to the advantage of men. This is why the Assembly of First Nations (AFN) is male-dominated, as are many other Indigenous political organizations, and also why "women's issues" are often treated as separate from and secondary to each "nation's issues." But as Monture (2004, 42) reminds us, the AFN is an "organization of chiefs [that is] *Indian Act* based and ... there is nothing particularly 'Indian' about that piece of legislation."

This gender imbalance still exists, although it is being resisted by many women and men. These individuals have taken on the tasks of learning and teaching others that our traditions demand "balancing" as a prerequisite for building and maintaining healthy nations. Recognizing

that revitalization includes acknowledgment of the role of women in protecting Mother Earth, contemporary Indigenous women in Canada are conducting moon ceremonies and other water ceremonies, as well as participating in walks to raise awareness of the destruction done to water (McGregor 2008). These actions reflect a revitalization of women's traditional role as life givers, which exists in most Indigenous societies. As McGregor (2008, 27-28) points out,

> Women play an important role in First Nations cultures as spokepersons for water and carrying the primary responsibility for protecting that water ... water is understood as a living force which must be protected ... it is the giver of life with which babies are born ... women thus have a special relationship with water, since, like Mother Earth, they have life-giving powers. Women have a special place in the order of existence.

In conducting the ceremonies and participating in acts of resistance against abusers of water, women are teaching others about Indigenous peoples' traditional gender roles and responsibilities.

Reintroducing gender balance does not mean that the roles taken on by each sex must be fixed or identical to those of our ancestors (Anderson 2000; Amadahy 2003). Just as precontact roles could shift in order to benefit the community, contemporary gender roles can be fluid in order to bring about balance. Balancing implies recognizing that each member of the nation might have specific contributions to offer the community and should be encouraged to become actively involved so that healthy relations are restored within the nation. As Mary told me,

> Balance means that men maybe have their own responsibilities, women have their own too. But what really counts is that community's needs get done. All the responsibilities are important, necessary. If a man wants to take care of things that most of the times women do, why not? Let him. We shouldn't be jealous of that. We have to be equal and remember that what's important, at the end, is that our community is taken care of.

Recognizing the fluid nature of roles challenges the notion that Indigenous identity should remain frozen in a precontact, romanticized state. As well, it demands further recognition that Indigenous cultures have always been fluid; in fact, "even our oral histories speak of traditions changing over time ... our societies were not static. We learned, grew

and evolved like any other people" (Amadahy 2003, 154). The fixation on a static, authentic, precontact Indigenous identity is a major factor in current divisions within our communities.

Drawing on the traditional principles of the Great Law of Peace could be an effective method not only for decolonizing the Oneida nation but also for healing from the negative legacies of colonialism that have divided the members of the nation by establishing foreign concepts and values of nationhood. The first principle is peace. As we move forward and away from a colonial condition, we need to re-establish peaceful ways of relating with each other. Living in peace means being able to respect ourselves and each other, which requires listening to each other's differences and acknowledging each other's experiences. It also means putting an end to existing divisions and all forms of oppression and exclusion. Current divisions within the nation must be addressed so that all can feel they belong to the nation, all can actively participate in their own ways in rebuilding the nation, and all can have an affirmation of their Indigenous status and Oneida identity. The Great Law of Peace is a very inclusionary set of guiding principles, as it invites those who want to follow the message of peace to join the other nations of the Haudenosaunee League under the Ohtehlase'kówa, or Great Tree of Peace. In fact, a new nation, Tuscarora, joined the league when it was welcomed and adopted by Oneida. Also, the Great Law of Peace gives clan mothers authority to accept new members into the nation; anyone who wants to learn about our culture can be adopted by a female and therefore join the nation through affiliation with her clan. Yet, due to the legacies of colonial practices, many of Oneida's own members have been excluded from membership in their nation and are still struggling to have their national identity acknowledged and affirmed by the Indian Act and/or by the Oneida nation.

The second principle of the Great Law of Peace is power. Again, we must remember that power in the Haudenosaunee context does not mean domination or control of one individual or group by another. It refers to a spiritually derived source of strength that exists inside of us and that allows us to be self-determining and to act upon our responsibilities to ourselves and to the whole community. However, due to the transformations that took place after the introduction of European concepts, including the gender imbalance created by colonization, power has become the source of unequal relations, with the result that some groups no longer act in the best interests of the whole community or strive to achieve consensus. Some leaders no longer represent the people of their

nation, and some men ignore the teachings of our ancestors and walk ahead of women rather than alongside them. In short, in some cases, the oppressed have become the oppressors, and through forms of exclusion they are perpetuating the oppressions that their many sisters and brothers have had to endure at the hands of the colonizers. Karen spoke of the pain that this form of oppression can inflict on the recipients:

> It hurts when it is someone you don't know who treats you badly. But, man, it is something even deeper; it really makes you bleed when it is your brother, your own father who treats you just as bad. When it is those who talk about oppression, about the white man oppressing us and then go and do the same to their own women, then who do you turn to?

Indeed, when some Indigenous people eagerly turn to their nation for support and healing but are turned away, where else can they turn given that outside of their nation they are also, if not more so, excluded and oppressed?

The third principle of the Kayanlʌhslaʔkóis righteousness, which characterizes the kind of governance to which the nations of the Haudenosaunee League must aspire. Such governance is kind, patient, caring, and attentive to the welfare of all members of each nation, of all nonhuman species, and of those not yet born. The leaders of each nation are particularly instructed to demonstrate these values when conducting the affairs of their nation, and they are expected to have clear and good minds. Following the principle of righteousness leads all to relate with each other in a healthy way, to attempt to maintain balance with all relations and with Mother Earth, and to keep in mind the health of future generations. Although I see many people who do follow the principle of righteousness when interacting with others, I also see many instances where the values taught to us by the Peacemaker are ignored. I see patterns of behaviour where some are not kind to each other, where some members of the nation are abused by others, and where some are left feeling that they are not "real Indians" because of the adoption of foreign criteria for membership and adherence to essentialist notions of identity. I do not see kindness when women are not respected by some men or when they try to speak out against some injustices and are told that their conduct is not "traditional" and that they have become too Westernized. These women may be trying to reaffirm their responsibility for mothering, they may be seeking the ability to act on their "Indianness"

through reacceptance into the nation if they have lost status due to the colonial impositions of Chapter 29, Section 12(1)(b), of the Indian Act, or they may be asking for assurance that the needs and voices of women will be incorporated in the agenda of liberation so that a true liberation from colonialism can occur in their lives.

Although I see limitations in the relevance of mainstream feminism to the analysis of Indigenous women's lives, I do not maintain that one must silence those women who see some benefit in using that analysis and space for their struggle against the silencing, marginalization, oppression, violence, and discrimination with which they live in their nations and in mainstream society. It is women's right to use the tools that they deem appropriate for improving their lives, those of their loved ones, and those of the members of their communities. Moreover, employing feminist discourse is one way to ensure the centrality of gender analysis in theorizing women's lives. Nonetheless, I object to dismissively labelling as "feminist talk" Indigenous women's call for their concerns, issues, and rights to be heard, respected, and addressed, as such a view ignores the seriousness of the conditions faced by Indigenous women and of the responsibility to re-establish a gender balance in our nations.

Women's Rights Equal Indigenous Rights: Addressing Gender and Other "Differences" in Nation (Re)building

Some of the legacies of colonialism currently faced by the Oneida nation, such as the establishment of patriarchy, sexism, internal divisions among different groups, and the challenge of how to move toward decolonization so that healing can occur and good relations can be re-established, are similarly experienced by other Indigenous peoples. For example, Maori people in Aotearoa/New Zealand are also in the process of decolonizing their land and also face the challenge of incorporating gender equality into the discourses of decolonization and the challenge of de-essentializing concepts of Indigenous identity (Hoskins 2000; Smith 1999; Jones, Herda, and Suaalii 2000; Johnston and Pihama 1994; Barcham 2000).

Jones, Herda, and Suaalii (2000) describe the current situation of women of the Pacific as "bitter sweet." By this terminology, they mean that the sweet fruit of independence gained by their countries has also brought some sour taste, as liberation seems to be reserved for the men and denied to the women: "The sweetness of indigenous gains in struggles for sovereignty and land rights have often been tinged for

women with the sour inevitability of male privilege" (10). Maori scholar Te Kawehau Clea Hoskins (2000) critiques the way that cultural discourses related to gender during decolonizing struggles have reconstructed and positioned Maori women in ways that ultimately seem to be working against their interests. She speaks of the ways that the search for an "authentic" Maori self, although valued by some because it is believed to be tied to an autonomous Maori future, could be problematic. She argues that it would be practically impossible to return to an earlier "authentic" identity after centuries of colonization and that it might not be desirable, as cultures change over time. Within a contemporary context, notions of authenticity might serve to divide Maori around constructed binaries of authentic and inauthentic Maori:

> Notions of authenticity within our reconstructive work can encourage and perpetuate binary distinctions and relationships, with their implied legitimacy and superiority, like tribal/urban, speaker of teo/non speaker, tuturu/born again, decolonised/colonised, dark/fair, full blooded/half caste. These kinds of distinctions perpetuate a narrow and oppositional worldview. Our subordinate positioning within oppositional dualisms inherent in the colonizing ethos is one we must be mindful not to re-produce within our own cultural reconstruction. (Hoskins 2000, 36)

Specifically with regard to gender, Hoskins (2000, 37) argues that Maori society must be mindful not to reproduce hierarchies of power wherein Maori women are required to follow a constructed notion of authentic Maori womanhood that ignores the reality that contemporary Maori identities are shaped by socio-historical contexts and have therefore taken on a multitude of forms, none of which is more or less authentic than any other. Hoskins (2000, 37) argues that "what is required for our reconstructive work as Maori is the development of and engagement with notions of identity which acknowledge and provide space for our multiplicity, our contradictions, and our difference as people, while at the same time affirming and encouraging our sameness." Furthermore, "traditional" gender discourses construct Maori women within cultural parameters that do not work in their best interests, as the process of colonization in New Zealand, similar to that of Canada, has reorganized and reconstructed gender roles and given rise to relationships that are patriarchal and that reduce women's roles to servitude (Hoskins 2000; Johnston and Pihama 1994). It is therefore necessary that Indigenous women critically investigate how "tradition" is or is not a discourse that

can empower them during the decolonization movement and that they assert themselves and take back those spaces that they have been denied. This demands that within the struggle for independence from colonialism, the struggle for gender equality within and outside of Indigenous societies should also be incorporated. As I have argued elsewhere (Sunseri 2000), only when a national liberation movement offers an emancipatory place for women in all of its phases can it be called truly liberatory for Indigenous women because only then can women walk in equality with men and children along the same path and achieve the gender balance that existed prior to colonization. Only then will we, as women, truly experience a "restoration of our original institutions of power, management, authority, choice, permission, and jurisdiction ... [which] is what nationhood is all about" (Maracle 2008, 38).

Hence, although many Indigenous women do not fully embrace most mainstream feminist theories and movements, especially those aligned with a liberal view, others recognize the fluidity of feminist theories as well as the need to "both address sexism *and* promote Indigenous sovereignty simultaneously" (Smith 2007, 95, original emphasis; see also Green 2007). Like Maracle (2008, 45), I

> respect women who have taken up the Canadian feminist response, unlike those who dismiss them because they are "influenced from outside our world." I believe their feminism is in response to the internal male invasion of our areas of jurisdiction. Unlike those who condemn them for operating from outside our culture, I understand that they are operating from within the current conditions.

Nonetheless, I personally do not label myself or my work as "feminist" – not because of a fear of being condemned but because I still see limitations in the feminist approach, as it is not fully engaged with colonialism, with decolonialism, and with a reaffirmation of Indigenous traditions that are women-centred yet gender-balanced. I see our main fight to be with the Canadian state and a persistent colonial society. This position does not mean that I am antifeminist, only that, like Monture-Angus (1999) and Monture (2004), I do not preoccupy my work and most of my energy with the movement or theory of feminism. Yet, of course, as an Indigenous, Haudenosaunee woman, my perspective is ultimately necessarily gendered and centred on women's experiences of both the past and the present.

Recently, I have seen more potential for a deeper integration of feminism and Indigenous worldviews and experiences. Within Canada, an Indigenous feminism is emerging whose adherents "see great potential for positive change through feminist praxis in anti-colonial context ... claiming that Aboriginal feminism is the tool that will bring about decolonization" (Green 2007, 26). Feminists of this sort do not view feminism as a man-hating ideology (a perception that I have heard from a remarkable number of men and women alike in my community, including a participant in my research), nor do they wish to reject Indigenous cultures, traditions, or personal and political relationships with men (Green 2007, 26). However, they point to the fact that "tradition is neither monolithic, nor is it axiomatically good ... Women around the world have found themselves oppressed through a variety of social, religious, political and cultural practices" (Green 2007, 26-27). Indeed, I share this view of tradition, as do some of the women who contributed to this book; we must not be afraid to look critically at how tradition can be disempowering when used to silence, exclude, and further oppress some members of our nations. For Indigenous feminists, "feminism has provided tools to critique oppressive traditions – and to claim and practice meaningful non-oppressive traditions" (Green 2007, 27). This use of feminist discourse can be only positive, yet one does not have to resort to feminism to engage in such a critique of tradition: in my community, many elderly women who do not identify themselves as feminists have critiqued men – and women – who have tried to use traditions in such oppressive ways, calling on them to remember the Creator's teachings and that traditional practices are meant to heal us, not to further hurt us by creating gender inequities or divisions.

The gender inequities and the divisions deriving from binary constructions are also currently splitting Indigenous communities of Canada. One can see examples of these outcomes when examining some discourses of cultural and national identities that are constructed around notions of "purity" of blood, reserve residency, and other similar conceptions that divide Indigenous nations based on essentialist and exclusionary identities. What seems to be forgotten and/or distorted within such discourses of nationalism is that these ways of defining Indigenous identity are not traditional but are due to colonial constructions of identity that have produced what McIvor (1999, 179) has termed a "fictitious body of Indians." Unfortunately, some Indigenous communities are not challenging such colonial constructs but, in the name of

pragmatic essentialism and as a method to survive culturally as Indigenous people, are modelling their criteria for membership in their nations after colonial constructs. A possible result of such adaptations is a persistent exclusion and oppression of those whose Indigenous identity is constructed as inauthentic and who are thus viewed as "outsiders." Moreover, relying on such essentialist criteria ignores the fact that the original marginalization and exclusion of most of these so-called "outsiders" resulted from what Lawrence (2004) argues was part of the agenda of colonial cultural genocide, which took many forms, including the disempowerment of women in their nations. Such disempowerment of women was effected by erasing their "Nativeness" through dispossessing them of their status as members of their nation if they "married out" and also by banning them from voting in their band councils and from participating in the appointment of traditional chiefs, in the case of matrilineal societies like that of the Oneida nation.

The devastating practical result of colonial policies such as that outlined in Chapter 29, Section 12(1)(b), of the Indian Act was that for several decades many women and their descendants were robbed of their Indigenous right to belong to their nations and were forced to leave their communities, thus ending their participation in all community activities. Canadian colonial laws have disrupted Indigenous ways of belonging to Indigenous nations, and many communities are still struggling to heal from the legacies left by such divisive practices of cultural genocide. I agree with Lawrence (2004) that one needs to regard such policies as attempts at cultural genocide, as they resulted in erasing many individuals' right to be "Indians" and divided our communities along binaries such as full-blood/mixed-blood, status/nonstatus, and reserve/urban. These policies impacted formations of identity and, in the case of the Haudenosaunee League, affected each nation's ability to live in accordance with the principles of the Kayanlʌhslaʔkó, which had been set in place so that people would put down their arms, unite in a circle of friendship and peace, and "live in a good way." The gendered element of such policies cannot be easily ignored, as women were the original potential targets of such a dispossession of identity, as were their children, grandchildren, and great-grandchildren, some of whom were boys/men.

McIvor (1999) argues that the struggle to face and remove such barriers in order to fully live as "Indians" is not merely an issue of gender: it is both a women's issue and an Indigenous issue. She explains that the

broad struggle for recognition of their sex equality rights represents the effort by Aboriginal women to shed the shackles of oppression and colonialism ... Aboriginal women's sex equality litigation is a story of women striving to achieve the most basic incidents of citizenship: equal status and membership within Aboriginal communities, equal entitlement to share in matrimonial property, and equal participation in Aboriginal governance. (McIvor 2004, 107)

In short, the struggle of Indigenous women is part of the history of colonialism, which translated into various forms of dispossession – of land and of cultural identity – and into attempts to erase the "Indian" from many groups (Lawrence 2004). Through denial of "legal" membership status, many women have not been able to live as *Indian women,* and this exclusion must be recognized as simultaneously multiple, as they have not been able to identify themselves as both "Indian" and women at the same time, categories that must be understood as interdependent. Hence their current struggle to claim their Indigenous identity as equal to that of those who were not denied this identity is not merely their individual right as women but also their collective right given that within an Indigenous worldview the individual and the collective are correlated and cannot be separated. This acknowledgment leads, then, to a further consideration of the challenges this particular group faces.

Some women have pointed out to me that neither Oneida, nor Haudenosaunee, nor Indigenous identity is something obtained from the state or other structures. They have commented that one can feel and act as a member of such a nested identity regardless of whether one possesses the legal piece of paper that "proves" one's identity, as the Creator is the one who gives us our original Indigenous rights. Nonetheless, it cannot be denied that the internalization of constructed notions of identity is dividing our peoples into those who are "naturally" viewed and treated as members of their nation and those who constantly have to negotiate, "prove" their identity, and struggle to have others recognize them as Indigenous. Yet, as many Indigenous scholars argue (Lawrence 2004; Simpson 2000; Anderson 2000; Barcham 2000; Monture-Angus 1995, 1999; Stevenson 1999; McIvor 1999), such constructions are not based on Indigenous traditions. Rather, they constrain Indigenous peoples to adhere to an imaginary primordial concept of identity and require them to prove that they have retained precontact, premodern,

non-Western characteristics in order to assert their Indigenous rights. Ultimately, this demand cannot accommodate multiple, evolving, fluid ways of being and becoming Indigenous. As well, in the search for the pure and authentic Native, many individuals are excluded from participating in rebuilding their nation. Such boundaries to community membership are at times enforced by those members who are "legally Indians." This practice is often

> based on the need to maintain Native land in Native hands and to control who will have access to community resources. There is the ever-present, pressing need to protect the cultural knowledge that the colonizing culture for over a century has targeted for extinction and a determination that only those who have shared a colonized people's history should participate in shaping its destiny. (Lawrence 2004, 13)

However, the experience of colonialism has varied among groups, with differences being most likely between those who have lived on "reserves" and who thus appear Native and those who have been forced to leave the "reserve" and who thus may not appear Native (Lawrence 2004). But the experiences of all such groups make up the whole colonial experience. Different experiences need to be recognized, notions of "authenticity" must be questioned, and there must be an end to the construction of a hierarchy of colonial experience. Each experience of colonization must be validated so that each Indigenous individual feels that he or she has specific gifts to bring to the nation that will be well received by others for the wellbeing of the collective.

Earlier, I noted that dreaming is a powerful and necessary component of decolonization. I hope that such dreaming will help our respective Indigenous nations to heal from the legacies of colonialism and to remember the message of peace that was delivered to us many centuries ago, which served the purpose of unifying the nations of the Haudenosaunee League and establishing good relations among them. Perhaps a revitalization of the principles of the Great Law of Peace can help us to accommodate differences and to truly challenge colonial constructs, the purpose of which was to eliminate the "Indian problem." If we do not find ways to remove the present divisions and unequal relations, the dream of decolonization might turn out to be a nightmare for many, and the changes produced by a decolonizing nationalist movement could prove to be "bitter sweet." As pointed out by Altamirano-Jiménez

(2008, 129), we must ensure that gender issues no longer remain "submerged in political struggles emphasizing self-determination, cultural differences, and experiences of material and social inequalities." Pushing women's voices, experiences, issues, and contributions aside can make some women reluctant to engage in the decolonizing movement, but such exclusion can also "create alternative spaces of action and strategies aimed at challenging the legitimacy and hegemony of such [exclusionary] discourses and power" (129). This is not necessarily a bad thing, as Indigenous women's "discourses [could] both reproduce Indigenous traditions and resist the hegemony of dominant representations of tradition" (129).

Women, then, and all other marginalized groups within Indigenous nations, need to take part in this dreaming activity in order to transform the dream into a reality. They can contribute their own visions, stories, and gifts to building a free, peaceful, balanced decolonized Turtle Island so that we can again be of one mind, as the Creator intended. We need a strong, committed Indigenous leadership to "take up the challenges of so-called modernity and return Indigenous peoples to our rightful place within the global community ... The well being of our communities depends on how well our leaders can effectively participate in this complex, often challenging world" (Turner and Simpson 2008, 2). In the process, Indigenous leaders must be careful not to be co-opted by the state and not to internalize a colonial mentality and the structures of governing that go against our own empowerment and our just traditions. Doing so will enable them to attack the "state's claim to authority over Indigenous peoples ... [and to engage] in the first stages of a movement to restore their autonomous power and cultural integrity in the area of governance" (Alfred 2005a, 39). Much is at stake if we fail to ensure that our leaders are successful in resisting co-option by the state: the wellbeing of our communities, the future of our young and of our unborn children, and the wellbeing of our Mother Earth. However, there is potential for success: our communities are increasingly revitalizing our traditions and are attempting to restore balance to our relations within our communities and with mainstream society. I do believe that Sky Woman is guiding us on a path that will lead us to a better future for our youth and will return women to their rightful places within our nations – but we must let her do her work.

Concluding Remarks

I often show a film in the sociology classes that I teach entitled *Keepers of the Fire,* where four groups of Indigenous women of Canada share their experiences and talk about the ongoing struggles they face both within their respective communities and within mainstream Canadian society and the Canadian state. In describing their challenging roles, these women term themselves "warriors" of their nations; they are ordinary women who are carrying the responsibility to fight against various forms of oppression in their daily lives. The concept of "warrior" used by these women has a specific Indigenous cultural meaning. "Warrior" refers to an individual who carries the burden of peace. A warrior must ensure that good relations are maintained between Indigenous peoples and all other people and species and, most important, that the land is protected and nurtured so that it can sustain the present and future generations.

At the beginning of the film a Cheyenne proverb is spoken by the narrator: "You can't kill a Nation until the hearts of the women are on the ground." Next, an overview is presented of the changes in gender relations that have occurred in most Indigenous communities due to patriarchal colonial structures. Despite the Canadian state's efforts to destroy Indigenous peoples' cultures and extinguish their nations through attempts to force their women's hearts to the ground, Indigenous women have kept resisting their colonization and have been engaged in the war against colonialism for many centuries. Many of my students are surprised to learn of the powerful roles that women held in their nations and have become more aware of the connection between colonialism and contemporary Indigenous women's conditions.

My Oneida name is Yeliwi:saks, which means Gathering Stories, Knowledge. According to Haudenosaunee traditions, a clan name gives a clan

member specific responsibilities, which correspond to one's given name, so that one can contribute to the wellbeing of the community. In carrying the responsibility to acquire knowledge and pass it on to others, I share my knowledge of the Oneida people's and other Indigenous peoples' issues with others, as I regularly do in my university classes. During my research, I acquired a deeper knowledge of the multitude of Oneida women's experiences in their nation. As part of my clan name's responsibility, I aim to contribute to the existing literature on nation and nationalism by offering an Indigenous perspective. I am working toward becoming a word warrior (Turner 2006) by articulating Indigenous peoples' differences from the dominant culture and by creating a space for Indigenous voices in the academy (Turner 2006). Drawing on my own experiences with Oneida nationalism, my exposure to traditional teachings throughout the years, and my reading of the literature by other scholars, I began my research as though I were having a dialogue with the literature that I had been exposed to, more specifically the modernist theories of nation and feminist theories. I was interested in finding out whether and how these theories applied to the case of the Oneida nation. Although most theories do offer valuable insights about the concept of nation and can be used to understand contemporary Oneida nationalism, they have some limitations.

The strength of mainstream theories of nationalism in relation to Oneida, and possibly other Indigenous nations, derives from their challenge to any a priori concept of nation on the grounds that such a concept is a social construction. This allows one to consider nations and their ideological components, nationalisms, to be constructed by people in specific contexts and to be fluid entities. In reviewing Oneida's case, one can see this to be true: Oneida people's sense of themselves as a nation went through changes. Oneida changed from a specific independent nation to one that belonged to a large confederacy of nations: the Haudenosaunee League, also known as the People of the Longhouse. Moreover, the Oneida nation was later subdivided into three different communities in the mid-1800s. More significantly, the Oneida nation, after the colonization of North America, suffered the same colonial experiences as other Indigenous peoples and became a colonized nation. Recently, a decolonizing nationalist movement has taken shape on Turtle Island, and the Oneida nation is in the process of redefining itself as a nation and envisioning a decolonial future. As Little Bear (2004) explains, Indigenous philosophy incorporates the idea of renewal, a recognition that everything/everyone is interrelated and always in flux; in fact, our

ceremonies revolve around renewal. I also understand this to mean that our nations are renewing themselves at the moment, that the past is in motion with the present in preparation for the future; we are connecting with our Indigenous teachings and living them in a today that is necessarily shaped by our past.

The limitation of male/mainstream theories of nation is due to their insistence on conceptualizing nation only in relation to modernity and statehood. In doing so, they exhibit a Eurocentric bias and quickly dismiss the formations of nations outside of modern industrialized European models. By looking at the existence of the Oneida nation prior to and outside of European-based characteristics of nation, I am in some way "writing back to the empire" (see Ashcroft, Griffiths, and Tiffin 1989). In doing so, I am showing that there is evidence of nations outside of European nation-states and that there can be a theory of nation and nationalism that is an alternative to mainstream Eurocentric/ Westerncentric theories. For example, Oneida has a long history of identification as a nation, the origins of which date to centuries before the arrival of Europeans: its members shared a language, a culture, a territory, and an elaborate form of governance. Different from European nation-states, Oneida was founded on a less fixed notion of territory, had no private ownership of lands, and had no hierarchical political organization, hence no state. Yet the absence of these characteristics does not in itself mean that the original Oneida people were nationless. Only when one constructs a typology of nation that is modelled exclusively after European experiences and sets this typology within a linear and evolutionary framework do Indigenous nations such as Oneida become viewed and labelled as "tribes." One must remember that such a construction demonstrates Eurocentric biases and can facilitate the perpetuation of the discourse of "civilization," the main function of which was to justify the colonization of those who lacked features of "civilized nations." In "writing back" to master narratives of nation, I challenge such dominant discourses and in the process add to an already emerging global Indigenous scholarship whose one aim is to decolonize academia. This decolonizing project insists that societies such as that of Oneida be recognized as nations whose members never extinguished their right to exist as such and who are currently engaged with the existing nation-states that occupy their lands in a negotiation process in order to form a nation-to-nation relationship and to have Indigenous forms of governance recognized.

In this book, I have looked particularly at the transformation of the roles of Oneida women in their nation. Oneida women originally had a central and powerful position in their nation, owing to the Creation Story, where the beginning of human life on earth is credited to a woman. Due to this story's teachings, Oneida women were given prominent roles in their nation and were viewed as "mothers of the nation." The concept of "mothers of the nation" has been critically analyzed by some feminist theorists because of its contradictory consequences for women during most nation-building projects. As these theorists argue, women may gain status from such a construct, but they can also be rigidly controlled by it, especially in cases where membership in a nation is based on a strict notion of purity of blood and on essentialist notions of culture. However, historically for Oneida women, as well as for other Haudenosaunee women, "mothering the nation" did not constrain them to the private sphere or result in negative controlling mechanisms. The symbolic meaning of the concept of mothering extended well beyond the biological reproduction of citizens for the nation. In fact, the concept took on concrete form in the material world for Oneida women, as shown by the example of the various responsibilities and rights attributed to clan mothers in each of the Haudenosaunee nations.

But it cannot be denied that the colonization experienced by Indigenous nations has led to unequal gender relations within the nations and to other divisions and inequities. Some examples of such devastating consequences are: the imposition of patrilineality as the basis for registration under the Indian Act and for acquisition of Indian status; the "marry-out" clause of the Indian Act, which stripped women who married nonregistered, nonstatus males of their Indian status; the enforcement of a government structure based on elected band councils in Indigenous communities; and the denial of women's right to participate fully in the political activities in their communities as they had previously done. The narratives that I have shared here reveal that contemporary Oneida women see their current conditions within their community to be largely derived from imposed colonial policies and ideologies, which have resulted in a deterioration of their positions in many social systems. Given this circumstance, they feel that a decolonizing nationalist movement has the potential to restore the gender balance that existed in their nation prior to colonialism. A decolonizing nationalist movement should be understood as one that aims to form a new relationship with the Canadian nation-state and its society by breaking

away from colonialist structures of governance. Such a movement is rooted in Indigenous notions of nationhood and sovereignty and is committed to re-establishing an autonomous and self-determined Oneida nation.

The experiences of the women who contributed to this book have reinforced in me, and hopefully in my readers as well, the belief that participation in such a decolonizing nationalist movement is empowering for them both as Oneida people and as women. They feel that decolonization is the locus of their empowerment because their struggle is devoted to liberating themselves from persistent colonial conditions. Additionally, they view their involvement in such a movement to be part of their overall responsibility as mothers of the nation. Many of the women in fact talked of the traditional active participation of Oneida women in the public matters of their nation. This required participation is stated in the Great Law of Peace, the body of principles that historically guided matters of governance for the Haudenosaunee nations. In the process of decolonization, these women are attempting to reclaim those spaces that were previously held by Haudenosaunee women. Hence the root of their liberation can be found within an Indigenous tradition that was woman-centred and provided a basis for gender balance. These women feel that it is not only their right to participate in the decolonizing nationalist movement but also their responsibility as Oneida women. Moreover, they believe that Oneida women's specific gendered issues can be best addressed within a decolonizing movement. Through their active participation in the ongoing formulation of discourses of nationalism, they have an opportunity to ensure that issues of gender will not be ignored on the path toward decolonization.

It must be recognized that presently these women's participation in their nation is full of complexities, paradoxes, and challenges. The warnings offered by some feminist analyses of nationalist discourses and projects that one needs to be careful not to prematurely applaud women's seemingly empowering roles in nationalist movements do have, then, some validity in the case of Oneida women. There are indications that women's participation in the current nation-(re)building movement in Oneida contains many tensions. For example, "tradition" can be used in contradictory ways. At times, it can be used as a tool to empower them by teaching members of Haudenosaunee nations about the inclusiveness, balance, and equality of Haudenosaunee traditions derived from the principles of the Great Law of Peace. However, there are cases

where "tradition" is used in ways that silence and marginalize women by constraining them in devalued domestic spheres and regulating their behaviour.

Ultimately, I argue that there is no single version of Indigenous nationalism. Some Indigenous nationalisms can be progressive and based on notions of inclusiveness, peace, balance, and righteousness. Others can take an exclusionary form and be based on essentialist criteria, such as purity of blood, and therefore have the potential to create divisions and to perpetuate unequal relations within nations. But overall, Oneida women have shown that they are gaining political, social, and economic agency as they contribute to the future formation of a decolonized Oneida nation. Through their participation, they are shaping the evolving discourse of nation, often in contestation with male-dominated organizations. By carrying their responsibility as warriors of their nations, they aim to return the powerful symbols of Sky Woman and Lynx Woman to a revitalized Indigenous-based political structure. Hence it is possible that their roles and rights can be ensured and realized and that the present divisions existing in the Oneida nation, which are ultimately linked to colonialism, can be addressed and removed by following those principles of the Great Law of Peace that can still work in contemporary Indigenous lives. Because those principles allow for differences to be recognized and accepted and for gender balance to be possible, they can reduce the risk of perpetuating essentialist, exclusionary, and oppressive practices.

I hope this book can be beneficial to my Oneida nation. As my community is engaged in a decolonizing movement whose goal is to re-establish an autonomous and self-determined nation and to revitalize Indigenous cultural and political structures, my review of Oneida and Haudenosaunee political history could offer insight into some social factors that are contributing to the present challenges faced in the community. I have also illustrated the inclusiveness, equality, and peace that existed within Indigenous nations like Oneida that were guided by the ethic of "living in a good way." Within a nation founded on such principles, gender balance was vital for obtaining harmony and wellbeing. Today, such balance has been disrupted due to centuries of colonization and the introduction of patriarchal and other divisive relations in our community.

Decolonizing implies the capacity to dream of a better world. Indeed, the women who contributed to this book have shared with us their dream of a decolonized nation while also making us aware of the need

to integrate gender equality into a decolonizing nationalist project and to remove other divisive colonial legacies. The women who made this book a possibility do believe that decolonization is the central concern for Indigenous women, but they also argue that decolonization means a removal of *all* forms of unequal relations that are present in our "Indian country." And even though it must be recognized that such relations are often legacies of colonialism, it is time to stop using the "colonial excuse" when explaining present conditions and instead to take on the responsibility of acting justly so that balance can be brought back into our communities. Women, together with men, are warriors of the nation and as such have a vital role to play in (re)building the Oneida nation.

NOTES

Introduction

1 Onyota:aka can also be rendered as Onyota'a:ka.
2 For a detailed discussion of my methodology and a general discussion of decolonizing Indigenous research, see Sunseri (2007).

Chapter 1: Theorizing Nations and Nationalisms

1 I have come across the term written in this way in various Indigenous texts, academic and not so academic. I can't recall where I first saw it. However, within an academic context, I first encountered it in Ladner (2000, 37).
2 The significance of wampum belts is covered in subsequent chapters in great detail.
3 Chapter 3 provides a history of these processes.
4 These contentious issues are analyzed in much more depth throughout this book.

Chapter 2: A History of the Oneida Nation

1 The five nations of the Haudenosaunee League became the Six Nations when Tuscarora joined them, through adoption by Oneida, in 1722.

Chapter 3: Struggles of Independence

1 In 1997 the Supreme Court of Canada ruled on the *Delgamuuk* case. In its judgment, it stated that First Nations' rights to the land are protected under the Constitution and that these extend to contemporary use. However, the judgment was ambiguous, as it stated that Aboriginal rights could be regulated and that the burden to prove exclusive use and occupancy of traditional Aboriginal lands rested with First Nations. In reaching this decision, the Supreme Court took into consideration oral testimony and oral traditions as valid forms of evidence. For more on this case, see Battiste (2000), Monture-Angus (1999), and Coates (2000).
2 In many Iroquoian stories, the Europeans are referred to as the Salty Beings.
3 This is the Seneca word for the Great Law of Peace, referring to the message of peace provided by the Peacemaker.
4 The concept of mothering is further discussed later in the book.

5 In 1985, as a result of intense community organizing within Indigenous communities, an amendment to this section of the Act was passed, known as Bill C-31. This bill reinstates the Indigenous status of women who have "married out," as well as the status of their children. However, this granted reinstatement is not applicable to their grandchildren because of a "second-generation cut-off rule." The implications and limitations of this bill are covered in more detail in Chapters 5 and 6.

Chapter 4: Women, Nation, and National Identity

1 The role of the Peacemaker in the formation of the Haudenosaunee League is discussed in earlier chapters. Upon receiving the message of peace from the Creator, the Peacemaker convinced Jigonsaseh (who is also known as the Lynx Woman) and the chiefs of each of the five nations of the league to put aside their weapons of war and follow the message of peace, power, and righteousness – the founding principles of the Great Law of Peace.

2 Chapter 2 discusses in detail the importance and structure of the clan system, which is a basis of unity, peace, and harmony among all the nations of the Haudenosaunee League. Every member of each nation belongs to a clan, derived from his or her mother, and is a kin relation of other members of the same clan among all the nations. The Oneida nation is made of three clans: Turtle (my clan), Wolf, and Bear.

3 The Longhouse refers to the traditional socio-political organization of the Haudenosaunee League. The Longhouse obtained its name from the physical structure of the league's meeting place in front of a fire inside a longhouse.

4 Chapters 2 and 3 discuss the significance of wampum belts, which are made of beads and are used by many Indigenous peoples in North America to exchange cultural and historical knowledge. The Friendship Belt to which Barbara referred is made of strings of wampum beads that document a pledge of friendship between two different people or nations.

5 I want to give special gratitude to my mother, to my sister (although not an elder, she has been a teacher to me in many ways), to my Aunt Donna, and to my clan mother for teaching me all of this throughout the years.

6 Mary pointed out that she doesn't know much of the history of the clan system and does not think too much about her own clan, what it stands for, and what it means. Only when directly asked about her clan did she give it some serious thought.

7 Due to many internal and external factors, the original Oneida nation, which was located in what is now known as New York State, split into three communities: one stayed in the original territory, one went to Wisconsin, and one settled in Ontario in 1840. This latter community is known as Oneida of the Thames, and it is the community to which I belong.

8 Due to my mixed ancestry and my ability often to pass as "non-Native," my experiences of racism are not identical to those of Sheri. Nonetheless, I have experienced direct and systemic forms of racism, and I therefore never feel that I neatly belong to the category of "Canadian" or that I am perceived as such by many viewers.

9 The following discussion on Indigenous mothering is derived mostly from this article.

10 Debbie asked me to use bold and capitalized letters here when she saw an early draft of this book. She wanted her feelings of urgency to be clear.

REFERENCES

Abdo, Nahla. 1994. "Nationalism and Feminism: Palestinian Women and the Intifada – No Going Back." In Valerie Moghadam, ed., *Gender and National Identity*, 148-70. London: Zed Books.

Acoose, Janice. 1995. *Iskwewak – Kah'ki Yaw Ni Wahkomakanak: Neither Indian Princesses nor Easy Squaws*. Toronto: Women's Press.

Alfred, Gerald R./Taiaiake. 1995. *Heeding the Voices of Our Ancestors: Kahnawake Mohawk Politics and the Rise of Native Nationalism*. Toronto, New York, Oxford: Oxford University Press.

–. 1999. *Peace, Power, Righteousness: An Indigenous Manifesto*. Don Mills, ON: Oxford University Press.

–. 2005a. "Sovereignty." In Joanne Barker, ed., *Sovereignty Matters: Locations of Contestation and Possibilities in Indigenous Struggles for Self-Determination*, 33-50. Lincoln: University of Nebraska Press.

–. 2005b. *Wasáse: Indigenous Pathways of Action and Freedom*. Toronto: Broadview Press.

Altamirano-Jiménez, Isabel. 2008. "Nunavut: Whose Homeland, Whose Voices?" *Canadian Woman Studies* 26, 3-4: 128-37.

Amadahy, Zainab. 2003. "The Healing Power of Women's Voices." In Kim Anderson and Bonita Lawrence, eds., *Strong Women Stories: Native Vision and Community Survival*, 144-55. Toronto: Sumach Press.

Amnesty International Canada. 2004. "Stolen Sisters: A Human Rights Response to Discrimination and Violence against Indigenous Women in Canada." http://www.amnesty.ca/resource_centre/reports/view.php?load=arcview&article=1895&c.

Anderson, Benedict. 1991. *Imagined Communities*. Rev. ed. London and New York: Verso.

Anderson, Kim. 2000. *A Recognition of Being: Reconstructing Native Womanhood*. Toronto: Second Story Press.

–, and Bonita Lawrence, eds. 2003. *Strong Women Stories: Native Vision and Community Survival*. Toronto: Sumach Press.

Anthias, Floya, and Nira Yuval-Davis. 1989. *Woman-Nation-State*. London: MacMillan.

–. 1992. *Racialized Boundaries: Race, Nation, Gender, Colour and Class and the Anti-Racist Struggle*. London: Routledge.

Antone, Eileen M. 1993. "The Educational History of the Onyota'a:ka Nation of the Thames." *Ontario History* 85, 4: 309-20.

–. 1998. "Oneida of the Thames Historical Booklet." In Raymond Skye, ed., *The Great Peace: The Gathering of the Good Minds*, 2-40. Brantford, ON: Working World Training Centre.

–. 1999. "The Move to Canada." In Laurence M. Hauptman and L. Gordon McLester III, eds., *The Oneida Indian Journey: From New York to Wisconsin, 1784-1860*, 135-38. Madison: University of Wisconsin Press.

Ashcroft, Bill. 2001. *On Post-Colonial Futures: Transformations of Colonial Culture*. London and New York: Continuum.

–, Gareth Griffiths, and Helen Tiffin, eds. 1989. *The Empire Writes Back: Theory and Practice in Post-Colonial Literatures*. London: Routledge.

Bannerji, Himani. 2000. *The Dark Side of the Nation: Essays on Multiculturalism, Nationalism and Gender*. Toronto: Canadian Scholars' Press.

Barcham, Manuhuia. 2000. "(De)Constructing the Politics of Indigeneity." In D. Ivison, P. Patton, and W. Sanders, eds., *Political Theory and the Rights of Indigenous Peoples*, 137-51. Cambridge: Cambridge University Press.

Barker, Joanne. 2005. "For Whom Sovereignty Matters." In Joanne Barker, ed., *Sovereignty Matters: Locations of Contestation and Possibility in Indigenous Struggles for Self-Determination*, 1-32. Lincoln: University of Nebraska Press.

Barman, Jean, Yvonne Hebert, and Don McCaskill. 1986. *Indian Education in Canada*. Vol. 1, *The Legacy*. Vancouver: UBC Press.

Battiste, Marie. 2000. "Introduction: Unfolding the Lessons of Colonization." In Marie Battiste, ed., *Reclaiming Indigenous Voice and Vision*, xvi-xxx. Vancouver: UBC Press.

Baydar, Gülsüm. 2006. "Territories, Identities, and Thresholds: The Saturday Mothers Phenomenon in Instanbul." *Journal of Women in Culture and Society* 31, 3: 689-715.

Bédard, Renée Elizabeth Mzinegiizhigo-kwe. 2006. "An Anishinaabe-kwe Ideology on Mothering and Motherhood." In D. Memee Lavell-Harvard and Jeannette Corbiere Lavell, eds., *Until Our Hearts Are on the Ground: Aboriginal Mothering, Oppression, Resistance and Rebirth*, 65-75. Toronto: Demeter.

Bhabha, Homi K. 1985. "Signs Taken for Wonders: Questions of Ambivalence and Authority under a Tree outside of Delhi, May 1817." *Critical Inquiry* 12, 1: 144-65.

–. 1989. "Remembering Fanon: Self, Psyche and the Colonial Condition." In B. Kruger and P. Mariani, eds., *Remaking History*, 131-50. New York: St. Martin's.

–. 1994. *The Location of Culture*. London: Routledge.

–, ed. 1990. *Nation and Narration*. London: Routledge.

Blauner, Robert. 1987. "Colonized and Immigrant Minorities." In Ronald Takaki, ed., *From Different Shores: Perspectives on Race and Ethnicity in America*, 149-60. New York: Oxford University Press.

Borrows, John. 1997. "Wampum at Niagara: The Royal Proclamation, Canadian Legal History, and Self-Government." In Michael Asch, ed., *Aboriginal and Treaty*

Rights in Canada: Essays on Law, Equality, and Respect for Difference, 155-72. Vancouver: UBC Press.

Bouatta, Cherifa. 1994. "Feminine Militancy: Moudjahidates during and after the Algerian War." In Valerie Moghadam, ed., *Gender and National Identity,* 18-39. London: Zed Books.

Campisi, Jack, and Laurence M. Hauptman, eds. 1988. *The Oneida Indian Experience: Two Experiences.* Syracuse, NY: Syracuse University Press.

Charles, Nickie, and Helen Hintjens, eds. 1998. *Gender, Ethnicity and Political Ideologies.* London: Routledge.

Chatterjee, Partha. 1986. *Nationalist Thought and the Colonial World: A Derivative Discourse?* London: Zed Books.

–. 1993. *The Nation and Its Fragments: Colonial and Postcolonial Histories.* Princeton, NJ: Princeton University Press.

Cherifati-Merabtine, Doria. 1994. "Algeria at a Crossroads: National Liberation, Islamization and Women." In Valerie Moghadam, ed., *Gender and National Identity,* 40-62. London: Zed Books.

Coates, Kenneth. 1985. "Betwixt and Between: The Anglican Church and the Children of Carcross (Chooutla) Residential School, 1911-1954." *B.C. Studies* 64: 27-47.

–. 2000. *The Marshall Decision and Native Rights.* Montreal: McGill-Queen's University Press.

Collins, Patricia Hill. 1990. *Black Feminist Thought: Knowledge, Consciousness and the Politics of Empowerment.* New York: Routledge.

–. 2000. *Black Feminist Thought: Knowledge, Consciousness and the Politics of Empowerment* (second ed.). New York: Routledge.

Dannenmann, Kaaren, and Celia Haig-Brown. 2002. "A Pedagogy of the Land: Dreams of Respectful Relations." *McGill Journal of Education* 37, 3: 451-69.

de Alwis, Malathi. 2003. "Reflections on Gender and Ethnicity in Sri Lanka." In W. Giles, M. de Alwis, E. Klein, and N. Silva, eds., *Feminists under Fire: Exchanges across War Zones,* 15-24. Toronto: Between the Lines.

de Mel, Neloufer. 2003. "Agent or Victim? The Sri Lankan Woman Militant in the Interregnum." In W. Giles, M. de Alwis, E. Klein, and N. Silva, eds., *Feminists under Fire: Exchanges across War Zones,* 55-74. Toronto: Between the Lines.

Deerchild, Rosanna. 2003. "Tribal Feminism Is a Drum Song." In Kim Anderson and Bonita Lawrence, eds., *Strong Women Stories: Native Vision and Community Survival,* 97-105. Toronto: Sumach Press.

DiQuinzio, Patrice. 2006. "The Politics of the Mothers' Movement in the United States: Possibilities and Pitfalls." *Journal of the Association for Research on Mothering* 8, 1-2: 55-71.

Dirlik, Arif. 1994. "The Postcolonial Aura: Third World Criticism in the Age of Global Capitalism." *Critical Inquiry* 20: 328-56.

Doxtator, Deborah Jean. 1996. "What Happened to the Iroquois Clans? A Study of Clans in Three Nineteenth Century Rotinonhsyonni Communities." PhD diss., Department of History, University of Western Ontario.

Dua, Enakshi. 2000. "The Hindu Woman's Question." *Canadian Woman Studies* 20, 2: 108-17.

Eglitis, Daina Stukuls. 2000. "Mother Country: Gender, Nation, and Politics in the Balkans and Romania." *Eastern European Politics and Societies* 14, 3: 693-702.

Enloe, Cynthia. 1993. *The Morning After: Sexual Politics at the End of the Cold War.* Berkeley, Los Angeles, and London: University of California Press.

Fanon, Frantz. 1963. *The Wretched of the Earth.* New York: Grove.

–. 1965. *A Dying Colonialism.* New York: Grove.

–. 1967. *Black Skin, White Masks.* New York: Grove.

Fenton, William. 1998. *The Great Law and the Longhouse: A Political History of the Iroquois Confederacy.* Norman: University of Oklahoma Press.

Foucault, Michel. 1980. *Power/Knowledge: Selected Interviews and Other Writings, 1972-1977.* New York: Pantheon.

Gehl, Lynn. 2000. "The Queen and I: Discrimination against Women in the Indian Act Continues." *Canadian Woman Studies* 20, 2: 64-69.

Gellner, Ernest. 1983. *Nations and Nationalism.* Ithaca and New York: Cornell University Press.

Giles, Wenona, Malathi de Alwis, Edith Klein, and Neluka Silva, eds. 2003. *Feminists under Fire: Exchanges across War Zones.* Toronto: Between the Lines.

Gilroy, Paul. 1987. *There Ain't No Black in the Union Jack: The Cultural Politics of Race and Nation.* London: Hutchinson.

–. 1993. *The Black Atlantic: Modernity and Double Consciousness.* Cambridge, MA: Harvard University Press.

Goodleaf, Donna. 1995. *Entering the War Zone: A Mohawk Perspective on Resisting Invasions.* Penticton, BC: Theytus.

Green, Fiona Joy. 2006. "Developing a Feminist Motherline: Reflections on a Decade of Feminist Parenting." *Journal of the Association for Research on Mothering* 8, 1-2: 7-20.

Green, Joyce, ed. 2007. *Making Space for Indigenous Feminism.* Black Point, NS: Fernwood.

Haig-Brown, Celia. 1988. *Resistance and Renewal: Surviving the Indian Residential School.* Vancouver: Tillacum.

Hall, Catherine. 1994. "Re-Thinking Imperial History: The Reform Act of 1867." *New Left Review* 208: 3-29.

–. 1996. "Histories, Empires and the Post-Colonial Moment." In I. Chambers and L. Curti, eds., *The Post-Colonial Question: Common Skies, Divided Horizons.* London: Routledge.

–. 1999. "Gender, Nations and Nationalisms." In E. Mortimer, ed., *People, Nation and State: The Meaning of Ethnicity and Nationalism,* 45-55. London: I.B. Tauris.

Hall, Stuart. 1992. "The West and the Rest: Discourse and Power." In Stuart Hall and B. Gielben, eds., *Formations of Modernity,* 275-331. Cambridge, UK: Polity and Open University.

–. 1994. "Cultural Identity and Diaspora." In P. Williams and L. Chrisman, eds., *Colonial Discourse and Postcolonial Theory,* 392-403. New York: Columbia University Press.

–. 1996a. "New Ethnicities." In D. Morley and K.H. Chen, eds., *Stuart Hall, Critical Dialogues in Cultural Studies,* 441-49. London: Routledge.

–. 1996b. "When Was 'the Postcolonial'? Thinking at the Limit." In I. Chambers and L. Curti, eds., *The Post-Colonial Question: Common Skies, Divided Horizons,* 242-60. London: Routledge.

Henderson, James (Sákéj) Youngblood. 2000. "Postcolonial Ledger Drawing: Legal Reform." In Marie Battiste, ed., *Reclaiming Indigenous Voice and Vision,* 161-71. Vancouver: UBC Press.

–. 2007. *Treaty Rights in the Constitution of Canada.* Toronto: Nelson/Carswell.

Hobsbawm, E.J. 1992. *Nations and Nationalism since 1780: Programme, Myth, Reality* (second ed.). Cambridge: Cambridge University Press.

Hodgson, Maggie. 1992. "Rebuilding Community after the Residential School Experience." In Diane Engelstad and John Bird, eds., *Nation to Nation: Aboriginal Sovereignty and the Future of Canada,* 101-12. Concord, ON: Anansi.

Hokowhitu, Brendan. 2002. "Te Mana Maori – Te Tatari I Nga Korero Parau." PhD diss., School of Physical Education, University of Otago.

Hoskins, Te Kawehau Clea. 2000. "In the Interests of Maori Women? Discourses of Reclamation." In A. Jones, P. Herda, and T.M. Suaalii, eds., *Bitter Sweet: Indigenous Women in the Pacific,* 33-48. Dunedin, New Zealand: University of Otago Press.

Howe, LeAnne. 2002. "The Story of America: A Tribalography." In Nancy Shoemaker, ed., *Clearing a Path: Theorizing the Past in Native American Studies,* 29-48. New York: Routledge, 2002.

Jacobs, Beverly. 2008. "Response to Canada's Apology to Residential School Survivors." *Canadian Woman Studies* 26, 3-4: 223-25.

Jaimes, M. Annette, and Theresa Halsey. 1992. "American Indian Women at the Center of Indigenous Resistance in Contemporary North America." In M. Annette Jaimes, ed., *The State of Native America: Genocide, Colonization, and Resistance,* 311-44. Boston: South End.

Jayawardena, Kumari. 1986. *Feminism and Nationalism in the Third World.* London: Zed Books.

Johansen, Bruce E. 1998. *Debating Democracy: Native American Legacy of Freedom.* Sante Fe, NM: Clear Light.

Johnson, E. Pauline Tekahionwake. 2002. *Collected Poems and Selected Prose.* Toronto: University of Toronto Press.

Johnston, Darlene M. 1986. "The Quest of the Six Nations Confederacy for Self-Determination." *University of Toronto Faculty of Law Review* 44, 1: 1-32.

Johnston, Patricia, and Leonie Pihama. 1994. "The Marginalization of Maori Women." *Hecate* 20, 2: 83-98.

Jones, Alison, Phyllis Herda, and Tamasailau M. Suaalii, eds. 2000. *Bitter Sweet: Indigenous Women in the Pacific.* Dunedin, New Zealand: University of Otago Press.

Kalter, Susan. 2001. "America's Histories Revisited." *American Indian Quarterly* 25, 3: 329-51.

Keung, Nicholas. 2009. "Status Indians Face Threat of Extinction." *Toronto Star,* 10 May. www.thestar.com.

Ladner, Kiera L. 2000. "Women and Blackfoot Nationalism." *Journal of Canadian Studies* 35, 2: 35-60.

Laenui, Poka (Hayden F. Burgess). 2000. "Processes of Decolonization." In Marie Battiste, ed., *Reclaiming Indigenous Voice and Vision*, 150-60. Vancouver: UBC Press.

LaRoque, Emma. 1996. "The Colonization of a Native Woman Scholar." In Christine Miller and Patricia Chuchryk, eds., *Women of the First Nations: Power, Wisdom, and Strength*, 11-18. Winnipeg: University of Manitoba Press.

Lavell-Harvard, D. Memee, and Jeannette Corbiere-Lavell, eds. 2006. *"Until Our Hearts Are on the Ground": Aboriginal Mothering, Oppression, Resistance and Rebirth*. Toronto: Demeter.

Lawrence, Bonita. 2002. "Rewriting Histories of the Land: Colonization and Indigenous Resistance in Canada." In Sherene Razack, ed., *Race, Space, and the Law: Unmapping a White Settler Society*, 21-46. Toronto: Between the Lines.

–. 2004. *"Real" Indians and Others: Mixed-Blood Urban Native Peoples and Indigenous Nationhood*. Lincoln: University of Nebraska Press.

Lazarus, Neil. 1999. *Nationalism and Cultural Practice in the Postcolonial World*. Cambridge: Cambridge University Press.

Little Bear, Leroy. 2000. "Jagged Worldviews Colliding." In Marie Battiste, ed., *Reclaiming Indigenous Voice and Vision*, 77-85. Vancouver: UBC Press.

–. 2004. "Aboriginal Paradigms: Implications for Relationships to Land and Treaty Making." In Kerry Wilkins, ed., *Advancing Aboriginal Claims: Visions/Strategies/Directions*, 26-38. Saskatoon: Purich.

Loomba, Ania. 1998. *Colonialism/Postcolonialism*. London: Routledge.

Mackey, Eva. 2002. *The House of Difference: Cultural Politics and National Identity in Canada*. Toronto: University of Toronto Press.

Magee, Kathryn. 2008. "'They Are the Life of the Nation': Women and War in Traditional Nadouek Society." *Canadian Journal of Native Studies* 28, 1: 119-38.

Mann, Barbara Alice. 2000. *Iroquoian Women: The Gantowisas*. New York: Peter Lang.

–, ed. 2008. *Make a Beautiful Way: The Wisdom of Native American Women*. Lincoln: University of Nebraska Press.

Maracle, Lee. 2008. "Decolonizing Native Women." In Barbara Alice Mann, ed., *Make a Beautiful Way: The Wisdom of Native American Women*, 29-51. Lincoln: University of Nebraska Press.

Martin-Hill, Dawn. 2003. "She No Speaks and Other Colonial Constructs of the Traditional Woman." In Kim Anderson and Bonita Lawrence, eds., *Strong Women Stories: Native Vision and Community Survival*, 106-20. Toronto: Sumach.

–. 2008. *The Lubicon Lake Nation: Indigenous Knowledge and Power*. Toronto: University of Toronto Press.

McClintock, Anne. 1995. *Imperial Leather: Race, Gender and Sexuality in the Colonial Contest*. New York: Routledge.

McGinty, Anna Mansson. 2007. "Formation of Alternative Femininities through Islam: Feminist Approaches among Muslim Converts in Sweden." *Women's Studies International Forum* 30, 6: 474-85.

McGowan, Kay Givens. 2008. "Weeping for the Lost Matriarchy." In Barbara Alice Mann, ed., *Make a Beautiful Way: The Wisdom of Native American Women*, 53-68. Lincoln: University of Nebraska Press.

McGregor, Deborah. 2008. "Anishinaabe-Kwe, Traditional Knowledge, and Water Protection." *Canadian Woman Studies* 26, 3-4: 26-30.

McIvor, Sharon Donna. 1999. "Self-Government and Aboriginal Women." In Enakshi Dua and Angela Robertson, eds., *Scratching the Surface: Canadian Anti-Racist Feminist Thought,* 167-86. Toronto: Women's Press.

–. 2004. "Aboriginal Women Unmasked: Using Equality Litigation to Advance Women's Rights." *Canadian Journal of Women and Law* 16: 106-36.

Middleton, Amy. 2006. "Mothering under Duress: Examining the Inclusiveness of Feminist Mothering Theory." *Journal of the Association for Research on Mothering* 8, 1-2: 72-82.

Mihesuah, Devon Abbott. 2003. *Indigenous American Women: Decolonization, Empowerment, Activism.* Lincoln: University of Nebraska Press.

–, ed. 1998. *Natives and Academics: Researching and Writing about American Indians.* Lincoln: University of Nebraska Press.

Miles, Robert. 1989. *Racism.* London: Routledge.

Moghissi, Haideh. 1999. *Feminism and Islamic Fundamentalism: The Limits of Postmodern Analysis.* London: Zed Books.

Monture, Patricia A. 2004. "The Right of Inclusion: Aboriginal Rights and/or Aboriginal Women?" In Kerry Wilkins, ed., *Advancing Aboriginal Claims: Visions/ Strategies/Directions,* 39-66. Saskatoon: Purich.

–. 2008. "Women's Words: Power, Identity and Indigenous Sovereignty." *Canadian Woman's Studies* 26, 3-4: 154-59.

Monture-Angus, Patricia. 1995. *Thunder in My Soul: A Mohawk Woman Speaks.* Halifax: Fernwood.

–. 1999. *Journey Forward: Dreaming of First Nations' Independence.* Halifax: Fernwood.

Morris, Glenn. 1992. "International Law and Politics." In Annette Jaimes, ed., *The State of Native America,* 55-86. Boston: South End.

O'Reilly, Andrea. 2004. *Mother Outlaws: Theories and Practices of Empowered Mothering.* Toronto: Women's Press.

Ouellette, Grace J.M.W. 2002. *The Fourth World: An Indigenous Perspective on Feminism and Aboriginal Women's Activism.* Halifax: Fernwood.

Page, Jake. 2003. *In the Hands of the Great Spirit.* New York: Free Press.

Parker, Arthur C. 1916. *The Constitution of the Five Nations, or The Iroquois of the Great Law.* Albany: University of the State of New York.

Parry, Benita. 1994. "Signs of Our Times: A Discussion of Homi Bhabha's *The Location of Culture.*" *Third Text* 28-29: 5-24.

Porter, Robert B. 1998. "Building a New Longhouse: The Case for Government within the Six Nations of the Haudenosaunee." *Buffalo Law Review* 46: 805-945.

Pratt, Mary Louise. 1992. *Imperial Eyes: Travel Writing and Transculturation.* London: Routledge.

Quayson, Ato. 2000. *Postcolonialism: Theory, Practice or Process?* Cambridge, UK: Polity.

Riley, Glenda. 1986. *Inventing the American Woman: A Perspective on Women's History.* Arlington Heights: Harlan Davidson.

Said, Edward. 1978. *Orientalism.* London and Henley: Routledge and Kegan Paul.

Shohat, Ella. 1993. "Notes on the 'Post-Colonial.'" *Social Text* 31: 99-113.

Silva, Neluka. 2003. "Introduction." In W. Giles, M. de Alwis, E. Klein, and N. Silva, eds., *Feminists under Fire: Exchanges across War Zones,* 37-40. Toronto: Between the Lines.

Simpson, Audra. 2000. "Paths toward a Mohawk Nation: Narratives of Citizenship and Nationhood in Kahnawake." In Duncan Ivison, Paul Patton, and Will Sanders, eds., *Political Theory and the Rights of Indigenous Peoples,* 113-36. Cambridge: Cambridge University Press.

–. 2007. "On Ethnographic Refusal: Indigeneity, Voice, and Colonial Citizenship." *Junctures* 9: 67-80.

Simpson, Leanne R. 2004. "Anticolonial Strategies for the Recovery and Maintenance of Indigenous Knowledge." *American Indian Quarterly* 28, 3-4: 373-84.

–. 2006. "Birthing an Indigenous Resurgence: Decolonizing Our Pregnancy and Birthing Ceremonies." In Memee Lavell-Harvard and Jeannette Corbiere-Lavell, eds., *"Until Our Hearts Are on the Ground": Aboriginal Mothering, Oppression, Resistance and Rebirth,* 25-33. Toronto: Demeter.

Smith, Andrea. 2007. "Native American Feminism, Sovereignty and Social Change." In Joyce Green, ed., *Making Space for Indigenous Feminism,* 93-107. Black Point, NS: Fernwood.

Smith, Anthony D. 1993. *National Identity.* Reno: University of Nevada Press.

Smith, Linda Tuhiwai. 1999. *Decolonizing Methodology: Research and Indigenous Peoples.* London: Zed Books.

St. Denis, Verna. 2007. "Feminism Is for Everybody: Aboriginal Women, Feminism and Diversity." In Joyce Green, ed., *Making Space for Indigenous Feminism,* 33-52. Black Point, NS: Fernwood.

Starna, William A. 1988. "The Oneida Homeland in the Seventeenth Century." In Jack Campisi and Laurence M. Hauptman, eds., *The Oneida Indian Experience: Two Perspectives,* 9-22. Syracuse, NY: Syracuse University Press.

Stevenson, Winona. 1999. "Colonialism and First Nations Women in Canada." In Enakshi Dua and Angela Robertson, eds., *Scratching the Surface: Canadian Anti-Racist Feminist Thought,* 49-80. Toronto: Women's Press.

Sunseri, Lina. 2000. "Moving beyond the Feminism versus Nationalism Dichotomy: An Anti-Colonial Feminist Perspective on Aboriginal Liberation Struggles." *Canadian Woman Studies* 20, 2: 143-48.

–. 2007. "Indigenous Voice Matters: Claiming Our Space through Decolonising Research." *Junctures* 9: 93-107.

–. 2008. "Sky Woman Lives On: Contemporary Examples of Mothering the Nation." *Canadian Woman Studies* 26, 3-4: 21-25.

Thomas, Chief Jacob E. 1989. *The Constitution of the Confederacy by the Peacemaker.* Wilsonville, ON: Sandpiper Press.

–. 1994. *Teachings from the Longhouse.* Toronto: Stoddart.

Trask, Haunani-Kay. 1996. "Feminism and Indigenous Hawaiian Nationalism." *Signs* 21, 4: 906-16.

Turner, Dale. 2006. *This Is Not a Peace Pipe: Towards a Critical Indigenous Philosophy.* Toronto: University of Toronto Press.

–, and Audra Simpson. 2008. "Indigenous Leadership in a Flat World." Research paper for the National Centre for First Nations Governance. http://www.fngovernance.org/research/turner_and_simpson.pdf.

Turpel, Mary Ellen. 1992. "Indigenous Peoples' Rights of Political Participation and Self-Determination: Recent International Legal Developments and the Continuing Struggle for Recognition." *Cornell International Law Journal* 25: 579-602.

–. 1993. "Patriarchy and Paternalism: The Legacy of the Canadian State for First Nations Women." *Canadian Journal of Women and Law* 6: 174-92.

Valverde, Mariana. 1991. *The Age of Light, Soap, and Water: Moral Reform in English Canada, 1885-1925*. Toronto: McClelland and Stewart.

Voyageur, Cora J. 2000. "Contemporary Aboriginal Women in Canada." In David Alan Long and Olive Patricia Dickason, eds., *Visions of the Heart: Canadian Aboriginal Issues*, (second ed.), 81-106. Toronto: Harcourt Brace and Company.

Wallis, Maria, and Augie Fleras. 2009. *The Politics of Race in Canada*. Don Mills, ON: Oxford University Press.

Webster. 1997. *The New Webster's Encyclopedic Dictionary of the English Language*. New York: Gramercy Books.

Wotherspoon, Terry, and Vic Satzewich. 1993. *First Nations: Race, Class and Gender Relations*. Scarborough, ON: Nelson Canada.

Young, Robert. 1990. *White Mythologies: Writing, History and the Rest*. London: Routledge.

–. 1995. *Colonial Desire: Hybridity in Theory, Culture and Race*. London: Routledge.

Yuval-Davis, Nira. 1997. *Gender and Nation*. London: Sage.

–, and Marcel Stoetzler. 2002. "Imagined Boundaries and Borders: A Gendered Gaze." *European Journal of Women's Studies* 9, 3: 329-44.

INDEX

The letter f following a page number denotes a figure; m denotes a map.

Printed and bound in Canada by Friesens

Set in Stone by Artegraphica Design Co. Ltd.

Copy editor: Robert Lewis

Proofreader and indexer: Dianne Tiefensee

ENVIRONMENTAL BENEFITS STATEMENT

UBC Press saved the following resources by printing the pages of this book on chlorine free paper made with 100% post-consumer waste.

TREES	WATER	SOLID WASTE	GREENHOUSE GASES
5	2,144	130	445
FULLY GROWN	GALLONS	POUNDS	POUNDS

Calculations based on research by Environmental Defense and the Paper Task Force.
Manufactured at Friesens Corporation